THE COMPLETE COLLECTOR'S GUIDE TO

FAKES
AND
FORGERIES

COLIN HAYNES

D1155457

Cover design and interior layout: Anthony Jacobson
Editors: Tammie Taylor and Lynne Weatherman

Library of Congress Catalog Card Number 87-51419

ISBN 0-87069-512-6

10 9 8 7 6 5 4 3 2 1

Published by

A Capital Cities/ABC, Inc. Company

Wallace-Homestead Book Company
Post Office Box 5406
Greensboro, NC 27403
(919) 275-9809

Contents

Preface

Some collectors spend a great deal of time and money on their hobby simply because they enjoy it; others, because they see collecting as an investment. All—no matter why they collect—want to avoid being cheated. As you read this book, you'll go with me behind the scenes of a fascinating business to get inside tips that will help you do just that. At the same time, you'll learn ways to acquire all kinds of interesting collectible items that will give you years of pleasure in both their pursuit and ownership.

Whether you spend a few dollars every month, or have thousands to put into the collecting hobby and its investment opportunities, the information contained in the following pages is just as applicable. I will try to share with you my love of browsing through antique shops, galleries, and flea markets all over the world; the satisfaction of getting bargains that build a legacy to help give my family financial security; the joy of possessing something I like to see and touch; and the satisfaction of being able to spot fakes and shady practices—with enough good deals under my belt to accept getting ripped off occasionally, so that I can write it off as good experience that will be paid back several times over in the lessons I've learned. I also plan to show you how you can make a profit from your vacations overseas.

I have visited hundreds of antique dealers, wholesalers, galleries, restorers, and auction houses on four continents, and this book combines those experiences with information from literally thousands of sources. I have found that there are many expert, honest dealers out there who may become your friends and helpers. There are also dishonest people waiting to exploit you; if you have already suffered at their hands, please contact me at the address on the following page.

But let's start thinking positively and get into the many ways you can ensure that you have a high proportion of good deals. Let's look at the tricks of the trade and the way dealers and auction houses conduct their business, and let us peek through the door at the nefarious activities of the fakers around the world.

And don't forget the basic rule that collecting must be fun for you if it is to be both pleasurable and profitable.

Acknowledgments

Grateful acknowledgment is made of Sotheby's in Sussex for permission to use its photographs, with special

thanks extended to Managing Director Leslie Weller and his expert staff, particularly Press Officer Patricia Brown, for their assistance. While the opinions in this book are those of the author alone, the information disseminated by Sotheby's, Christie's, and other leading auctioneering houses has been invaluable to me in the process of monitoring market trends.

Colin Haynes
1421 Riverview Dr.
Fallbrook, CA 92028 USA

CHAPTER

INTRODUCTION 1

Introduction

Defining the Antique and Its Market Value

The *Oxford English Dictionary* defini-
tion of *antique* uses the terms *ancient,
olden, aged, venerable, old-fashioned,*
and *out-of-date.* But the word *antique*
is being applied increasingly, especially
in the United States, to many items
that simply are *not contemporary,* and
which feature in the stock of general
dealers and gift shops. Some customs
officers, collectors, and dealers are
more specific. They define the antique
as an object that is more than a hun-
dred years old.

I will use the word *antique* in this
book to indicate any aged article of in-
trinsic value that is handled by the
world's antique trade, including mem-
orabilia and collectible items that are
of particular interest in the American
market, but do not yet figure promi-
nently in the antique business in
Europe.

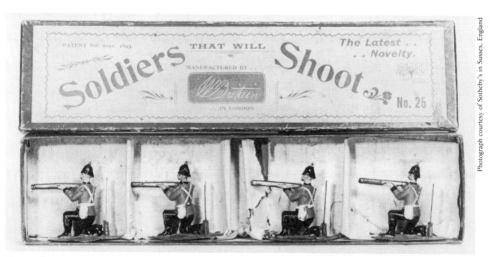

*Prices have appreciated enormously on old toys, making them prime candidates for faking.
These English toy soldiers, for example, sold for the equivalent of a few cents when they were
made at the turn of the century; now they're worth more than $400. Beware, particularly, of
Taiwanese fakes of American cast-iron toys, including money banks.*

3

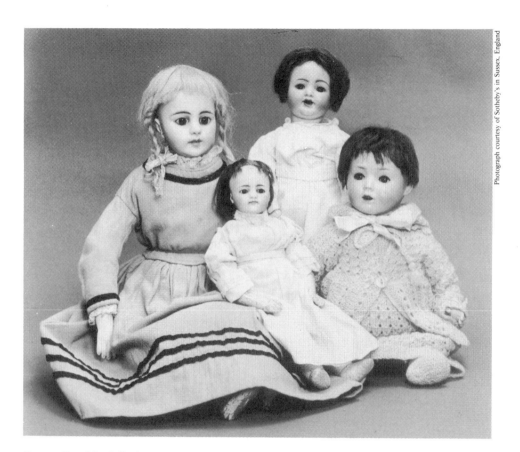

Rare collectible dolls fetch very high prices these days, so there is much faking of them and their clothes, resulting in some excellent work that is very deceptive. The bisque German doll of 1915 pictured at right sold for nearly $3,000. The rare examples pictured above are worth over $4,000 because of their historical and collectible significance: They date from the turn of the century, when real artistry first found a place in dollmaking, resulting in lifelike features and distinctive characterizations akin to those of sculpture.

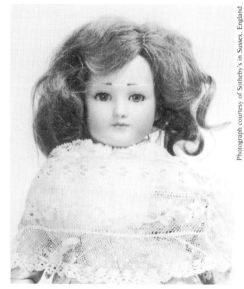

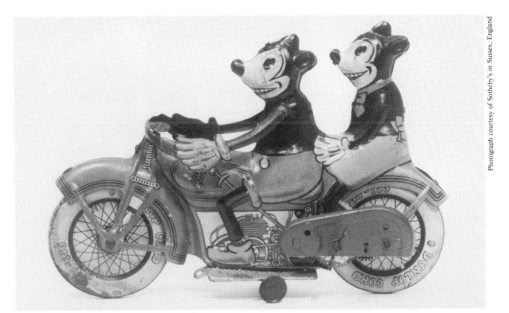

Watch for fakes of tinplate toys, which will have the paint distressed and perhaps some areas rusted to increase the appearance of authenticity. Again, enormous profits can be made from successfully passing these off as antiques. This genuine Tipp tinplate and clockwork model of Mickey and Minnie Mouse on a motorcycle dates from around 1930 and sold at auction for nearly $4,000.

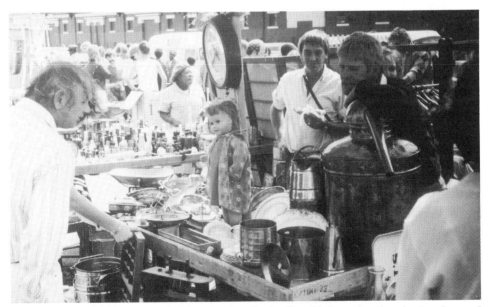

Flea markets and swap meets are fun places to find collectible bargains, but they're also used frequently to move both outright fakes and reproductions that have been aged artificially to deceive eager bargain hunters.

I will not use the word *antique* to describe such specialist collectible categories as beer cans, Barbie dolls, posters, and other advertising matter unless the items are classics of their kind and are old enough to have a rarity value.

Readers may find themselves understandably baffled in assessing the realistic market value for an antique. As long as the antique in question is genuine, the old adage that market value is simply the amount acceptable by motivated buyers and sellers at any given time is very true, and a properly publicized and responsibly conducted auction is one of the best ways of establishing that acceptable amount. But do bear in mind that published auction prices include commissions paid by the seller and, often, a premium paid by the buyer, which together can make up 20 percent or more of the actual price paid.

Buyer Beware

With those distinctions made, let us take a look at several classic examples of dishonest dealing as it is conducted across the antique market.

It Pays to Be Suspicious

The mugs arrive early at this Southern California auction, which has been widely advertised for more than two weeks by the traveling group of entrepreneurial types staging it.

They have trucked in several tons of goods, set up a canvas awning for shade, and provided chairs and refreshments for the eager potential buyers. Their cash flow is healthy, even before the hammer starts to fall, as they collect $50 registration fees from those who intend to bid; they're also doing a roaring trade in coffee, Coke, and hot dogs.

There is no catalogue, nor has there been much opportunity to have the normal day's antique auction preview at which the knowledgeable can make a careful and unhurried examination of the lots being offered. But everything is set out attractively, the public address system works well, and there are at least a half-dozen senior staffers around to talk to buyers.

The audience is affluent and well-dressed, with designer jeans the most popular dress on this pleasant Sunday afternoon. No sign of the usual group of dealers who attend antique auctions—none of their vans and station wagons parked among the Cadillacs, Lincolns, and Jaguars.

The dealers have intentionally stayed away from this kind of sale. It is a very slick, professional operation, carefully orchestrated to separate the less experienced buyer from the maximum amount of money in the shortest possible time.

The first few items are small antiques which go at very attractive prices, including a delightful dollhouse—probably from the thirties—that sells for an amazingly low $20. Some of the successful bidders for bargains are, I discover subsequently, stooges who are part of the auctioneering team. I hang around afterwards and see some of the genuine lots being loaded back into the truck for use to seed the stock in the next city where this scam is to be staged.

The brisk early sales have a visible effect on the audience. They become more alert, switched on by the apparent opportunity of securing bargains. Even husbands who have been dragged along by wives, when they would have much preferred an afternoon on the golf course, sit up straighter and prepare to participate.

This room, furnished in the Queen Anne style, is full of fakes typical of the reproduction furnishings from Victorian and subsequent times that are frequently misrepresented as being genuine.

The next couple of hours are extraordinary. Paraded before us are a remarkable collection of fakes and phonies, interspersed with a few genuine items, most of which are "bought-in" by being knocked down to bidders who belong to the auctioneering team.

Coins, jewelry, furniture, pictures, ornaments—all sell at surprising prices. One bidder pays $820 for an ornate gilt clock in the French style of the nineteenth century. It looks great from a distance of 50 feet. I open the back later and find that it has a Taiwanese electronic movement.

Still, the auctioneer cannot legally be faulted in his descriptions as the buying fever spreads among his audience. Rarely does he slip in his descriptions of articles being *in the style of* or some similar meaningless phrase help-ing to give credibility to what he is selling. He establishes such rapport with the audience that, after knocking down three signed "limited edition" Picasso prints for prices in the $300–$500 range, he even gets away with saying, "They're all guaranteed . . . if you can find us after this sale!"

When another so-called limited edition—this time said to be Remington bronzes—starts generating big business, more examples are brought out discreetly from the back of the truck. They are a tribute to contemporary Far Eastern craftsmanship. There are oak and pine furniture pieces which look quite good, but are obviously modern reproductions of genuine antique European and American cabinetmaking. The buyers would have noticed that had they been given

the opportunity to look closely at the backs of the drawers and the hardware.

There are also some classic examples of chests-on-chests and display cabinets in which genuinely old pieces have been combined and reworked to such an extent that they are effectively reproductions.

How sad that these enthusiastic buyers should be cheated into paying a great deal of money for fakes. In later chapters, you'll discover a number of ways to inspect items so that you can avoid this kind of situation and be able to return home confident of your purchases, ready to display them with pride.

Meanwhile, Across the Water

Come with me now to the other side of the Atlantic to a section of London which is home to an impressive antique dealer's showrooms, where we are greeted by an elegant young lady who appears to be imitating the style of Princess Di.

We examine the stock, all of it undoubtedly genuine, including some fine Chippendale English chairs. It is all so discreet and up-market that when we emerge as serious potential buyers of an attractive walnut bureau, we are introduced quickly to a senior staff member. This equally elegant individual is like a young David Niven, complete with sober suit, old-school tie, and an immaculate accent obviously acquired at Eton or Harrow schools and refined in the upper echelons of English society.

Such an up-market establishment does not have anything as vulgar as price labels on its goods, and we can make no sense of the hand-written coded tags. Yet the code is, in fact, very simple. A nine-letter word or phrase is used to indicate the trade and the retail asking prices, preceded (in many cases) by the acquisition price. If we know the code, we are able to understand the key facts now whizzing around in the Englishman's mind as he works out the most profitable deal.

The code word is *Washington*, and the letters in the code word correspond, respectively, to the numerals in the series 1234567890. For example, the label on the bureau we were inspecting reads SHI/GIN/OTN. That bureau was bought a couple of weeks before for £345 off the roof rack of a "runner's" car, soon after dawn in the Portobello Road market. (The runners are at a low, but essential, level of the antique trade; they acquire goods cheaply from a variety of sources, such as country auctions, and then pass them on to other dealers, usually selling them straight out of their vehicles.)

After being spruced up a bit by a restorer, the bureau has gone into stock at this store for sale to any other dealer interested in it for £750, a mark-up of about 100 percent, including the cost of the modest cleaning and repair work it first required.

The store would be very happy to let it go at the retail coded price of £980—or give us a 10-percent discount with a minimum of haggling. Instead, the salesman registers that we appear well-heeled, but not very expert, and gives us a lyrical description of the piece and its ancestry, which he believes to have included a period spent in the country home of some minor member of the English nobility. By the time he gets to the asking price he has the confidence to try for £1,250 and, when we look a little startled, throws in a 12-percent discount for cash, and free packing and shipment.

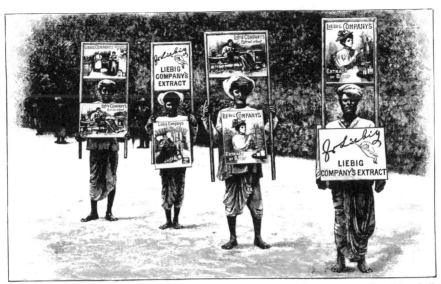

The charm of old advertising, typified in this 1897 original engraving of walking billboards in Bombay, India, is copied extensively to meet the demand for display items.

Capital of Fakes

Probably the world's biggest concentration of fakes is to be found in the Grand Bazaar in Istanbul, the meeting place for both European and Asian chicanery supplemented by a steady influx of low-value items imported from the Far East.

There are about 4000 individual shops in the Grand Bazaar, peddling everything from jewelry and carpets to statues and icons. If you have the courage to penetrate the maze of stores and their aggressive sales tactics, you'll find small, independent workshops on the fringes of the bazaar where tourists are usually warned not to go. The owners are proud of the work they put into making reproduction metalwork and other items, and you can make attractive purchases there at a fraction of the price you'd pay for the

Indian wood carvers still work in the traditional way, faking copies of the designs of their forebears.

same kind of goods if they had passed through dealers' hands and were being sold from conventional retail outlets.

The salesman is so charming and helpful that it would seem most ungracious to haggle; anyway, he has outmaneuvered us psychologically by offering a substantial discount before we even asked for one. Little do we suspect that we are paying almost four times the sum given for the bureau a few weeks previously on the fringes of a London street market.

Here, There, and Everywhere

We should make three more trips into the murky world of antique dealing before getting to the details of how to protect ourselves from being cheated. Come with me, then, to Johannesburg, Upper Manhattan, and the Carolinas.

Troubled South Africa is a happy hunting ground for collectors while its exchange rate on major currencies such as the dollar, pound, yen, and mark remains so low. We go into a classy antique shop near our hotel in Johannesburg and see some really beautiful cottage-type furniture in rich, glowing, mature wood. The salesman is not very bright or helpful and notably lacking in information about his products, but we just cannot resist ordering a beautiful wooden gun rack at less than $100 and a magnificent trestle dining table for the equivalent of about $250. They radiate antiquity, despite having the gleam of recent tender loving care, which has given them a rich lustre and brought out the beauty of the wood.

Our purchases look as if they were used by the early Dutch settlers 200 years or more ago. In fact, they left the factory only two weeks ago. The wood from which they are made is genuinely old, but until recently, was in the form of railway sleepers.

In many countries, old timber sleepers are being torn up and replaced by steel or concrete ones, yielding a substantial new source of genuine old timber to be used in manufacturing antique reproductions such as our purchases today. Some of these items represent excellent value for the money and will both enhance your home and have the potential for appreciation because the good examples have an inherent quality and style. But you want to know what you are buying so that you don't pay too much for it in the mistaken belief that you are acquiring a piece of history as well as a quality example of furniture construction. Identifying the actual age of a wide range of collectibles will be a major topic of discussion in the following pages.

We next travel to the U.S. and take a cab to upper Manhattan to explore the fascinating selection of antiques shops there. After our overseas trips, we have turned our backs on American pine furniture because we saw it in Europe and Scandinavia at a fraction of its cost here. Instead, we are looking for American antique *bargains.*

There don't appear to be many in Manhattan, but in one store, we pick up what seems to be a really old and genuine piece of Sandwich milk white glass. Later, we show it to a specialist collector in this field who, without a word, puts it alongside one of his own similar pieces. Horrors! Our new acquisition now shouts out that it is a fake.

The genuine glassware has a beautifully smooth surface, and its color is so much whiter and more lustrous than that of the fake. Our collector friend clicks his thumbnail against the

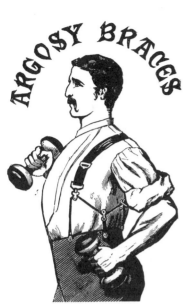

Thousands of successful products have been faked—even suspenders, or braces, *as this British ad calls them.*

rim of the authentic piece and it gives out a clear ring; the quality of its sound is like that of a Stradivarius violin compared to the dull tone produced when the fake gets the same treatment.

We should do better when we go the the Carolinas—the happy hunting ground for America's antique dealers—and we're pleasantly surprised at the ease with which we gain access to a North Carolina "wholesaler" who offers us a "trade" 10-percent discount on anything we buy. In fact, he is happy to sell to anybody who comes through the door, and a genuine dealer will get much more than 10 percent off his marked prices, as would a private collector prepared to bargain with him.

The wholesaler tells us that he gets a container-load of antiques in from Europe twice a month, and that most

of them are snapped up by American dealers. We buy a very attractive china soup tureen with Blue Willow design and the $165 price appears a good one. It is genuinely English, but we fail to realize that the color is wrong and the tureen too heavy to be genuine eighteenth-century work by master craftsman Thomas Turner. What helps to fool us is the way in which the glaze was cracked artificially by the English forgers who produced such work earlier this century, even going so far with their "aging" process as to scratch and grind wear marks on the bottom of the piece.

However, the tureen is still old enough and good enough to be a reasonable buy. It may even be that we can unload it at a profit in another part of the country.

We don't do so well with the antique furniture we buy in South Carolina. There, we forget to examine the backs of the cupboards and the undersides of the drawers using the rule-and-light test. We also misjudge the age of the hinges and screws *and* overlook several of the subtleties of patina in our excitement and haste to snap up what are actually fake reproductions instead of bargain antiques.

Lacking a basic knowledge of silverware faking, we also buy a tea tray that started life as a meat platter (and so is worth far less than what we end up paying for it), along with a coffeepot that is actually just a dressed-up mug. Furthermore, unaware of how we could use the pin test to help verify its authenticity, we take our chances and pay well over the odds for an apparently old Virginia landscape painting that actually was recently imported from the Far East. And, not knowing how easy it is for even a small foundry to produce vast numbers of fakes very

11

Use Your Computer to Track Down Fakes and Phonies

Your personal computer and telephone can be valuable tools in researching collectibles of all kinds and acquiring information that will help you identify fakes.

By linking the computer to the telephone via a modem, you can gain access to vast databases on auction prices and trends, collecting, art, and more—all for as little as $100. For instance, a host of collectibles references are available through the Wall Street Journal *database, offering information such as expert opinions, details of appraisals, and biographies of artists that can be useful in proving—or dis*proving—*claims of provenance.*

A variety of such databases are available, each for a small annual subscription fee, with additional charges depending on the amount of time the service is used. Some, like Dow Jones, offer attractive low-cost introductory subscriptions to encourage you to get started. Some sources are yours for just the cost of the telephone call.

Talking to several established computer dealers will help you determine the right equipment for your authentication needs. In addition, there are a number of computer-related magazines and directories that carry details of the various databases described.

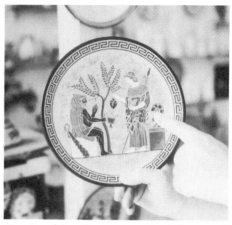

Here is a fake of an ancient Greek decorated plate, copied from a museum original and sold in Athens for a few dollars.

cheaply, we get a bit carried away in our purchase of brass and iron wares.

We might have bought a lot more items overseas—or bargained harder with American dealers—if we had known about mark-ups as high as four or five times the original cost of antiques that cross the Atlantic. We could also have considered the way further profits inflate the eventual retail selling price as the stock changes hands several times within the trade before getting to the public, but we didn't realize the extremes to which that sort of thing gets carried.

Those are some of the factors to be discussed in the upcoming chapters, which will reveal a whole new dimension to the joy of collecting and point the way to the satisfaction of buying wisely for sound investment.

CHAPTER TWO

JEWELRY

Jewelry

Never buy what you are led to believe is a genuine antique piece of jewelry without a detailed invoice and money-back guarantee—unless you are so enthused about the price and attractiveness of the piece that you are prepared to accept that it may be fake. For many years, the world antique market has been flooded with fake jewelry, much of it created in Europe and sold in the United States. In recent years, the Far East has also become involved in jewelry faking on a grand scale.

It Can Happen to Anyone

As in any other area of collecting, experts and amateurs alike can be fooled by jewelry fakes. What was billed in 1987 as "the most magnificent collection of ancient jewelry ever exhibited" supposedly had been authenticated by experts when the pieces went from New York for a highly publicized show at London's Royal Academy. That publicity backfired when a number of other experts started questioning the authenticity of many of the pieces. Even a hastily summoned secret seminar of 24 scholars and curators from around the world failed to resolve the controversy, with those who examined the pieces proclaiming some to be authentic, others to be pastiches made up from different periods or areas, and still others to be such poor examples of workmanship that they did not even deserve to go on show. The president of the Society of Jewelry Historians, Jack Ogden, maintained that one piece in the exhibition actually figured in his classic book *Jewelry of the Ancient World* as an example of faking.

The incident has many lessons to teach about faking in general and the counterfeiting of jewelry in particular. Not much was known about the background, or *provenance*, of a significant proportion of the pieces being exhibited. If they had gone on display at the Royal Academy, they would have increased enormously in stature and consequent value. The acceptance of any work of art as part of a major exhibition or display at a leading museum or gallery does wonders for establishing a pedigree that reads most impressively if the work later comes up at auction. Such acceptance has more significance in the collecting and investment world than, in society, does the cachet of being invited for a cosy chat at the White House or to tea at Buckingham Palace. As a concrete example, look at the enormously high prices paid for the Duchess of Windsor's jewels when Sotheby's auctioned them in Geneva. While I am not suggesting that they were fakes, I do feel that their pedigree helped those gems garner often-unrealistic prices.

In addition to quality, age is a vital factor in determining the highest possible sale price for a collectible, which is why so many fakers spend a great deal of time working with artificial aging processes. Both of these beautiful singing-bird boxes are genuine and are similar in size, but the mid-19th century example (at left) sold for nearly $5,000 while the 20th-century box fetched less than $800.

Intentional Fakes

On the other hand, thanks to the difficulty of telling the genuine from the counterfeit, many people choose to wear what is called *faux*—the French word for *false*—jewelry. Wealthy celebrities sometimes do so with the intention of confusing any observers who may be entertaining devious notions of "sharing" their wealth. One of the first things Elizabeth Taylor did after receiving her fabulous diamond ring from Richard Burton, for example, was to get a copy made. So the fact that a piece has had rich previous owners is absolutely no guarantee of its authenticity.

Of course, costume jewelry is not fake if it is sold as such. Rather, this kind of imitation is to be praised for bringing bright baubles within the price range of the general public, and it has certainly proven popular in that respect: Costume jewelry sales in the U.S. alone are approaching a billion dollars a year. But while such pieces are retailed as faux on Fifth Avenue or in Neiman-Marcus stores, the better pieces provide opportunities for un-

scrupulous subsequent sellers to fool less experienced buyers by representing them as genuine. When this is the case, and the buyer pays too much for something because it has been falsely described as genuine, *faux* does become *fake*.

The situation gets even more confusing when the faux pieces are copies of designs originated by such up-market jewelers as Cartier (which happens frequently).

Methods of Faking

When pieces with backgrounds of *apparent* authenticity can be moved through international auction houses or the trade, their potential selling prices are sometimes so great that thousands of hours of work by expert fakers will pay off handsomely. Consequently, fakers may go to enormous lengths to make their work appear genuine. It is even said that reproduction rings have been stuffed into the gullets of turkeys and left there for the digestive juices to attack the gold and gemstones in order to create the appearance of aging.

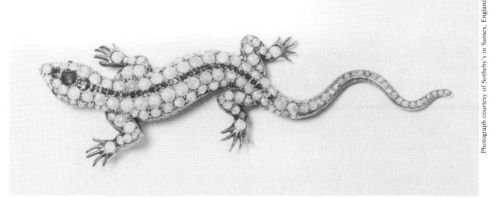

Genuine opals and rubies such as those found in this Victorian lizard brooch—worth more than $6,000—are very difficult to distinguish from paste or doctored gemstones, and are well worth the fakers' efforts to duplicate them. A fake of such an early piece, if successfully done, could attract a buyer at far higher prices than would be offered for a genuine example of jewelry dating from a decade or two ago.

Antiquities in bronze and pewter, and other materials purporting to date from ancient Egypt or the Saxon and Norman eras in Britain, have been faked in substantial quantities. In addition, even though gold, silver, platinum, and gemstones resist most of the artificial aging processes used on other materials from which fake antiques are manufactured, there are some new chemical processes, developed by fakers, which produce very effective results that can fool even museum experts and the most knowledgeable specialist collectors.

At the upper end of the market, so much fake jewelry has been attributed to former English and French nobility ownership, it seems the wearers would have been buried in their overwhelming collections. The collector investing comparatively small sums in pieces such as jewelry of Victorian times must also be careful. Dealers can buy so-called "antique" jewelry in bulk lots at very low prices. When this jewelry is subsequently offered to the public as genuine—thereby generating enormous profit margins—there is often a double fraud. The piece itself is not genuine, but rather a modern reproduction, and the stones which so influence the value are imitation as well.

Zircons (artificial diamonds), agates, lapis lazuli, amber, jade, and pearls all can be artificially produced so well, laboratory equipment is needed to detect that they are not the real thing. Inexpensive industrial diamonds of the kind used for grinding and drilling can be given almost the whiteness and brilliance that make them appear to be worth many times their actual value.

Testing whether an apparent diamond will scratch glass is not even a reliable test of its authenticity. *Doublets* and *triplets*, which consist of genuine diamond sections cemented to glass to give the appearance of a large stone, pass that test. But while the outer layer or layers are genuine, most of the mass of such a stone is worthless. Keep in mind, too, that the same technique used to create these diamond imitators is practiced very effectively on other gemstones.

Other tools of the faking trade include chemical stains that can upgrade inexpensive jade, turquoise, and quartz to make them look like valuable antique stones. There is also a clever plastic treatment for turquoise. Topaz and amethysts benefit from irradiation; emeralds can be oiled; and aquamarines, rubies, and sapphires change color when subjected to heat. While the simpler surface treatments with dyes are relatively easy to detect, many of the others frequently fool experts unless expensive and complicated tests are performed on the stones in question.

Finally, genuine stones may be mixed with a preponderance of fakes in remanufacturing jewelry, something that can be undertaken quickly and rather economically by expert fakers.

What Are the Best Indicators?

The brilliance of a purported diamond's *reflection* is definitely a better indicator of the stone's authenticity than its age. Fakes cut from crystal have been around for hundreds of years. Even the Romans could make good paste imitations of diamonds. Their trick of backing a diamond with thin, reflective metal to give more luster is still used by contemporary fakers, even though it should be a giveaway. After all, genuine cut diamonds are remarkable in their ability to reflect virtually all the light that enters them, which means that a good stone should not need a reflective backing to make it sparkle. If you examine them closely at different angles, you can see right through some fake diamonds because of their lack of reflection.

One old dodge by jewelry fakers is to cement fragments of gemstones together to make a larger and apparently more valuable stone. Soaking a suspect piece in alcohol might reveal the trick by dissolving the glue, or it could prove inconclusive with some of the modern adhesives. At any rate, you risk ending up with a pile of stone chippings, so think carefully before conducting this test.

Color, another indicator critical to a gemstone's value, is not so easily verified as authentic, especially now that it has become a norm, even outside the faking world, to treat colored gemstones in order to improve their appearances. Before finalizing a purchase, you are justified in asking to what extent your stone has had its natural qualities *enhanced* (the trade prefers this term to *treated*), but often the retail jeweler actually doesn't know.

Certainly a clear diamond at a bargain price has to be suspect, as most genuine stones have some discoloration and other imperfections. (Indeed,

The Glasgow Exhibition: Diamond Cutting and Polishing

some naturally colored diamonds with attractive blue, yellow, pink, and green tinting can be more valuable than those that are colorless.) The best diamonds are generally colorless and graded from *D* down to *Z,* according to the amount of brown or gray tinting they acquired from the chemicals present when they were formed ages ago by the enormous pressures and heat of the deep underground.

Among the many faking tricks used to improve the color of gemstones is to bombard them with radiation. This is particularly effective in giving low-grade diamonds of uneven color a more acceptable yellow tint. Notably, a fake of the famous Deepdene diamond, having prompted a bid of more than $1 million at auction, was examined by experts who found that it had been irradiated in a neutron or electron stream.

Fortunately, you don't need to take a Geiger counter with you to spot some fake tints. These have been added to the surface, particularly around the edges, and will rub off with a cleaning solvent. Drop some examples of these impressive stones into a glass of gin or vodka and the alcohol will remove their color!

The jewelry trade also uses *gradings for clarity,* which depend on the degree to which the diamond is free from blemishes and inclusions. Another measure of a gem's value is its *cut,* the way in which the stone has been sliced and polished to create the facets. The aim is to cut the diamond so that light is reflected toward the center from each of the facets.

Another indicator of value is weight in *carats* and *points.* (There are 100 points to a carat, and 142 carats to an ounce.) Keep in mind, however,

Faking or Accepted Practice?

"Tell me anyone who is not treating their colored gemstones to make them appear more valuable," a leading international dealer told me during a cozy chat in a California restaurant.

If something is such common practice, is it still faking? If the answer is no, *why is there still such secrecy about it in the jewelry trade—such an obvious reluctance to let the public know what is going on? Even though some of the more responsible people in the gemstone business are advocating greater disclosure of this artifical coloration, often your retail jeweler just cannot give an accurate answer about the extent to which your prospective purchase has been tampered with since it left the ground. The treating process is taking place on the* supply *side of the trade, where all but the finest (or the very cheapest) stones available today are likely to have been irradiated,* heat-treated, *or otherwise color-enhanced by means of dye, oil, or wax.*

Another problem, which some perceive merely as good business, is cutting the stone in order to improve the selling price rather than to enhance the gem. For example, a big stone may be cut in an inferior way just to preserve its size, thus yielding more profit but detracting from its actual value and appearance. In fact, many colored gemstones are cut so flat, you can almost see through them.

Be warned also of language used to enhance the perceived value of stones that are difficult to sell because they are not well known. Describing the red spinel *as a* ruby spinel *is a deliberately confusing ploy to associate the spinel with the known and prized ruby by exploiting their similarities in color. Nor is the* citrine topaz *a type of topaz, but another stone altogether.*

that heavier is not necessarily better, as all the other factors mentioned must be taken into account in order for a gem to be properly appraised.

These complicated grading systems give shady sellers a good deal of ammunition with which to bamboozle innocent buyers. A gem may come with all kinds of fancy paperwork and impressive technical specifications, but unless you are an expert, such trappings are mostly meaningless. The only really sure way of assessing both authenticity and value is in a very well-equipped professional laboratory where, for example, the stone can be x-rayed. A diamond is pure carbon and will show transparent when x-rayed, whereas many of its imitators will appear opaque.

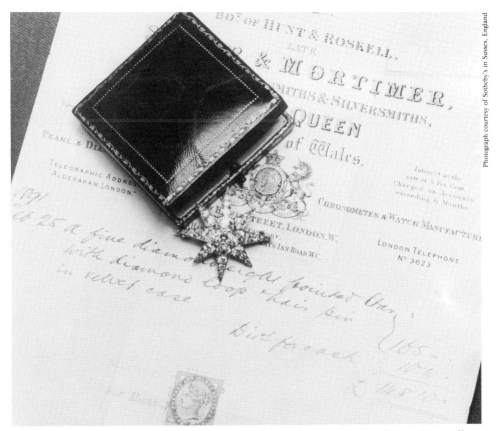

Good documentation could be an invaluable aid to authentication, but few antique collectibles are as well supported as this eight-pointed star diamond brooch accompanied by the receipt issued when it was sold new in 1891.

The Best Approaches

Much of the fake jewelry on the market has been around for a long time and so is becoming genuinely old. If that is true of something you're thinking of buying, you may consider it worth adding to a collection whether or not it is authentic.

If you are spending a significant sum on a piece of jewelry because you believe it to be genuine, don't hesitate to get a specialist's opinion. Also, remember that it is always safer to buy from dealers who concentrate their efforts in this field, are jealous of their reputations, and are prepared to guarantee what they sell with a written description of the individual stone or piece of jewelry.

Don't be tempted to pay high prices for apparently genuine jewelry when you are vacationing in places such as Istanbul or India. Just because the real thing is produced more inexpensively there doesn't mean that it will be offered below the international

Testing Pearls

Pearls are a special problem, since they are imitated in such a variety of ways. In fact, most "natural" pearls these days are cultivated artifically by inserting beads of mother-of-pearl into oysters kept in underwater cages. In a couple of years, the oyster coats the bead with natural pearl. One way of identifying a pearl cultivated by this process is to look down the drill-hole with a mirrored device, rather like a tiny periscope. Both natural and cultured pearls can be examined under strong magnification with a light behind them, which shows the different ways in which the layers have formed. And then there are completely false pearls, which are identified by their reactions to various chemical tests.

Also note that a real pearl has a natural and rather uneven surface which is not always reproduced in imitations. With a little experience, you can feel this roughness by gently passing a pearl between your teeth. As with other touch-and-smell tests, this requires practice, and the comparison of something genuine with a variety of fakes.

market value. Such bargains are just as likely to be fakes as the ones you find anywhere else in the world.

Buy what you like at a price you find acceptable, even if the piece is not what the seller claims, and you have no cause for complaint. And, many experts say, don't buy jewelry for investment. It can be a hedge against inflation, but the mark-ups in the trade are high, and you usually have to wait a long, long time before being able to get even your original price back on resale.

CHAPTER THREE

METAL WORK

Metalwork

Metalwork is one of the more profitable categories in the business of faking antiques. Metal objects are comparatively easy to "age" rapidly and reproduce in large numbers. Many of them are small enough to be portable and are popular among amateur, casual collectors, or for gifts. Metalwork produces fast-moving high-volume sales stock that more than compensates the faker for the effort of acquiring originals, making molds, and taking considerable trouble to see that castings are aged artificially.

Faked metalwork causes particular problems to the world antique trade when artificially aged hinges, locks, bolts, handles, and screws are used to try to confuse the process of identifying the dates and origins of furniture. In addition, stoves and fireplaces, firedogs and backs, foot scrapers, garden furniture, and all kinds of wrought-iron objects made recently are being peddled everywhere as genuine articles after having been dipped in a chemical bath and given some accelerated rusting. Bronze castings of "limited edition" sculptures and much fake brasswork, such as fire irons and warming pans, are being churned out from small foundries in the Far East, Europe, and the United States. In regions where labor costs are typically low, such as the

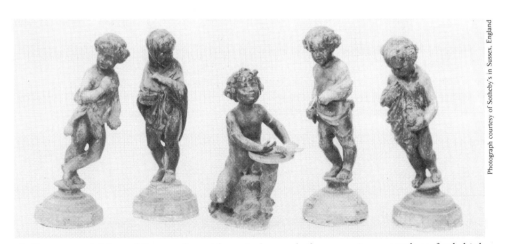

Antiques—and fakes of them—do not have to be made from precious metals to fetch high prices these days. These late-19th-century lead pieces (approximately two feet tall) should fetch high prices because of the booming popularity of garden statuary.

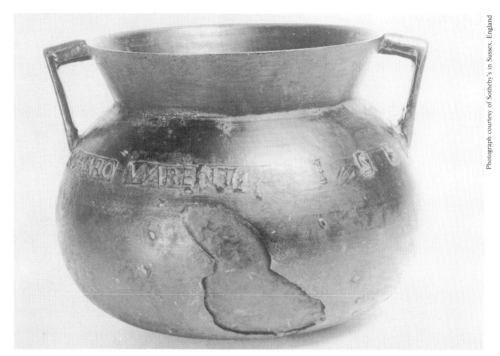

Photograph courtesy of Sotheby's in Sussex, England

Turkey and other parts of Asia abound in skilled fakers of bronze and ironware, resulting in copies of items, such as early bronze cauldrons that resemble this one from the 16th century. They fake both the article and the repairs that would inevitably have been necessary over the centuries when such items were used, not just displayed.

Far East, considerable handwork to achieve aging effects can be justified, and there are myriad small workshops specializing in this field.

During a visit to Taiwan, I was offered a limitless supply of fake iron- and brasswork, and the manufacture of high-quality reproductions from any originals I cared to supply. The business is so lucrative that I received endless telephone calls to my hotel room, followed up by an attractive female representative of the company knocking on my bedroom door and offering other incentives.

A look at the other side of the market explains why fakers consider it worthwhile to expend more energy

Kitchen and other types of scales are increasing in value, so many are being reproduced—either as complete fakes or with weights that are old, but do not belong to the same instrument. Check that weights nest properly, are of the correct mass, and show genuine signs of use and age.

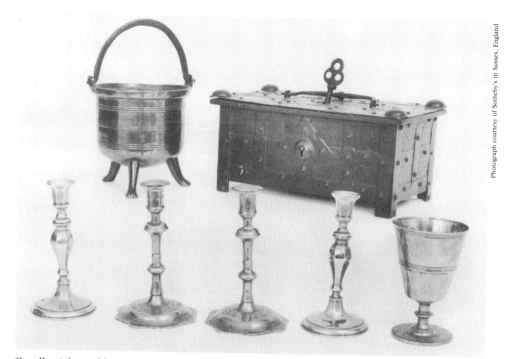

Candlesticks, goblets, iron- and brass-bound boxes, keys, and locks—all are popular candidates for fakery.

making the imitations than that which was required for the originals. A collection of bronze and iron keys was sold in New York for more than $4,000; an eighteenth-century French iron door knocker fetched $1,440 at auction in London; and another interesting French piece, a wrought-iron padlock from the eighteenth century, went to a New York buyer for $1,210. There is obviously a growing interest in base and alloy metalware, which could provide excellent investment opportunities for collectors on small budgets if they take care to avoid the many fakes around.

Safeguards

Metalwork faking has opened up highly profitable international markets for small foundry owners, with some of their work fooling even the experts. How well, then, can you protect yourself from being cheated?

To be honest, it's very difficult in most cases. Much of this work first entered the market with its makers having no intention to deceive. Rather, it was manufactured and wholesaled to meet the demand for reproductions of interesting old pieces. After such reproductions have changed hands two or three times, their origins become obscure, and even an honest dealer may stock them as genuine because he or she can't tell the difference. On the other hand, unscrupulous dealers sometimes deliberately represent something as original and mark up the price accordingly, knowing they can buy hundreds more of the examples wholesale, at a very low cost.

Prices for collectible old metal toys can run into the thousands of dollars, so many such items are being reproduced and aged artificially. Model trains, cars, and mechanical toys in both wood and metal are also gaining the attention of fakers.

Someone can take apart a genuine Victorian garden bench, for example, make molds from the pieces, and cast reproductions that are virtually identical to the original. Chemical treatments, some vigorous wire brushing, and rusting by more chemical dips (or exposure to the elements for a few weeks) achieve rapid aging effects that may be difficult to detect, even if you scrape the metal surface with a knife.

Still, you can watch for several rather obvious signs of possible problems. In particular, be cautious of painted ironwork, especially if the paint obscures nuts, screws, and bolts. Also, when the screws or bolts used to fasten the different castings together can be examined under a magnifying glass, you should get valuable clues to their age. Modern threads are more uniform and more sharply cut than really old fastenings. Be very suspicious of nuts and screws that undo easily, as they may have been fastened together for the first time only a few weeks previously, whereby they could still bear traces of lubricating oil or

grease. Another quality to examine is coloring, since exposed surfaces of recently cast iron should have a lighter color than genuinely old items. Where parts are fastened together, there should be at least slight wear from movement occurring over the years. In addition, the bottoms of feet should show scratches and wear patterns, but these can be faked easily.

If you compare old and new brasswork, you will also see differences in color and surface appearance. This suggests a general strategy you can adopt to help guard against being deceived: Try to get together representative examples of real antique metalwork, and make suspect purchases only on the condition that you can return the items for a full refund if examination against your similar, genuine pieces gives you grounds for suspecting the others are fake. Putting any genuinely old piece alongside a suspected modern reproduction is always one of the best tests of authenticity because it makes apparent all the slight differences of original manufacture, as well as those that result from natural aging.

War-Related Items

Military items, including weapons of all kinds, are growing areas of collecting in which faking is prominent. Along with replicas from much earlier times, there's also a great deal of reproduction militaria purporting to date from twentieth-century wars.

Typically, many reproductions are created with honest intentions, and they only become fakes when they are passed off as originals. The quality of the fakes varies enormously. Suits of armour, swords, shields, and firearms are frequently reproduced in modern materials, notably in various forms of oil-derived plastics and contemporary alloys. They give themselves away immediately by having the incorrect weight and feel.

But traditional materials and methods of construction are also used. One young English swordmaker openly produces and sells convincing copies of all kinds of early swords and daggers (which are easy to age artificially). He demonstrated one of his traditional English long swords to me by hitting it against a block of wood, where it snapped in two. But that is not a test of authenticity, as many of the genuine early swords broke in combat.

Photograph courtesy of Sotheby's in Sussex, England

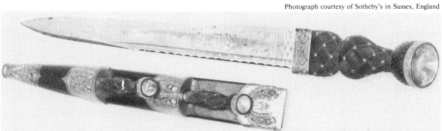

Ornamental daggers are faked extensively in Asia and the Far East. This one is a genuine example. Its quality construction, materials, and style contributed to its authentication as having Victorian vintage and belonging to a Scottish Highlander in the famous Black Watch.

Nor is it a test of authenticity that a firearm actually works. Traditional black-powder guns are being reproduced for the popular pastime of restaging famous battles, and while only intended to give a convincing bang and cloud of smoke, they can be doctored to fire a bullet. Proof and makers' marks can be fairly easily contrived as well. So never try to authenticate a firearm by using it: The workmanship may be so inferior—or the real age so great—that it blows up in your face.

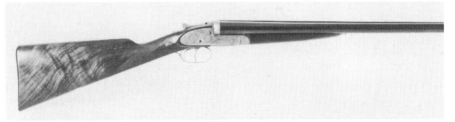

Be very careful of false makers' names and decorations on sporting guns, which offer enough profit to tempt forgers. This is one of a genuine pair of Purdey 12-bore game guns that fetched over $25,000 at auction.

Decorative reproduction pistols are pouring out of Spain, North America, and other areas because they make attractive souvenirs and display pieces. I see them in antique shops all the time, but most are clearly modern reproductions of inferior quality. Look for bone and plastic inlays instead of genuine ivory or mother-of-pearl, and check the wood and metal for signs of artificial aging.

There are so many early rifles being exported from South Africa that their wholesale prices are quite low. They are genuine, but there is an element of trade deception when the prices are inflated to make them appear rare collectibles. You should be able to find them attractively priced (less than $50) in retail outlets in Europe and the U. S. Note that some are relics from the Boer War with the English and have had their bolts removed or welded into place.

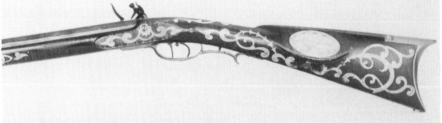

Everything was "right" and authentic about this 19th-century flintlock Kentucky rifle, which is why it fetched some $35,000. Attempts to copy such high-quality antique firearms are rare, but with prices like this providing a temptation, fakers in some countries might spend a year or two making a reproduction.

Copies of suits of armor have been made for many years. One check for authenticity is to see if they really are wearable. The genuine ones are surprisingly small—remember that the stature of previous generations was much smaller than that of our own society, which benefits from better nutrition.

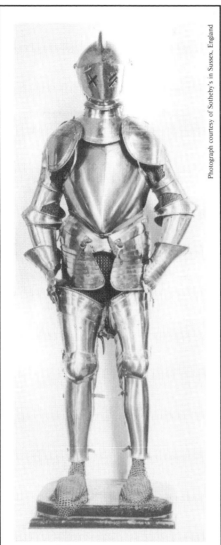

A suit of plate armor made in the style of the 16th century, but probably manufactured much later. One giveaway is that it is nearly six feet high; 400 years ago, a man of that size would have been exceptional. Nevertheless, the quality of workmanship and the time needed to create good reproduction armor gives it considerable value. This suit sold for nearly $10,000.

In requesting such an agreement from the dealer, you might say something like "I accept the price and it appears to be a nice piece, but we know that it is almost impossible for even the experts to tell good reproductions from originals in this field. I have a similar item at home. If I am not completely happy with my purchase after I have had the opportunity of comparing it to the one I have, will you give me a refund?"

No honest dealer anxious to do further business with you should refuse such a reasonable request. Indeed, the principle applies to any antique you buy from a reputable dealer; the dealer should be prepared to take it back and refund your money if you can show good cause that the piece is not what it purports to be.

Don't hesitate to ask for the same conditions of sale if you are not confident about the hardware on a piece of furniture. More convenient and less time-consuming is to carry around with you some genuine small hardware items and compare these against the handles, hinges, locks, and such that you find on suspect purchases. Compare, also, such fittings on different pieces of supposedly antique furniture in the same shop or warehouse. If you find several identical fittings on different furniture, it's a good clue that they could all be phoney, or over-restored and bought by the dealer from the same source—but not genuine items acquired from a number of different sources.

The readiness with which a dealer is prepared to give substantial discounts on metalwork represented as genuinely old is also an indication of whether the item is a cheap reproduction that can be easily obtained and overpriced for resale. If the piece is

genuine, the dealer probably paid more for it and put far more effort into its acquisition, and so would rather wait for another buyer than cut the price.

The Metals

Let's take a closer look at the different metals involved in this popular branch of fakery.

Ironwork

Iron collectibles are usually wrought, cast, or worked from steel, the variations in the types of iron stemming from their different carbon content.

Wrought iron, for example, has very little carbon in it and can be worked easily, while cast iron is very brittle. Thousands of fake trivets, fire dogs, fire irons, and firebacks are in the marketplace, and again, your best bet in identifying the genuine article is to look for natural wear and surface deterioration. Pieces used in and around the fireplace should have picked up a hard, caked deposit, while a softer oily accumulation of dirt on the surface would indicate either recent use or an attempt at faking.

A guide to whether a piece of ironwork comes from Europe or the United States is the degree of ornateness and detail in the design—American work tends to be plainer.

Tinware

Tinware has also become very collectible, and there are some fine pieces available because the resistance to rusting achieved by tinning the iron has enabled it to be preserved in good condition. Much of their value lies in the way tin objects are decorated (often by printing). Even old chocolate or tea tins and other commercial containers that were manufactured in large volumes can command good prices—

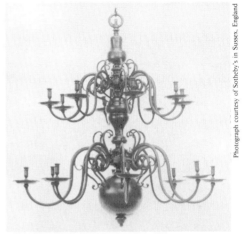

Photograph courtesy of Sotheby's in Sussex, England

Chandeliers can be doctored in various ways to add to their value, and the current high-market prices are making the practice worthwhile. This early-18th-century Flemish example fetched $1,600 despite having holes drilled for electrical wiring. Look out for such alterations to lamps, which can drastically reduce values.

$100 or more in New York, for example—but still be picked up cheaply in rural areas.

European tinware started arriving in the United States in the 1730s, and soon afterward, domestic production began in earnest, particularly in Connecticut. Some pieces were stenciled and others painted, with black the favored color in New England, while Pennsylvania tended toward reds. Production really boomed after the Civil War.

Much tinware was *japanned*, or finished in a coal-based lacquer simulating the high-gloss black achieved by Japanese craftsmen and also used on wood and papier-mâché articles. Products given this effect are sometimes referred to as *tole work.*

If you buy wisely, you should not go wrong with genuine tin kitchen equipment, coffee- and teapots, caddies, trays, and printed containers. An

32

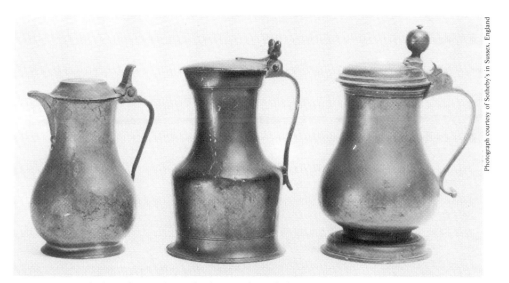

Old pewter, including the marks on high-priced English pewter, is comparatively easy to fake. Look carefully for the characteristic colors and texture of natural patination, as present in these three tankards that are worth several hundred dollars apiece.

Early American japanned tin coffee tray can fetch $400 from an enthusiastic collector.

There are many contemporary reproductions available in tinware, but the prices are not yet high enough to justify the effort of faking, and the pieces that have been mass-produced originally were not very expensive anyway. Tinware was made to be used, so you must be prepared to accept its showing some wear and deterioration. A near-mint example of almost any tinware should be grabbed if the price is right.

Pewter

An alloy of tin with lead, copper, or antimony produces pewter with its distinctive gray color. Pewter is usually cast and often engraved for further decoration. Its production started in Britain in the Roman era, and the few good pieces made from the sixteenth century should be hallmarked. Production of American pewter really did not

get underway in any volume until the eighteenth century and, as with wrought iron, the designs tend to be simpler than those from Europe.

Unfortunately, much of the pewter work available is fake. With some really good antique pewter changing hands for prices higher than $5,000, the fakers have been active in this sphere of collecting for many years and are so skilled, they have fooled many museums and expert collectors. As with other metals, some of the fakes appear to have endured a couple of centuries of aging after actually having spent less than half a minute in a chemical dip. Indeed, much of what dealers genuinely offer for sale as pewter is really Britannia metal—a much harder alloy of tin, antimony, and copper that can be worked by machine and therefore produced cheaply in high volume.

You may be able to tell the difference between this imitation and the

33

original by scrutinizing the color of a piece; Britannia metal has a more bluish appearance. Scraping the bottom of the piece with a knife and listening carefully gives further clues, since pewter yields a rather sharp, clear sound, while Britannia metal makes a dull screeching noise.

The marks of old craftsmen can also be faked readily in pewter. Many so-called pewter valuables have resulted from the fakers' taking a wax impression of a genuine mark, making a steel punch based on the impression, and then embellishing modern reproduction pieces or inferior pieces with additional engraving or by replacing a mark with a more valuable one.

Use a magnifying glass to see if the edges of a punched hallmark or of engraved lines or embossing are sharper and cleaner than they should be if they are genuinely old. A really ancient piece from Europe may well have been cleaned regularly with an abrasive such as sand, and this gives a distinctive appearance that cannot be readily copied.

Copper and Brass
Some people find copper and brass difficult to differentiate, but copper has a sheen and a slight reddish tone quite distinct from the golden color and gloss of brass, which is an alloy of copper and zinc. Copper and tin together produce the alloy bronze. All these materials are being used by fakers for an enormous variety of items, including furniture hardware.

Remember that if there are screw threads visible, you can use them as a way of assessing whether a piece is genuinely old; as described above, modern threads are more uniform and more sharply cut than those you would see on old hardware. Surface scratching, patina, and general signs of wear can

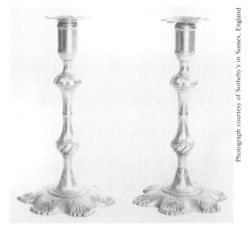

A reasonably competent craftsperson can produce realistic fakes of brass candlesticks, which are fetching big prices these days. This pair of Georgian candlesticks auctioned for more than $1,600.

help you identify reproductions as well.

Actually, as suggested earlier with regard to fake metalwork in general, most of the modern reproduction brassware on the market today is not manufactured with the intention to deceive, but problems arise when it gets into the hands of unscrupulous dealers who try to pass it off as antique.

Silverplate and Silverware
Copper is plated with silver, sometimes on both sides, to form silverplate, a very popular medium for both collectors and fakers. Genuine old Sheffield plate from England is much prized, with good eighteenth- and nineteenth-century pieces fetching thousands of dollars. Antique items and forgeries of this type range from inkstands to Communion wine flagons, from pepper pots to soup tureens.

The electroplating of silver, which killed the Sheffield plate industry in the nineteenth century, has been used to produce fake pieces that are falsely

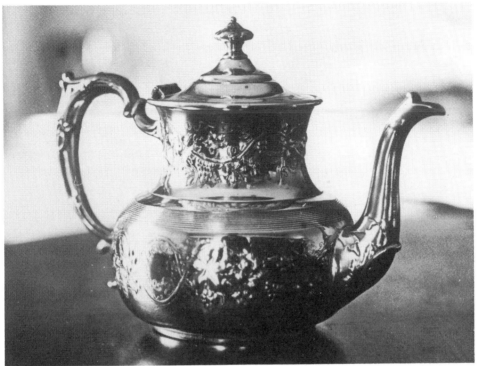

This teapot is not early Victorian silver, but a recent fake with phoney hallmarks. It does not show the characteristic wear and coloration of age, and since it will not pour properly, it is not even functional.

A silver tray presents many opportunities for faking and forgery to increase its value. Look out for recently added decorative details or the transplanting or forgery of hallmarks.

represented as a more valuable Sheffield. Since electroplating (like Sheffield plating) proved to be a much less expensive process than producing solid silverware, its discovery also led to many fakes being circulated among the unsuspecting as genuine silver. To complicate matters further, Sheffield plate, which is valuable in itself, is also often passed off as genuine silverware with the help of forged marks.

As a result, trying to spot phony silver or silverplate simply by comparing hallmarks to those found in reference books is not sufficient. Much Sheffield plate was never hallmarked anyway, and reproductions of old Sheffield plate, electroplate, and silverware play all kinds of games with hallmarks. For example, a faker can make dies

A genuinely old silver teapot stand bearing the proper hallmarks can be vastly enhanced in value with the addition of a fake body, whereby a complete teapot is fabricated. Keep in mind that the lid of a genuine teapot has the same hallmarks found on the base. As well as signs of recent soldering and other tampering, check for correct proportions: Would the pot, for example, stand safely on its base and be properly balanced to pour effectively?

that copy old hallmarks, as described in the "Pewter" section. Or marks can be cut from low-value or damaged pieces and transposed by soldering or welding to create an impressive fake. In this way, a hallmark might move from, say, a spoon to a tea tray. Sometimes you can see a telltale joint where this has been done, and the joint becomes more visible if the piece is heated slightly.

Look carefully for joints which reveal that a piece of Sheffield, electroplate, or genuine silverware has been otherwise doctored to make it more valuable. Such doctoring may range from turning a spoon into a fork or a tankard into a coffeepot to making extensive repairs and additions, such as the replacement of feet, spouts, or handles. You can often reveal the joint where this kind of work has been done by breathing on it when the piece is

Silver spoons of various kinds have become very popular collector items, so many have had their shapes changed and hallmarking altered by fakers seeking to increase their value. Also, spoons are often a source of genuine hallmarks that are removed and put onto larger pieces in order to achieve higher selling prices.

An urn made of silver or some other metal can be doctored in many ways to increase its apparent value. Decoration and handles may be added, lost lids manufactured, and hallmarks forged. Look particularly for signs of genuine aging, patination, and hallmarking on silver pieces.

Fake silver candlesticks crop up all the time in the antique trade. They may be cast from originals, complete with hallmarks, or they may be reconstructions with forged marks. Look for signs of recent soldering—try breathing heavily onto the item to highlight joints with the condensation of moisture from your breath—and compare the style and proportions with known genuine examples. Candlesticks were the most cleaned and polished items in households, so they should show a great deal of natural wear.

With your fingers, trace the decorative line running horizontally around this attractive silver jug near the base of the handle. Immediately you will see how it is a fake made by adding the top section and handle to a goblet. With some fakes like this, a wine funnel may have been adapted (cut down, with a base and top added) to create a more valuable piece.

cold. Watch, too, for changes in the patina, although this is a less reliable test, since silver oxidizes so readily. Patina also varies considerably from one piece of silver to another because so many different polishes will have been used on any old piece of silver.

Incidentally, when polishing silver surfaces of any kind, you should be very careful and not use abrasive cleaners at all. Instead, rely on special silver polishes of a reputable brand, and use those only sparingly, along with routine cleaning: a gentle wash with water and soap or a mild deter-gent, finished by rubbing with a soft cloth.

Another test to identify faking or extensive reworking is to use your forefinger and thumb like a pair of calipers on the inside and outside of the piece to feel for unusual thin spots.

You really need to see examples of each side by side to identify the differences between electroplated and Sheffield-plate pieces. In comparing the two, note especially the brighter silver color of the electroplating process compared to the slight blue-gray tinge associated with Sheffield plate. Always bear in mind that electroplated pieces have been dipped completely in a vat, so the

37

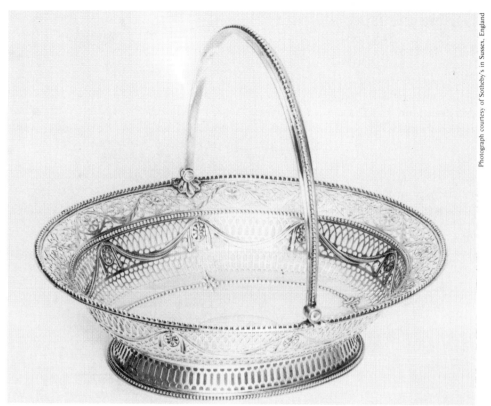

Pierced silver is difficult to reproduce, but commands such high prices that fakers will devote the time and effort necessary to make realistic copies. This is a Georgian cake basket worth $7,000.

plating covers everything, while the Sheffield process can leave signs of solder around joints and seams. In addition, the original Sheffield craftsmen would roll the silver around exposed edges of copper or cover such edges with a silver beading, but be careful in using this technique for identification, as fakers are also good at it.

Since they are much older than electroplated pieces, Sheffield items usually show a great deal of wear, and many of them have "bloody" portions where repeated polishing has rubbed through the silver to the copper base. In some instances, such wear has been restored by electroplating, which can reduce the value of the piece in the opinion of some collectors.

Good antique silverware is fetching high prices these days. There is strong interest now in rare American pieces from the nineteenth century, such as the pair of mugs made by Joseph Lownes of Philadelphia, circa 1800, which brought $4,400. Even a tankard can go for thousands of dollars at auction. In one exceptional case, Sotheby's sold a silver-gilt William and Mary engraved tankard, dated 1690, in New York for $46,200.

Apparent bargains in silver should immediately be suspect because good genuine pieces are snapped up quickly in this buoyant market so littered with fakes.

Suiting the Specialty to the Budget

If you want to collect metalware, you can do so on a small budget and get a high proportion of genuine pieces if you focus on those made from base metals and their alloys. There seems to be a lot of scope for getting into the field of tinware where prices should only rise, where there are not so many deliberate fakes, and where the reproductions are glaringly obvious. Also, it is a particularly interesting field because of the way the various items reflect comparatively recent history, offering older collectors the opportunity to revive childhood memories.

Your expertise and your budget need to be much more extensive if you expect to make much progress with silver or plate, although these are fields that offer a much greater selection of really attractive pieces along with the opportunity for much greater profit if you buy and sell well. Until you can identify the silver fakes with some degree of confidence, it might be wise to concentrate on smaller and less expensive items such as cutlery, sugar tongs, and salt-and-pepper sets. You might even seek out damaged pieces or slightly mismatched sets and pairs, which you can get for prices sometimes as low as half of what you'd pay for good examples. The experience you gain from examining and handling even the dregs of the antique silver market will prove a good investment if you want to graduate into more specialized and expensive areas as your expertise improves. If you do specialize at that point, look for a category that is not yet fashionable and where prices can be expected to rise.

I emphasize the warnings about forged hallmarks and the extensive alterations that have been done to put false additional values onto the thousands of pieces you'll see on dealers' shelves and at auction. Do not, as so many collectors tend to do, base your purchasing decisions on just a check with a hallmark reference book. The identification of a hallmark on any silver—whether the piece costs $20 or $20,000—is but the start of what can be fascinating detective work to secure a bargain or to avoid making an expensive mistake.

The Mark of the Artist

The addition of artificial patina to metalwork is perfectly legitimate when done without the intention to deceive. Indeed, it is a logical extension of the skills of an artist—especially one who, like the distinguished sculptor Gerard De Leeuw, wished to have full control of the creative processes.

His widow, Mrs. Elizabeth De Leeuw, described to me how the excitement would build up in their household as a work modeled in clay neared the point of casting after months of painstaking effort. De Leeuw's attention to detail and artistic integrity emphasizes how a genuine work of art reflects the creative skills and intellectual qualities of its creator, aspects no faker can reproduce. As you study and try to develop a rapport with the objects that make up your particular area of collecting, you become attuned to the dedica-

tion and effort an artist puts into his or her work, thus developing a kind of sixth sense that makes a fake shout its phoniness to you from across the room. At the same time, a genuine work of art draws you to it and creates an emotional reaction that is far more effective in identifying fakes than even the most elaborate scientific tests.

Indeed, throughout the history of collecting, there have been many incidents of fakes being authenticated by so-called experts who listed all kinds of technical and materialistic reasons why they felt the works were genuine. Yet, so often that it seemingly could not be sheer coincidence, an enthusiast using intellectual and emotional criteria can spot even the most brilliant fake by sheer instinct.

Let's look, in more detail, at the creation of a De Leeuw bronze casting for an illustration of this concept of becoming sensitized to the artist's standards. I select De Leeuw, specifically, because he is a rare example of an artist not motivated by material gain. He cared enough about the quality of his work to destroy something that did not meet his standards, even if it represented hours of effort, and even if he could sell it at a profit.

De Leeuw would make a mold of his work in plaster and then use it to make a bronze cast by means of the cire perdue, or lost-wax process. He used gelatine or synthetic rubber as a lining to ensure that the most intricate aspects of his work would

Busts and other forms of sculpture in bronze and other materials are popular items for faking. Look for genuine patination; signs of repair, which will reduce value; and marking on the base. Often, fakes of genuine work are inferior in both artistry and casting technique.

be reproduced accurately.

This flexible mold would reproduce in beeswax the details of the work. Even the fireproof core of the mold, which would have no direct visible influence on the appearance of the final casting, would still be created painstakingly. De Leeuw had his own formula for using ground brick, asbestos, fireproof cement, gypsum, and ethyl silicate to make a tough and stable core on top, supporting the 5mm-thick wax coating containing the details of his sculpture.

De Leeuw would then hammer a number of metal pins through the

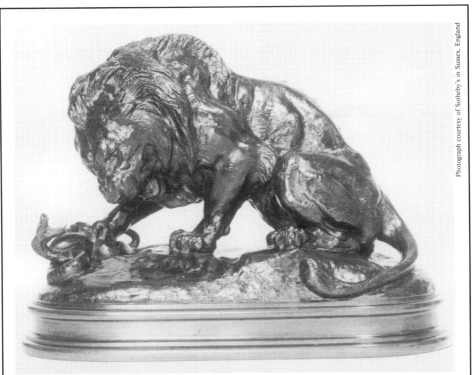

The temptation to fake gets stronger all the time. Dating from the mid-19th-century, this bronze model of a lion and serpent sold for more than $7,000, and it could well repay a faker to try to copy this kind of work.

wax and into the core, together with solid wax rods placed at carefully determined points. The model—fireproof core, wax outer layer, metal pins, and wax rods—would then be encased in a layer of sifted sand, the grains bonded together by gum arabic. Around this would go an outer casing made from the same mixture as that used for the fireproof core.

The next step taken by De Leeuw would be to melt the wax to create a space into which he could pour molten bronze and make his casting. Sometimes he would spend several days insuring that all the wax was removed. The wax rods would melt as well, forming channels so that the molten bronze could get into the mold and air could escape without trapped bubbles being formed to the detriment of the final casting.

Mixing and melting copper and tin to produce inferior or mass-produced castings is quite different from carefully blending the correct ratios of the two metals and perhaps adding controlled qualities of lead, zinc, and iron to achieve the desired coloration and physical qualities. Appropriately, De Leeuw would mix and pour the bronze for his castings according to his own formulas. When

the metal cooled and both the outer casing and the inner core of his work were removed, he would devote many more hours with chisels, files, sandblaster, and nitric acid in order to achieve the desired surface finish to his casting.

Freshly cast bronze reacts with its environment to achieve a color and surface finish with a character very different from that of the bare metal. If the work spends its life in a comparatively pollution-free environment, it acquires a natural patina known as verdigris, which has a distinctive light green color. This patina is predominantly copper carbonate resulting from the copper and bronze reacting with the carbon dioxide in the atmosphere. If the work is exposed to polluted air, it develops an outer skin of copper sulfate that results from the bronze reacting with the sulfur present in polluted air. The outer skin varies according to the amount of sulfur in the air, and it ranges from shades of brown to an unattractive matt black.

Fakers try to add patina artificially to deceive potential buyers into thinking a new reproduction is a genuine old piece. They may use colored varnishes, acids and other chemicals, and heat processes.

De Leeuw, in his dedication to quality and artistic integrity, accelerated the patination process in order to ensure that the work would mature with the desired effect, not to deceive clients. He experimented with patina by varying the formula of the treatments he applied and the extent to which he would combine these chemicals with heat from a blow torch or fire. For example, he would warm the casting and apply a mixture of mercuric chloride and zinc and copper sulfate if he wanted a dark green patination. If the desired finish was to be a brown patination, De Leeuw would make up his own formula of potassium sulfate or saturated solution of copper in nitric acid; then he would heat the bronze. The addition of a small amount of silver to the solution would result in a black finish after the work was heated.

The final effect would often add a new dimension to De Leeuw's castings, sometimes with results that surprised even him. The finishes were always interesting and individual. In contrast, artificial patination conducted as part of a faking process usually seems to have no appeal of its own, but detracts from the work rather than adding to its aesthetic qualities. The intent to deceive comes through to the sensitive observer.

Although metal casting seems a simple and easily reproduced process, I hope this detailed description of one sculptor at work reveals the substantial difference between the inherent quality that results from the effort and skills put into a genuine limited-edition casting and the inferior characteristics of one that has been mass-produced. Using your collector's sense and artistic judgment to distinguish such quality is certainly an acquired skill, one that can give immense personal satisfaction in addition to saving you a great deal of money.

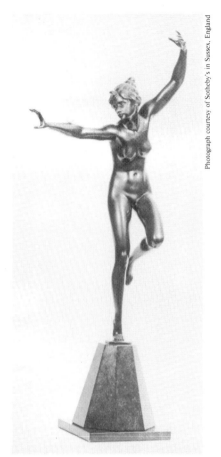

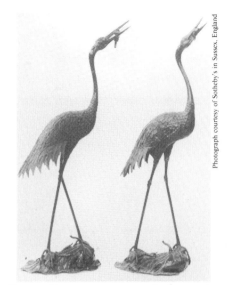

Bronze figures are comparatively easy to reproduce in a small foundry, and a broad range of chemicals are available to add the required degree of artificial patination. But few faking foundries have the skills to reproduce the detail and scale of this pair of Japanese bronze cranes, each more than six feet tall, which fetched more than $18,000.

Sotheby's experts evaluated a number of factors relating to this bronze figure (circa 1910) before being convinced that it was genuine and that they could catalog it as such. The patination was a distinctive chocolate brown color. The signature of sculptor Ernst Gustav Jaeger and the foundry stamp were authentic, and the style and quality passed the subjective evaluation of the auctioneer's experts. The positive identification gave confidence to buyers, who pushed the auction price to more than $7,000.

CHAPTER

TEX 4 TILES

Textiles

Oriental Rugs

Probably more pseudointellectual clap-trap is being propagated about inferior-quality oriental rugs than you'll hear about fakes in any other sphere of collecting. Many oriental-carpet dealers lyrically proclaim the artistry, crafts-manship, and investment potential of their wares, conjuring up images of skills passed down from generation to generation. They talk about the mystical symbolism of the designs and describe nomadic tribespeople happily knotting away to adorn their tents with works of art that rival paintings as wall decorations with great potential for capital appreciation. As they describe the sources of the rugs they are selling, the word *Persian* is applied to rugs of oriental design that come from India, Pakistan, China, Turkey, Afghanistan, the Soviet Union, Africa, and Europe, as well as those coming from the modern Persia—Iran. Indeed, the faking business has become so lucrative, the most salable designs are now spreading out of their traditional areas of origin.

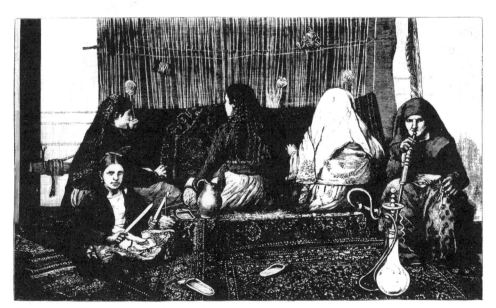

The reality of conditions under which oriental rugs are manufactured is often far removed from such romantic concepts as the one illustrated here.

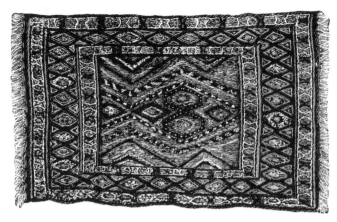

KURD RUGS, 5s. 9D. EACH.

Or Carriage Paid anywhere in the United Kingdom, 6s. 9d. each.

Although now you cannot buy a good oriental rug for the less than six shillings cited in this advertisement, there are sound investment buys available at prices lower than those often asked for fakes.

The reality is that many of the oriental carpets sold as genuine collectibles, handmade from pure quality wool, cotton, and silk, are in fact produced in volume by machines from inferior materials.

Others are handmade, but not by expert craftsmen. Thousands of children, some of them kidnapped into slavery, are laboring under atrocious conditions to meet the demand from Western buyers for oriental carpets. Their work is being sold by leading dealers and in reputable stores throughout the Western world at vast profits.

The London *Sunday Times* investigation into this racket in late 1986 coincided with my own research and has been a major contributor of the details of this most unsavory business. The newspaper's Insight team of Mazher Mahmoo and Barrie Penrose found seven-year-old children in an Indian village working 15 hours a day, seven days a week, for a weekly salary equivalent to about 38 U.S. cents each.

These children received the equivalent of $6 for their labor on carpets selling in a world-famous department store for nearly $2,000.

Other Indian carpets retail at more than $7,000 each with demand fueled by the hype given to oriental carpets as portable investments, coupled with a supply shortage resulting from the Soviet occupation of Afghanistan and the war between Iraq and Iran.

A report was prepared by the Anti-Slavery Society for the United Nations Commission of Human Rights in 1987, and various antislavery bodies have managed to rescue large numbers of the children exploited by this particularly abhorrent type of fakery. But others remain, beaten and abused until their masters discard them, often because their eyesight has been damaged too much for them to continue working effectively. Young fingers bleed and become calloused and deformed from tying millions of knots in carpets

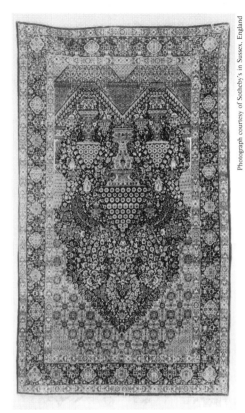

You might easily pay $5,000 plus for genuine handcrafted oriental rugs like this Kerman prayer rug, so faking them is a great temptation in countries with low labor costs and plentiful traditional skills and materials.

that might be able to pass the fake-detection tests for machine-made carpets, but which in no way represent original creative work by skilled craftspeople.

The profits from this trade are enormous. The Insight team calculated that the loom masters employing child labor at the bottom end of the chain receive about $138 (net) for a 15' × 10' carpet, after deductions for the cost of wool and other materials. The carpets cost the wholesalers about $360 each by the time they get them to their London warehouses, and they subsequently

These are good working conditions compared to those under which many oriental rugmakers labor.

sell them for $900 or more each. In turn, the retailers mark up the price 100 percent.

It is a commercial as well as human scandal.

While the results of the Insight team's investigation were ricocheting through the international oriental-carpet business, I was in Istanbul sitting with a British carpet-manufacturing expert, viewing a display of handmade Turkish rugs. In flat contradiction to what many carpet dealers have told me, the British expert said that all the rugs we were seeing could be produced by machinery and, if passed as fakes, would fool the novice collector.

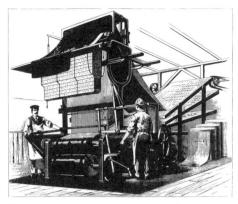

Even a century or more ago, machines were being used to weave oriental rugs and carpets to be passed off as valuable handwork.

The world center for fakes is the bazaar area in Istanbul, Turkey. The arrow shows where you can buy the genuine article at duty-free prices in the Güntur establishment.

Fakery at Different Levels of the Business

Deception goes on at every level of the oriental-rug business, which is structured like a pyramid. At the base of the pyramid is the large volume of mass-produced machine-made rugs of oriental design, most of which are sold for what they are: comparatively low-cost floor coverings. The first level of fraud is by those who try to pass these off as genuine handmade rugs, which make up the upper part of the pyramid.

On the higher levels of the pyramid, different types of rugs are available in progressively diminishing quantities. Infinitely better than machine-made, although still produced in large quantity, are commercial-grade handmade rugs produced in large workshops in the towns and bigger villages. The best of these, produced in limited quantity by talented designers and master knotters, have considerable investment value.

Next, in an even smaller quantity, are the woolen rugs produced by the nomadic tribes. These have a particular charm because of their spontaneous simple designs and irregular shapes.

At the top of the pyramid—offering limited availability, and consequently, greater investment value and temptation to fakers—are the contemporary masterpieces, which are actual works of art in rug making, and the antique rugs. The antiques include masterpieces from the past along with more ordinary rugs that have increased in value as age has mellowed their colors and given them the equivalent of the patina so valued on woodwork and metalware.

Antique rugs are a major target for faking and misrepresentation, particularly considering that the problems facing the collector are only aggravated by differing definitions of what constitutes an antique oriental rug. Some dealers say antique status is acquired after 50 years; others use the term *semiantique* to try to inflate the value of a rug that is only 30 years old, or to give some vague credibility to a new rug that has been artificially aged. Connoisseurs of oriental rugs tend to accept as true antiques only the ones that are more than 100 years old, while anything more than, say, 40 years old, is simply old, and everything else is only

Some of the best oriental rugs were bought when this advertisement appeared during the late 19th century. Examine carefully any rug claimed to represent this group, as the age they have acquired naturally can be faked easily.

semi-old, or new. As you seek to verify claims that a rug is antique, bear in mind that a good rug will not show its age for decades and that traditional designs continue to be used.

The flat, woven edges of oriental rugs are made by a technique called *kelim weaving,* which is also used to make very collectible rugs without any pile. Kelim saddlebags, cushion covers, and soft furnishings are popular with interior decorators, so there is a flourishing business in faking them, as well. You should be aware that these articles are artificially antiqued and are produced by machine from inferior materials, just as are the knotted oriental rugs.

Developing a Feel for Quality

Don't let my vehement criticism of child labor and faking in the oriental carpet business inhibit your desire to experience the delight of a genuine handmade carpet. You can still find rugs that are produced by skilled, willing fingers, and that reflect real artistry and tradition in their materials, design, and execution.

No other collectible work of art can so combine the physical and sensual delights generated by the sight and touch of a really good oriental rug, especially one with the shimmer and life that only the incorporation of genuine silk into the weave can give. If you want to progress in this field of collecting and be able to identify the many fakes on the market, you must experience this unique relationship with the genuine article. You are particularly fortunate if you are able, as I was, to do so with the guidance of a sensitive and expert enthusiast who can convey to you his or her passion for oriental carpets.

Developing this sense of what is right and what is faked is vital to collecting and investing in collectibles. Even some dealers do not have it, so you can outsmart them if you specialize, building all the information and experience possible in your field of interest.

If you don't have a substantial background in dealing with oriental rugs and you are contemplating a significant investment in one, the best bet is to find an honest, knowledgeable dealer or an expert broker who will guide you as you make your purchase. Buying the best quality you can afford in whatever rug category you prefer is the soundest advice for investment purposes.

Some Simple Tests

You can avoid bad buys by applying several simple tests in addition to relying on the subjective aesthetic judgements and general feel for quality that is second nature for the enthusiastic collector.

Only handmade oriental rugs and carpets are really worth collecting—although good machine-made ones can still provide durable and attractive wall and floor coverings—so the first thing for the specialist to learn here is how to distinguish handmade from machine-made. The quick test is to examine the back and check whether the design can be seen as clearly there as it is on the front. If the pattern does not show through to the back, you are certainly looking at a machine-made rug.

However, some of the machine-made rugs do have the pattern on the back. Sometimes the pattern is printed, but more often it results from tufts of wool, cotton, or silk being looped through in the machining process.

The range of oriental rugs is vast, so you need to study many patterns, materials, and methods of fabrication in order to avoid the fakes.

As you become expert, you can "read" a carpet to assess its authenticity. This unique work, made in the 17th century in Ispahan, represents Shas Abbas's garden, with streams flowing from each end. Flowers, paths, canals, trees, and various birds and beasts are also depicted.

52

These loops can be pulled out with long fingernails or (preferably) tweezers.

You cannot pull the pile from a handmade knotted rug. In fact, by folding a handmade rug back on itself, you should be able to see the knot at the base of the pile, although this can be difficult with a tightly knotted quality rug, which may have hundreds of knots to the square inch. A long, sensitive fingernail is useful to dig down between the tufts and feel for the knot.

Once you've determined the rug is handmade, you still need to look closely to evaluate its quality and value. This value is related directly to four factors:

• Materials used
• Number of knots tied per square inch
• Aesthetic quality of the design and workmanship
• Age

Examining the carpet visually will give you an indication of all four factors.

The most valuable rugs are made of the very highest quality silk, created from the outer and finer silk strands from the silkworm's cocoon. A very expensive silk rug should have the pile made entirely of silk, woven on a foundation in which the warp is silk and the weft either silk or a good-quality cotton.

The natural sheen of a rug made from the finest silk thread is durable and will continue over the years to catch and reflect the light as you ruffle the pile. If the rug is made of the coarser and often broken lengths of the slub, or if it is made of the silk near the center of the cocoon, it will not have this natural sheen and fineness to the touch.

Even if a rug looks great hanging on the wall or thrown out by the salesperson for inspection, the shininess may have been added by a chemical treatment called *mercerizing*, or by ironing, which puts a temporary gloss on the pile. If you disturb the surface of such a rug, the sheen effect will be lost. A close examination may reveal the common trick of bulking out the silk by mixing cotton into the pile. (This does not imply that rugs with a mixture of materials are all faked or misrepresentational; some of the most collectible ones contain cotton, silk, and wool, as will be discussed momentarily.)

Remember the preceding considerations whenever a dealer claims a rug is made from fine silk. The Turks, for example, are particularly good at producing *art silk* rugs, which are not made of silk at all, but which can fetch ten times or more their true value if the buyer assumes that he or she is getting the product of industrious silkworms. The term *art silk* is a euphemism for mercerized cotton, which looks like silk and has a high gloss, but isn't nearly as smooth to the touch as real silk. As mentioned above, neither is such material able to retain its shine. If you see a fine genuine silk and an art silk rug side by side, the difference should soon become apparent, not only in the physical makeup, but also in the artistry and quality of work invested in the expensive silk.

Should you find that you are still in doubt about a silk rug's authenticity, you can perform a conclusive test that does not require expensive laboratory equipment. If you light a strand of real silk, it burns rapidly and shrinks into a tight ball, emitting a distinctive smell. Be careful not to get your nose too close as you sniff—when you put a

match to real silk, it flares up immediately. So-called art silk also flares up when first ignited, but then burns more slowly, much like a piece of paper.

When buying a rug, you may find it difficult or even embarrassing to apply this test in the dealer's showroom. But if you get a certificate saying your rug is made of genuine natural silk, and the rug fails the burn test when you get it home, you have a good case for demanding a refund.

Of course, you must not damage the rug when testing it. Use a pin or needle to pull out a single strand near the edge of the rug, and the removal should not be noticeable at all.

Your eyes and mouth can provide you with other quick tests of oriental rugs. Putting a strong light behind a rug made of any material will show up many defects, particularly repairs and areas of damage and excessive wear that could substantially reduce value. And your saliva is part of a handy portable test kit for checking the quality of dyes used in rugs. With a clean handkerchief or tissue, rub some saliva onto a suspect rug. Natural vegetable dyes may leave a slight stain on the handkerchief, which is acceptable, but beware of any heavy staining, which indicates substandard natural or chemical dyes, or the fact that the rug has literally been painted in a restoration job that may devalue it considerably.

Spot tests may also reveal various chemical treatments, including the use of bleach for artificial aging. Another deceitful practice you may detect is the use of a gold-colored wash. It simulates genuine woven gold color in faking a very collectible type of rug from Afghanistan that has become scarce as a result of the war there.

Traditional weaving on old or replica looms in Turkey and Greece results in work that may change hands several times and be doctored to give the impression of greater age and value before it finally reaches the public on the other side of the world.

Various treatments are used to age oriental rugs artificially. They range from using chemicals or burning (to create the effect of natural fading) to laying the rugs in the road for animals and trucks to pass over. Such distressing can be difficult to detect if it is well done, but often the work is rather sloppy, and you can spot such tricks just by looking at the back of the rug. A rug that has faded genuinely will have done so in spending most of its life on the floor or wall, so the back of it should be considerably less faded than the front, a result of its having been shielded from the light. Also, the underside of the knots showing on the reverse side of a naturally worn rug will

usually be flattened and probably rather shiny as a result of friction against the floor. (However, a flattening and shine on the loop part of the knots will not show clearly if the previous owner has used an underlay or has had the rug on top of a carpet.) You cannot fake this effect by laying the rug out on a dirt road for a few days, even if wheels and camels' feet effectively distress the pile on the front.

You can also check for natural fading by looking into the pile of an oriental rug and seeing how the color changes as you look down the tufts. If the fading has occurred naturally over an extended period of time, the effect of sunlight will have caused a steady change in color extending down the tuft—paler near the surface of the carpet and becoming gradually deeper toward the more protected part near the knot, where the sunlight could not reach. If a chemical has been applied to the surface to give accelerated fading, there will be a distinct line partway down the tuft at the deepest point where the chemical penetrated. Thus, the change of color will be sudden, not gradual.

Any artificial distressing or chemical treatments to fake or "antique" a rug can both distort its true value and dramatically reduce its life. Beware of rugs in which the boundary between different colors has become indistinct, often giving an almost out-of-focus visual effect. That is a sign of either inferior dying or a botched repair job.

However, don't be put off by slight variations in the colors or by irregularities of the pattern. Those are indications of the inevitable effects of handcrafting. Only the commercial machine-made rugs, which are not collectible, will have completely regular coloring and design. Indeed, one of the fascinating things about carefully studying a genuine handmade oriental rug is to spot the slight imperfections that are due to human error. You may even find the deliberate fault that a devoted Moslem rug maker will have incorporated lest Allah be offended by any effort to emulate him in achieving perfection.

While silk rugs are highly susceptible to fakery because of their value, there is also a good deal of trickery going on with oriental rugs made of cheaper materials. Wool of various kinds, cotton, animal hair, and jute are all used in authentic oriental rug making in a variety of combinations, since pure silk rugs are quite delicate and really only suitable for hanging on the wall, not for walking on. Silk-inlaid rugs, for instance, use wool and cotton to give added durability, with the silk highlighting elements of the design. These can be practical and highly attractive, carrying good investment value, as well.

But some of these rugs use inferior wool that will not last well, is much less attractive, and has a lower investment value. Just as pilling is a sign of a poorer-quality wool sweater, so a high instance of fluffing indicates an inferior grade of woolen carpet, which may well have been made from wool taken from a dead sheep. It is true that all wool in a new carpet will release fluff when rubbed, but continued, significant fluffing is a sign of poor quality. Such wool may feel dry, without the slight greasiness and elasticity of good-quality wool. A dry and brittle feel can also result when the surface of a rug is burned to fake aging.

The types of knots used to make oriental rugs are not directly related to rug values. Neither are they much help in identifying fakes. The Turks maintain that the double Turkish Ghiordes knot, a double loop around two warp threads, makes their rugs much tougher and longer lasting, but the single Senneh knot, which originated in Persia, is used in some of the highest-quality rugs available.

Some rug dealers try to talk up prices by pointing to signatures incorporated into the weave. This brings us to another problem: the faking of signatures and other marks on both rugs and tapestries. Fortunately, such forgery should show up under ultraviolet light if new material has been used, with the new threads giving off a fluorescence. Still, even genuine signatures tend to inflate the prices of rugs artificially because some of the best weavers do not sign their work. I would be wary of dealers who emphasize the importance of a rug being signed—exploiting this fact to talk up prices and increase hopes of better investment values is a materialistic Western concept. The real value in an oriental rug depends on its inherent quality of materials and workmanship and the aesthetic merits of its design. Unlike a Rembrandt oil painting, quality oriental rugs reflect team efforts by designers, dye masters, weavers, and even the master shearer who completes the rug-making process by trimming the pile and ironing it flat.

Quilts

When you next go to a garage sale or swap meet and see someone eagerly buying up old clothing, bedding, and curtain fabrics, you'll wonder whether that person is a faker gathering raw materials.

Quilt prices have skyrocketed. There is not much faking going on at the top end of the market, where prices these days can go as high as $10,000, but the potential profits at lower levels are attractive enough to stimulate extensive faking. The techniques, time, and equipment involved are fairly simple and inexpensive, so even quilts fetching a few hundred dollars can be faked profitably to generate a lucrative living. The still-ready availability of old fabric makes it possible to reproduce the work of the last hundred years or more in materials contemporary to the period being copied. Fakers are also well aware that the dating process is further confused by the fact that often a patchwork maker would use fragments of cloth collected over many years, perhaps even by several previous generations.

Even quilt display stands are being faked, particularly the English Victorian free-standing towel rail, which can be reproduced easily in pine or oak and then distressed and waxed to "age" it a hundred years in just a couple of hours.

The demand for quality old quilts far exceeds supply, so we can expect faking in this fast-growing area of collecting to accelerate along with the market. Some fakes and deceptions are difficult to spot, but fortunately, there are a number of readily recognizable clues to authenticity, which can be learned quickly.

Identifying the Fakes
First, in order to identify the categories most attractive to fakers, let's look at the types of quilts that are bringing good prices.

Crib or miniature quilts made for doll and baby beds are extremely popular because they are so easy to display and they make ideal complements to a

56

doll collection. They range in size from approximately one foot long, to fit a doll's crib, to a yard or more in length, serving as warm, attractive coverlets for babies. Such quilts can be framed easily and hung on walls to blend with or accentuate almost any decor scheme, so decorators as well as collectors are subject to the wiles of fakers who reproduce this type of quilt.

One means of faking highly salable small quilts is to create them from portions of damaged full-size quilts that have comparatively little value. To determine whether this is how a quilt you're considering actually originated, look at the quilt to make sure it is complete in itself, with the design, borders, and proportions all right for the scale. Disproportionately large elements in the design are a giveaway that it has been cut down from a bigger piece, as is the odd positioning of any design motifs. A dominant motif such as a group of flowers, an animal, or a patriotic emblem would normally be centered. If the focal point is awkwardly off-center and the symmetry of the design is wrong, you are probably looking at a cut-down example.

If a doll or baby crib quilt has borders only on two sides, or if its borders feature significant differences with some showing recent work, it may well have come from the corner of a full-size quilt. A pattern that runs right to the border and is cut off sharply is another suggestion of this kind of faking.

Another variety of quilt, the *Album,* is getting such high prices, it is very profitable to fake, with examples from Baltimore, Maryland proving especially popular. Some of the best authentic examples were community efforts to commemorate important local or national events, each block coming from a different household and having an appliquéd design, sometimes signed and dated by the originator. Sometimes the quilt featured a large block in the center bearing a patriotic emblem. With such an interesting combination of blocks, the Album quilt has a double appeal in both its overall visual impact and in the artistry of each individual block contributing to the larger composition.

Look with caution at signatures and dates, both in the individual blocks of collectively produced Album quilts and on examples produced by a single hand. A fake signature and date is easy to add and difficult to spot if attempts have been made to age the thread used. But handstitching is a bit like handwriting—very individual—so you can make comparisons between the stitching of the signature and that used elsewhere in the same work. If there is a remarkable similarity between the form and stitching of signatures on the different contributions to a community quilt, your suspicions will be aroused immediately that a single faker has been at work.

It is comparatively easy to find old fabric and to copy original designs to create a fake Album quilt, but usually an expert can tell by examining the stitching whether the quilt is appropriate to both the period and the region in which it was supposedly made. If manmade-fiber thread or fabric has been used, this is an obvious indication of faking or restoration work that can devalue a genuinely old collectible quilt by 50 percent or more.

Nor should you find machine stitching in a quilt dating from the early part of the nineteenth century or before. Indeed, handmade quilts of any period—even newly produced ones—always outdo the machine-made ones in value and investment potential.

The same techniques depicted in this late-19th-century engraving of traditional lacemaking in Belgium are used by lacemakers today, resulting in traditional designs that are very diffi- cult to distinguish as new if they are skillfully aged by artificial means.

Quilts having geometric design, with those made by the Amish being especially valuable, make up a third popular area for both collectors and fakers. Here, I must point out that the presence of machine-stitching is not an infallible clue to assessing value, as sewing machines were quickly adopted by quiltmakers soon after their inven- tion, and the Amish still produce tradi- tional quilts by both hand and machine.

Unlike the surface of an old piece of furniture, which provides so much information about authenticity, a quilt does not acquire a patina which can be relied upon as a guide to age. Yet an old quilt does offer evidence of aging that is difficult to fake realistically. The surface may be dirtied deliberately, but such soiling will not penetrate into the stitching or have the same appearance as that which is acquired naturally.

To increase the credibility of their work, fakers may even add a stain to a new quilt, creating slight damage to an inconspicuous area so that the value is not drastically affected. Or, they may tamper with real stains that would oth- erwise reduce the value of truly old quilts. If a stain does not spread over the border between one square and an- other, this probably means the adja- cent square, which you would also expect to have been affected by a spill, has been replaced. Look, too, at the back of the quilt, to see if the staining goes all the way through, as would often happen in a real-life situation.

To the expert, the outside borders offer many messages about what has happened to a quilt during a long life: extensive renovation, for example, or the addition of a section, both of which have a direct impact on value.

Although it may not be old, lace made in the traditional way by craftspeople trained in the old skills can still be valuable and highly collectible. With any such work, you should get some form of authentication, such as this certificate from the Kantcentrum workshop in Bruges, the Belgian lacemaking center.

Other Crafty Reproductions

The faking of quilts, clothing, other patchwork, woven coverlets, samplers, and all forms of needlework is rampant. Many of the tools used for these creations are also being reproduced, from thimbles to spinning wheels. The situation is complicated enormously by the resurgence in popularity of such traditional handcrafts; a dishonest dealer can go to almost any craft fair and find good contemporary work done in a traditional style, and then, with just a little fiddling, try to pass off a quilt, coverlet, or piece of embroidery as a collectible antique.

The only real protection from this kind of trickery is to study your chosen area of interest and learn about the styles, materials, and techniques apparent in authentic examples. Always shop for quality, watch for the use of recent, manmade materials, and link the price you pay to an informed, subjective judgment of the work and artistry involved. Even if you do buy an old quilt and subsequently find out that it has been artificially aged, if its intrinsic quality and design are attractive to you, and you did not pay too high a premium in your belief that it was genuinely old, you still have something to prize that could appreciate in value.

A THEATRE CLOAK.

These days, both contemporary and old collectible clothes are being faked. Modern fashion has spawned a whole subindustry of reproductions, many of which bear forged labels as they are passed off as genuine designer or brand-name items. Old clothes representing the fashion of previous generations have soared in value and are being reproduced, but their lack of authenticity is often betrayed by the use of modern synthetic textiles and thread.

CHAPTER FIVE

STAMPS

BY SPECIAL APPOINTMENT.

Stamps

Philatelists, unlike other collectors, can actually be grateful to fakers and forgers, without whose initiative stamp collecting might never have developed into such a popular and fascinating hobby that offers great investment opportunities.

Indeed, you can build a valuable stamp collection exclusively from forgeries, some of which are worth more than the genuine article. Some fake stamps are even so valuable that *they* have, in turn, been copied. This deliberate forgery of forgeries is certainly a unique twist to the problem of misrepresentation in collecting.

Famous Cases of Philatelic Forgery

Forgery is so integral to philately that the first practical manual on collecting stamps was all about fakes. *La Falsification des Timbres Postes* was published in France in 1862, a mere two decades after the world's first adhesive postage stamp was issued in 1840. It was needed urgently to help early collectors identify the genuine stamps from the many fakes already in circulation. During the 1850s and 1860s, forgers had become active in both Spain and France, lured by the opportunity to make quick profits—not from collectors, but from their own postal services. Those early forgeries, used to mail letters or to pay revenue dues, are

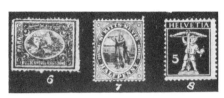

Examples of fakes: (from the left) An Egyptian stamp with the numerals in the top corner, inverted; a St. Kitts stamp showing Columbus looking through a telescope, which was not invented at the time; and a Swiss stamp with William Tell's son holding a crossbow with the string in the wrong place, where it could not possibly work.

among the ones that are now actually more prized among collectors than the genuine article.

With the 1872 one shilling green stamps came a particularly interesting early example of British stamp forgery aimed at defrauding the revenue: A gang passed them on telegraph forms through the London Stock Exchange. Although the *Stock Exchange Forgeries*, as they came to be called, were printed on paper without watermarks, the fakes were not unmasked until 26 years later.

Outright fakes were printed by the Allied and the German governments during both World Wars, and more recently, by governments involved in other regional conflicts such as those in Korea, Vietnam, and Nigeria. Stamps

of this type are known by philatelists as *progaganda forgeries* because they were intended for use in circulating propaganda through enemy postal services. Some were stuck on letters dropped from the air behind enemy lines, while others filtered into circulation through armies of occupation. Many such "official" forgeries now have a collectible value. In fact, some are so valuable that this is one of the cases in which it has become worthwhile to fake copies of the forgeries.

Some governments also take advantage of the gullibility of naive stamp collectors. Several small countries churn out stamps in vast quantities purely to supply the world collecting market, not seriously for mailing purposes. Most such issues have no more investment value than colored labels or the stickers you might collect at the supermarket, even if they do commemorate great cultural and historic events such as royal weddings or the World Soccer Cup.

At the same time, many responsible governments issue genuine commemorative stamps, often with special covers and franking to mark the first day of issue, and these can form the basis for a fascinating collection with real investment potential. They are favorites with fakers, however, so collectors should proceed with caution in this special-issue category, as well. In particular, commemorative issues from all over the world marking the coronations of British monarchs have been a perennial happy hunting ground for crooks who have forged large numbers of both the stamps themselves and the postmarks of the countries issuing them. The authoritative British stamp collectors' magazine *The Philatelist*, for example, has cited the case of two

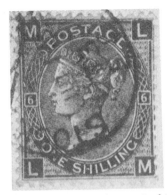

One very famous stamp forgery is this phoney British green shilling stamp, which was created to save on mailing costs, but has now become a collectible fake.

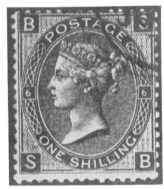

Another green shilling forgery went undetected for 26 years. Stamps resulting from this venture were all passed through the London Stock Exchange Telegraph Office on July 23, 1872, and were later released (in 1898) in large quantities onto the collectors' market.

A stamp oddity of considerable value is this issue commemorating the Coronation of King Peter of Serbia; seen upside down, it reveals a death mask of the murdered King Alexander.

Not only are stamps being forged, but special first-day-of-issue covers and cancellation marks attract forgers as well.

More examples of rarities of the type that attracts forgers. The French colonial stamp (pictured left) has the image upside down, while the rare Russian stamp was quickly withdrawn because it was considered disrespectful to reproduce the Czar's image in print.

dealers who forged the postmarks of a number of then colonies to create phoney first-day covers for the coronation of George VI.

The threat of retribution is apparently not much of a deterrent to fakers. Only a very small proportion of them land in jail. George Whitehurst and John Harris, the two responsible for the coronation forgeries just described, were convicted and received sentences of 18 months and 9 months, respectively. Strangely enough, a man whose work was rather limited in scope received the most horrific penalty ever recorded for a stamp faker. During the 1920s, a certain Chinese farmer was so poor, he resorted to cutting up used three-cent stamps and assembling, jigsaw-fashion, the pieces not obscured by postmarks. He touched up the joints with a paint brush and then used the reconstructed stamps to mail circulars seeking buyers for his rice. When the farmer was brought to court, the local magistrate had his hand amputated to put a quick stop to further philatelic philanderings, then sent him on to a higher court in Peking, where he was executed.

On the other hand, European forger Jean de Sperati, an infinitely more prolific faker who set off a multi-million-dollar shock wave in world philately with his deliberate intentions

of defrauding collectors, was sentenced to less than two years imprisonment.

Jean de Sperati's success likewise attests to the overwhelming numbers of fakes that have worked their way into the collecting world. Had the British Philatelic Association not stepped in and bought thousands of this man's fakes, the investment market for stamps might have collapsed. Even so, examples of Sperati's work exist undetected in many collections and still figure in the numerous fake stamps that change hands every year.

Other prolific stamp forgers include the Spiro Brothers of Germany, who mass-produced millions of examples of some 500 different varieties of stamps during the 1860s and 1870s, and Belgian forger Raoul de Thuin, who produced thousands of fakes, many of them purporting to be valuable Mexican issues, and many of which still figure undetected in American collections. Thousands of forgeries printed in Germany (from duplicates of the original plates supplied to the Transvaal Government) exist of stamps issued by the Boer Republic of South Africa during the nineteenth century. (Several dishonest dealers, by the way, have not even needed to create fake artwork; instead, they have obtained original plates or lithographic stones and run off their own reprints of collectible issues, sometimes forging the postmarks as well.)

One celebrated Japanese forger, Wada Kotaro, was so expert in recreating old rarities that his work is reputed to figure more prominently in many collections than the genuine examples of classic Japanese stamps that he copied with such skill.

A stamp with a mistake is worth far more in most cases than one without any errors, so watch out for forgeries that copy errors such as this inverting of the picture on British Nyasaland stamps.

In addition to the success generated by the fakers themselves, the propagation of phonies has been helped along by dishonest stamp dealers notorious for passing forged items to collectors. One of the most famous of this group was Arnold Benjamin of London. Sent to prison for selling a forged stamp, he is said to have sold the stamp again, on his release, for double the price, claiming it was more desirable for collectors after having served as an exhibit at his trial!

A Wise Approach

Although it seems the incidence of stamp faking has declined, in recent years, from the peaks reached during the late nineteenth century and the first half of the twentieth century, no one can be really sure that this is an accurate assumption—the trade is very secretive about these matters.

At any rate, if you collect stamps on any scale, chances are you will come across fakes and forgeries quite frequently. Of course, the very enormity of their presence means that phonies in philately are documented more comprehensively than those in any other sector of collecting, so you can substantially reduce the risk of being cheated by checking any stamp offered to you against the details recorded in various catalogs.

TO THE CONTINENT.
Via QUEENBORO' & FLUSHING.
ROYAL DUTCH MAIL.
Twice Daily in both directions. Day and Night Services. Large, Fast, and Magnificent Paddle Steamers.
Actual SEA Passage by the New 21 Knots Night Steamers 2¾ hours only.
GREAT ACCELERATION OF SERVICE from MAY 1, 1897.
BERLIN, arrival by Night Service 7 p.m. (M.E.T.), instead of 8.28 p.m.; LONDON, arrival by Day Service from Flushing 7.15 p.m.
Instead of 9.5 p.m. Direct and Accelerated Connections with LIVERPOOL (dep. 4.5 p.m.); MANCHESTER (dep. 4.15 p.m.); BIRMING-
HAM (dep. 5.45 p.m.), via Herne Hill and Willesden, WITHOUT TOUCHING LONDON.—Apply for Time Tables, &c., to the
"ZEELAND" STEAMSHIP CO.'S LONDON OFFICE, 44a, Fore St., E.C., where Circular Tickets may be obtained at Three Days' Notice.

There is much faking of postal cancellation stamps, such as this one used on the Royal Dutch mailboat service introduced between the U.S. and Europe in 1897.

One of the many temptations for stamp forgers aiming at the lucrative American collectors and investors market are such rare issues as this 1846 example from the postmaster of Millbury, Massachusetts.

Rare postmarks add greatly to the value of a stamp. This issue by the Dahlai Lama for use in Tibet has the postmark of Lhassa.

The majority of stamp dealers are honest and will make their stock readily available for inspection under well-lit conditions, volunteering catalogs and reference books to confirm the authenticity of stamps they are offering. Good dealers are even willing to give written money-back guarantees, lest the merchandise prove to have fooled even them.

Beware of buying expensive stamps at an auction without the benefit of such guarantees, especially if you are not knowledgeable about the particular stamp issues involved, or if it is not possible to make a proper examination before the bidding starts.

How Do They Do It?

In order to make your own judgment concerning the authenticity of a stamp, you need to acquire a knowledge of the kinds of deception that have proven successful for fakers.

Philatelists, first of all, distinguish between faking and forging. A *fake* stamp is one that started life as a genuine article, but has been altered deliberately in an attempt to fool collectors into thinking it is something of greater value. A *forged* stamp is one that is completely phoney, a facsimile created for the express purpose of making money off unknowing collectors.

A number of tricks make reproduced stamps of either type difficult to detect. Forgers are expert, for example, in the use of a wide range of chemicals to modify the colors of the stamp's design. The resulting fake is known as a *color changeling.*

Other chemical doctoring of stamps results in *erased* or *added cancellings,* altered according to the value of the cancellation mark in question. In some cases, a heavy cancellation or postmark can ruin the appearance of a stamp and drastically reduce

67

its value, whereby it is removed and the remaining design is touched up. On the other hand, fakers may attempt to add rare cancellations, which greatly enhance the value of the stamps. Experts can usually spot forged cancellations quickly because the ink used to create them is not correct.

Perforations can also be added or taken away to increase the rarity of a stamp and, consequently, enhance its value. One type of rare stamp results from an error in the stage of the manufacturing process in which separations are added to enable the individual stamps to be detached from the printed sheet. These separations, or perforations, are created by punching small discs of paper out of the sheet or by cutting slits in the paper by means of a process known as *rouletting.*

Perforation gauges are available to enable you to measure the number of dots in a given length and compare this with the catalog details of a particular stamp being checked. In addition, if the stamp is especially valuable, look carefully with your magnifying glass to ensure that a faker has not skillfully changed the perforations. They may have even been removed altogether, perhaps with a false margin added to create an *imperforate.* Profits that are thousands of times the original value of a stamp can be obtained by turning a common perforated example into a rare imperforate.

When fakers use the wrong kind of paper to make a stamp, identifying the watermark may solve the problem of authentication. Even the presence of a genuine watermark, however, is not a guarantee of authenticity. In the first place, many countries such as France and Spain did not use watermarks regularly as a protection against forgery.

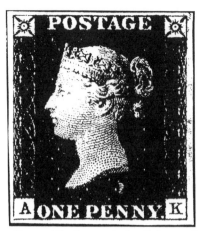

The Penny Black was indeed the world's first adhesive postage stamp, but it was produced in such vast numbers that many survive, and only the rare plate numbers have any great value today.

Plus, forgers actually bleach away the printing on real stamps of little collectible value and use the watermarked paper as the base for their fakes of rarities.

Another dodge used to contrive a watermark is the *laminated* stamp. This fake is created by thinning down the paper of two stamps, then sticking them together so that one becomes the back and the other, the face of a stamp, featuring the right combination of watermark, printing, and perforations to fetch a high price.

Stamps that are outright forgeries, at least, should be obvious once the type of paper used to make them is identified. More than 20 tests can be performed in order to do this. Some watermarks, for example, are revealed by putting the stamp face down on a dark surface. Also available are patented watermark detectors that accentuate the watermark by the use of benzine, but chemicals such as this may damage certain stamps. A safer

68

method is the kind of detector kit that uses color filters, but it is difficult—maybe impossible in some cases—to filter out the colors in multicolored stamps so that the watermark may be seen clearly.

If you have a genuine example with which to compare a suspected forgery, you can often spot differences simply by putting both under an angled light and comparing the surfaces of the paper.

When All Else Fails

If you do buy a dud from a dealer, take it back and politely ask for a credit. If your request is refused, or if you get taken for a ride at an auction, you don't necessarily have cause for despair. Remember that philately is the one area of collecting in which fakes may prove better investments than the genuine items. A skillfully forged stamp, especially one that has been hand painted, may display greater craftsmanship and be more aesthetically pleasing than the original.

Watch out, particularly, for an old Chinese three-cent stamp that has been reconstructed from tiny fragments. The highest price of all, a man's life, may have been paid for it.

CHAPTER SIX

coins and medals

Coins and Medals

Because coin and medal collectors often tread a minefield of faking, forgery, and sharp practices, they face a fascinating challenge in trying to find the good buys that do exist. After all, the opportunities for criminal activity in these areas of collecting are enormous. There may be as many as 15 million coin collectors in the U.S. alone; the number is uncertain because many have had their fingers burned and have pulled out of the field as they discovered it was not as attractive as it had seemed. But there are more than enough coin collectors remaining to relentlessly keep driving prices up and thus, attracting fakers. In a 1987 Los Angeles auction, for example, close to a thousand Greek, Roman, and Byzantine coins fetched nearly 5 million dollars, with the top price going for a single gold Greek octodrachma at $140,000.

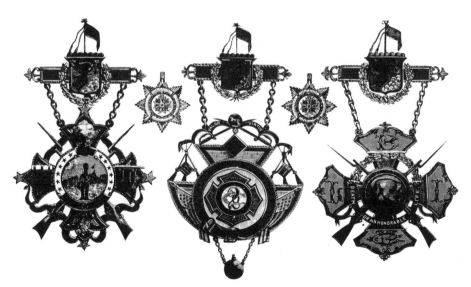

There have been so many wars that there are a wealth of medals now fetching sufficiently high prices to elicit fakery in this field.

The Grading Complication

One factor that confuses the issue for collectors trying to judge the fairness of prices in this field is the use of so many different and highly subjective methods of grading both coins and medals. Among the 5000 coin dealers in the U.S., the variety of grading interpretations can account for differences as large as thousands of dollars in the value of a single example.

The 5-billion-dollar-a-year American numismatics industry is trying hard to put its house in order and get away from the grading practices that generate such deviations in prices. Under pressure at federal and state levels to regulate the industry and make full disclosures about profits, the American Numismatic Association has appointed a task force to take charge of its part of the effort. Meanwhile, the Association's role as the most authoritative grading service is being challenged by the independent Professional Coin Grading Service in California, which makes exhaustive tests and keeps very comprehensive records.

Grading experts can earn as much as $20,000 a month for their highly specialized services, which reflects the skills needed to assess genuine collectible coins and identify the fakes. In other words, beginning collectors in this field should do a good bit of studying before spending any large sums of money on seemingly promising investments.

A basic requirement is to become familiar with the way investment-grade coins are rated in the different countries. *Proof* coins are defined similarly in most countries: A coin only qualifies as proof when it is manufactured according to the highest possible standards—struck from special dies and achieving near-perfect details and finish. Still, the astute collector will find that there are important variations in the way proofs are distinguished in various countries.

In the U.S., an *MS-70* coin is one in mint condition that must reflect very high quality coin manufacturing and no evidence, such as scratching, that the coin has ever been circulated. Proof and mint coins are usually sold in sealed packaging.

American gradings range down to MS-65 for investment-grade coins. Anything rated below that may be collectible for its intrinsic associations, but a rating that is just a few points lower may result in one example being worth a fraction of the value of the same coin with a higher grade. At the bottom of the rankings are various metal discs that can hardly be recognized as coins and which have little, if any, worth.

An Ideal Setup for Fakers

Europe, likewise, suffers from less than desirable grading practices—along with excessive mark-ups and outright faking—in both the coin- and medal-collecting fields. In Turkey, for instance, artificial aging is achieved by dunking buckets of fake ancient Greek and Roman bronze coins into the sewers. Throughout the collecting world, there is gross distortion of the intrinsic and investment values of contemporary commemorative medallions, and if this kind of distortion is successful, fakers will also be prompted to capitalize on the rapid "appreciation" of these popular items.

Tempted by the prospect of hundreds of thousands of dollars in profits, fakers everywhere are willing to go to great lengths to forge accompanying documentation as well as to create the phoney coins and medals. Often enough, the effort they actually expend

is not that great, considering the pay-off. Technically, it is not that difficult simply to fake the objects themselves. Excellent work could be produced from a workshop set up for less than $50,000, with the investment being recouped in the first job. In less developed countries, fakes are being produced on a large scale from simple equipment costing far less than that. They are then circulated internationally, accumulating massive mark-ups before reaching the final purchaser.

The traditional method of making coins and medals is definitely advantageous for the dishonest who are interested in this field. Unlike most other fakers, they are able to work from a large scale, with the final salable product becoming so reduced in size that imperfections are difficult to spot.

In this process, large-scale models are first made of each face of a coin or medal. Relief casts of them are then mounted into a reducing machine (a type of which has been available since 1824). The large-scale casts of the faces are traced by the machine in a simple mechanical process that takes about three days, producing very hard chrome and nickel molds from which the actual coins or medallions are struck in a stamping machine. The finishing and polishing work, likewise, requires only readily available equipment.

Medal and Documentation Tampering and Copying

A common fraud with war medals is to add soldiers' and sailors' names, obtained from reference books and official military medal rolls, onto the rims of the medals, greatly increasing their value. Again, the deception involved is not always that difficult to achieve.

In one instance, convicted British fakers Brian Davies and Harold Fletcher openly ordered, from a reputable British manufacturer, a machine that they planned to use to impress phoney names onto Crimean, Baltic, and Chinese war medals. They subsequently had this machine duplicated by another tool-making firm so they could get into volume production with their "work."

The manufacturers were so pleased with the quality engineering that went into their machine, they published a photograph of it in a professional journal. This led to an investigation and the eventual unmasking of the crooks. Although warnings of what had happened were published in specialist medal-collector publications, very few responded by seeking to have suspect medals authenticated, so large numbers of these imprinted fakes are probably still around.

A collector can't even rely on paperwork to prove that a prospective purchase is genuine. Fakers are well aware that the value of medals is closely linked to documentation supporting their authenticity, so they are also adept at forging the papers needed to accompany their products. Here, their job is made easier by the fact that original medal rolls are often either missing or inaccurate. Even when the source quoted to support a fake is accurate, the roll cannot confirm that the medal was actually presented to the specific soldier or sailor entitled to receive it.

An even easier faking trick is to use fake paperwork to inflate the value of perfectly genuine items such as a medal and bars. In this way, the faker profits without even getting involved in the complexities of working in metal.

In addition to complete copies being faked, names and other inscriptions are added to medals to increase value, and the accompanying documentation may be forged as well.

The only way to be really sure about both the medal and the supporting paperwork is either to be an expert or to consult one. Whatever the alternative you choose, it's best to be certain about the value of the medal before you buy it. If you find that authentication is going to take months of painstaking research—research that you have to pay for—you may decide not to bother, because you may not be able to recover that cost (in resale value) for a long, long time. If the next buyer along the line is, in turn, suspicious of your paperwork, and spends even more in duplicating the expensive research for him- or herself, it will be still more difficult to recoup your investment.

Commemorative medals are another ball game altogether. They have been struck for more than 400 years to mark many historical and otherwise celebrated events, such as the crowning of a king, the inauguration of a president, the launching of an ocean liner, great exhibitions, anniversaries of organizations, and so on. Often the manufacturing standards for them are not particularly stringent as they are with official coins, so faking them is relatively easy. Yet at one time, neither was there much profit in copying commemorative medals, because their values were low. Recently, however, these medals have become far more collectible, so values are shooting up, and more and more fakes are being circulated. I bought a commemorative medal purportedly issued at the time of the sinking of the Lusitania, only to discover later that it was a much more recent copy.

Mail-Order Magic

Now there is a big business in "limited edition" commemorative medals every time there is an anniversary or an event of sufficient interest to create a market demand. These aren't fakes in themselves, but the advertising and direct-mail promotional material used to sell them is too often deceptive in creating the impression that they have great investment potential.

As with other works of art, a commemorative medal's value will always be influenced by the artistic quality that goes into its creation, so you must always ask yourself if the price quoted is relevant to the artist and his or her work: Will the medal stand the test of time and appreciate, or at least hold its value? Also investigate carefully just how *limited* the edition is. A simple stamping press can churn out commemorative medals at better speeds than those attained by a sausage machine.

The mail ordering of coins presents similar problems. The coins themselves may be genuine, but the information about them very deceptive. A classic advertisement features a "two weeks only" offer on a collector's set of five Morgan silver-dollar coins for $98, actually bragging that since the same firm sold them previously for $250, buyers can now "save more than

twice as much." So what has happened to the $250 investment made by original buyers, who were wooed by a somewhat different advertising message?

The same advertisement cites tenfold increases in silver dollar coin values during the last ten years and says that some Morgans sell for as much as $20,000. That is confusing for the novice who does not understand the currently existing methods of grading coins and medals—methods which, as indicated above, are highly complex and controversial.

High-pressure telephone marketing is also a method of selling commemorative and military medals and coins. Be particularly careful of such misleading persuasive techniques.

Other Problems for the Coin Collector

Finally, the international gold and coin business is in a mess as a result of both extensive faking and some very dubious business practices that have led to a rash of lawsuits.

Even the reputation of the U.S. Mint has been tarnished as a result of Congressional allegations that it sold millions of underweight half-ounce and smaller coins. When the Mint recently began selling Eagle gold coins to the public again, after a break of 50 years, the half-ounce, quarter-ounce, and one-tenth-ounce denominations were struck on an average weight basis, resulting in some being too light and others having more than the required amount of gold.

The faulty specifications have since been changed. This was not deliberate fakery, and the Mint maintains that the differences were very slight. Nevertheless, mints in other countries were quick to exploit the situation by emphasizing their more stringent requirements regarding gold content.

Far more serious are the investigations and legal actions involving a number of coin dealers, including some well-knowns, accused of blatantly overvaluing coins, improperly grading them, and making enormous mark-ups. One investor claimed in a suit against a leading U.S. dealer that he had been charged 1.15 million dollars for a coin portfolio that had a true value of less than $500,000. (The normal profit levels for coin dealers are 20 to 40 percent.)

Prospective buyers who hesitate, for whatever reason, to seek advice from a trustworthy dealer or other expert before they make a deal would do well to consider the kinds of problems described here. The complexity of such lawsuits and investigations and the extent of the potential losses for the collector makes getting another opinion seem quite simple—and certainly worthwhile.

CHAPTER SEVEN

GLASS WARE AND CERAMICS

Glassware and Ceramics

Glassware

Prized glassware has been copied for centuries, and the making of reproductions continues in the U.S., Israel, Turkey, the Far East, and throughout Europe. The types being copied range from American Carnival and Depression glass of this century to Jacobean and Irish cut-glass examples purporting to be genuine antiques, but actually they're being churned out in large quantities from factories all over the world. Some fakes are made using modern techniques, while others are produced in age-old traditional ways that make them very difficult to assess for authenticity.

Items to watch for include the very collectible *yard of ale* drinking vessels being made today in America, which are then exported to England for engraving. Some of of them subsequently find their way back to the U.S. as apparently valuable old examples. Reproductions from museum shops that are sold initially as reproductions, later get passed as originals; the Jamestown Glasshouse in Virginia, for instance, produces very good replicas that can fool all but the expert when they are subsequently traded. The faking of Tiffany lamp shades (some in plastic) is an industry in itself, and most chandeliers have had a checkered history: Even if they are basically genuine, they may have been altered substantially over the years to meet the tastes of different owners. Glass paperweights are faked extensively, and genuine damaged examples are spruced up by grinding and polishing. New copies of traditional paperweight designs are being circulated, and the temptation to age them artificially is aggravated by prices that can top $20,000—justifying for fakers the handwork required to produce them.

Many of the fakes are sold to new enthusiasts, whose judgment is often clouded by the fantastic appreciation in values of even mass-produced glassware of recent times. In addition, antique dealers who lack specialized knowledge of glass have difficulty distinguishing the reproductions from the genuine, so prices vary wildly. Buyers can pick up genuine bargains on underpriced originals in one case and pay exorbitantly for unidentified reproductions in another.

I bought a large consignment of old bottles for my store, and after hours of trying to track down values in reference books, I was forced to price them largely on guesswork, in most cases just taking my total cost, dividing it by the number of bottles, and adding what seemed a reasonable profit.

An original 1896 advertisement of English glass and electroplated silverware items with their original prices. The values have now risen to the point at which copying is cost-effective.

Why You Can't Always Tell

Tests for authenticity of glassware aren't foolproof. Collectors, for instance, tend to ping the rim of a wine glass with a fingernail, or wet the rim and run a finger round it to see if there is a clear musical note. While this does result in a distinctive clear sound from genuine lead crystal, there is plenty of other cheap glass made today that also sounds very musical. You can hear the effect by listening to musicians who play sets of different-sized glasses filled to differing degrees with water. The sounds produced, that cover the musical scale, depend as much on the shape of each glass (and within it, the area of air that vibrates when the rim is stroked) as it does on the composition of the glass.

Collectors also tend to put too much store in the implications of a *pontil mark*. This is the mark on the base of a piece where, after being blown or molded, the glass would be fastened, still hot, to a pontil iron for finishing. At one time, most handmade glass had a pontil mark. In the old days, before about 1750, the base of the glass had a raised foot extending beyond the pontil so that it would stand properly and not scratch a polished surface. Then, better pieces had the pontil ground away, a practice still followed today. So the absence of a pontil may indicate recent glass pressed in metal molds, but even glass blown by the ancient Romans usually has no pontil. Plus, fakers throughout the ages, including those operating today, have doctored pontil

Old bottles have become a major collecting interest and their prices are rising fast, but still not to levels that would prompt extensive faking.

marks to fit the accepted norms for the work they are reproducing.

Neither do bubbles or an irregular shape necessarily indicate that a piece of glassware is old and primitive. Bubble glass has been imitated for years, and incorporating imperfections is a standard faking trick to give the impression of age and handmaking.

In fact, the better handmade glass of whatever period is distinguished by its inherent quality of workmanship and use of materials. These elements are difficult to reproduce, so it may cost more to fake them realistically than can be obtained from the going market prices for genuine examples. However, glass collecting is thriving to such an extent that there are very few categories in which it is not cost-effective to create fakes.

Forgeries of really old glass have often been intentionally broken to add to their apparent authenticity. In addition, fakers peddle pressed glass bearing hand-cut maker's marks, add engravings to both old and new glass to increase value, marry pieces together using the new extra-strong glues, and melt down beer and cola bottles to get the colors and opacity of antique glass.

Cut glass is not always cut by hand using a variety of abrasive cutting wheels and great artistry, as many people seem to assume. The cutting may be done by machine in mass-production, or it may be pressed into the surface of the molten glass in a mold. Hand-cut glass has sharper definition than you'll see in the machine-cut product, and it often bears visible marks left by the wheel. But these may have been made more obscure by the acid-polishing techniques introduced over the past hundred years.

Although some pressed or molded glass purporting to be cut crystal is easy to identify, you need considerable experience in studying the different types of glass and the ways they are decorated as you seek to distinguish the better fakes.

Like wood and metal, glass acquires a patina from age, but the patina can be added easily by chemical treatments that also conceal defects in color and general workmanship. Still, natural weathering on glass can be quite thick and will have built up in layers, while fake weathering is usually only a single, thin layer.

Chemical, x-ray diffraction, ultraviolet light, and other complex tests can analyze both the weathering and the constituents from which glass was made, thus indicating whether a piece suits the different periods and regions to which it is supposed to correspond. On the other hand, the faker is helped by the fact that the most valuable ancient glass often comes from very

dry regions and has suffered little weathering.

Differences You Can See

Despite all the disadvantages you may face in trying to identify genuinely collectible glassware, there are certain giveways you can detect through careful examination.

Decanters, for example, are faked extensively, frequently with the decanter itself being a genuine original, but not the stopper. (There seems to be something about both stoppers and keys that turns otherwise honest antique-shop browsers into thieves, and which, coupled with the natural possibilities of the stoppers being lost or broken, encourages such contrived mismatching.) Look for signs of fresh grinding

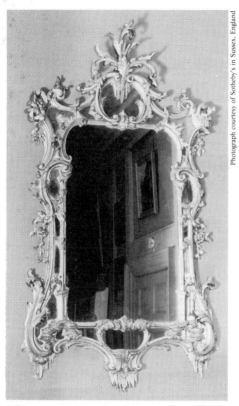

Photograph courtesy of Sotheby's in Sussex, England

This is one of a pair of George II wall mirrors, about 200 years old, having a market value today as high as $65,000.

and contrasts in style and color to check whether the stopper really is a genuine match with the bottle.

Mirrors are particularly difficult to fake because glass ages to give a distinctively softer, grayer reflection than the clear, sharp image of a modern or resilvered old mirror. An old mirror usually has thinner glass, and if it is hand-beveled, the edges will be softer in outline and less regular than those ground by machine. In addition, you can check the back of a mirror for the telltale signs of furniture faking that will show up in the wood frame and fastenings. The back will usually be protected by thin pine that should clearly be old, and that often is rather rough, without proper finishing.

A key element in identifying decorated glass is to look at the way the decoration has been applied and to use reference books to verify that it is appropriate to the style and techniques of the period. Acid etching, which has been used for a couple of centuries to decorate the surface of glass, tends to give a regular frosted finish—one that on more recent examples has not been very deep. Sandblasting to add decoration, which has been practiced for about a 100 years, leaves a finish you can recognize quite easily when such pieces are being passed off as engraved to inflate their prices. Just look through a magnifier and you'll see how the tiny grains of sand, blown at pressure onto the glass, have left their distinctive marks, quite different from the marking that results from either etching or engraving.

There may also be the gaps characteristic of stenciling techniques, especially discernible in lettering.

Generally Speaking

What's the best approach to picking your way through the jumble of fake glassware? It is really such a complex area of collecting that the safest method is to specialize. Study your chosen speciality carefully so that you become aware of the fakes in circulation and the various ways in which they can be identified. Often the color is not quite right, or the style and thickness not consistent with the genuine originals. Differences that are not otherwise readily apparent will stand out if a genuine piece of glassware is placed alongside a fake.

Forgers of more recent glassware may be able to get original molds or use contemporary equipment to create convincing, almost impossible-to-spot reproductions. Yet there are ways to

avoid being duped by even the most conniving imitators. The Heisey Glass Club was so worried about original molds being misused that they purchased them when the factory closed. Belonging to a group of enthusiasts such as this also helps you keep abreast of the current fakes and the deceptions being practiced.

Glass as Convenient Embellishment

Glass is sometimes also the culprit in helping disguise faulty originals or less than impressive fakes. For that reason, you should be very suspicious of collectibles that are contained in sealed frames or showcases that are both impractical and unreasonable to break open before buying.

Stuffed animals and birds, for instance, have become very collectible, and the smaller specimens are almost invariably inside sealed glass display cases. They are not being faked, but their inevitable deterioration from age is not readily apparent until you remove the case.

There are several reasons why something within a glass case, or a picture under glass, often looks far different from the way it looks when you can see it directly. Even if the glass is clear, imperfections and forgeries are much more obvious when the surrounding glass is not in the way.

The problem is complicated by the fact that the molecular structure of glass changes with age, making the glass itself less clear. You can wash off all the dirt and still not be able to see through it very well. In addition, such tests as using a raking light don't work properly in this kind of situation because of the refractions caused by the glass.

If, on the other hand, you already have a piece that you *want* to preserve and display under glass, think twice before having a very expensive case made up for it. Aquariums, which are mass-produced and relatively cheap, make excellent display cases when turned upside down and fastened to a base board. Just be sure that you thoroughly clean the inside of the glass before sealing the case. A little vinegar in the final rinse water will help keep it clean. Stubborn marks or scratches can usually be removed by using silver polish or a mildly abrasive rubbing compound such as jeweler's rouge or the pastes supplied for reviving paint on cars.

Pottery and Porcelain

For hundreds of years, fakers of pottery and porcelain have led charmed lives without retribution—with at least one exception: the master Italian ceramics faker Ferrucio Mengaroni, who specialized in extra-large works and was killed when one of them fell on him.

Copying of earlier genuine pieces became a major industry in the eighteenth century and has remained a prolific and highly profitable activity ever since. The demand from collectors is so great, and their lack of caution so lamentable, that pieces fresh from the kiln, costing only a few dollars to manufacture, are peddled regularly as genuine without even a need for artificial aging or marks.

Proceed with Care

Too many books for novice collectors give misleading advice about marks on china. As you might guess by now, trusting such marks is not wise. As in

A collection of reproduction ceramics mixed among a few genuinely old pieces in a European flea market.

An out-and-out fake of a Victorian teapot: The molded bamboo handle is actually plastic, crudely fastened to the china by badly shaped wire hooks, while the glaze is distinctly modern and the base shows no signs of wear. This teapot won't even pour properly—a lack of functional design characterizing many careless modern reproductions of supposedly period pieces.

other areas of collecting, there are so many of them and they have been so extensively forged or altered that they are most unreliable guides to authenticity. Pottery and porcelain marks were never strictly regulated in the same way that English silver hallmarking has been, so the scope for falsification and confusion is enormous. In a recent instance of such exploitation, the inmates of a British prison, in their occupational therapy classes, produced fake pottery bearing convincing marks that fooled ceramics experts for some time. If they had simply limited their production, the prisoners could probably still be enjoying the success of this venture.

The familiar crossed-swords mark of the Meissen factory has been forged on countless occasions, as has the distinctive *L* on Sèvres work and the identification of very collectible English

A family in Crete churns out reproductions of ancient Greek pottery by the thousands. The products of small workshops like these are popular with tourists and for the export trade. There is no deception intended by these successors of ancient craftsmen, but too often their work is passed off subsequently as being genuine, even if it rarely fools the experts.

Wedgwood and Doulton pieces. Europeans over the centuries have copied most of the important Chinese porcelain, along with any marks. Their now genuinely old reproductions have nowhere near the quality of style and materials of the originals, being generally much thicker and heavier, and featuring clumsy artwork.

Very old pieces of Chinese porcelain were given no marks at all, so a marked example purporting to originate from before the fourteenth century may well have been doctored.

Always examine the mark carefully under a raking light and through a glass, looking for signs of a disturbed surface around it, such as abrasion scratches or differences in color. A frequent trick is to dissolve the original mark on a piece of little value by painting acid on it or rubbing it off with an

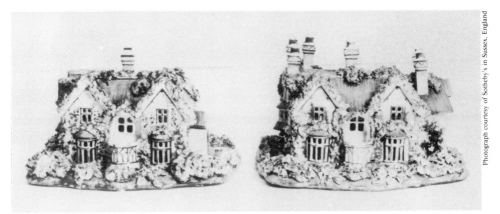

Pottery models of traditional English country cottages are popular collectibles. This pair of porcelain pastille burners modeled as gabled thatched cottages fetched over $5,000 at auction. But many that at first glance look similar are modern and of little value. You can even buy rubber molds in which to make such copies, and then color them yourself.

abrasive. The more valuable mark is then painted on to upgrade the piece and the area covered with lacquer or a glazing solution.

A phoney mark and its lacquer covering may dissolve when dabbed with acetone, but that test is not infallible, because hundreds of thousands of reproduction ceramics have been produced with false marks put on underneath the glaze at the time of manufacture.

Another commonplace fraud involving marks consists of buying rather plain pieces carrying genuine marks of the famous potteries where they were made, then doctoring them with gilding and elaborate patterns to increase the value. While the mark on one of these pieces is original, the product achieved in this way certainly is not.

Some ceramics fakers have entered into the business by initially offering repair services for prized original pieces and finding that the same techniques were more profitably employed to create reproductions. Also, in at least one case, the work of an honest artisan has been used by fakers to make their work more convincing. Edmé Samson of Paris used his skills to match up replacements for broken or missing pieces in sets brought to him by customers, including some now very valuable examples of Delft, Chelsea, and Meissen work. The *S* (for Samson) marks he put on his substitutes alongside copies of the original manufacturers' marks are removed easily by fakers wishing to pass the pieces off as genuine and worth twice their actual value.

Other Considerations

The great measures taken by the Chinese to protect their porcelain-manufacturing techniques from getting to the West gave the first major stimulus to ceramics faking. Despite all their efforts, the Europeans could make only poor copies of Chinese porcelain until the eighteenth century, when they figured out how the Chinese produced their fine, translucent hard-paste porcelain by mixing kaolin and china stone into a paste and then firing it twice at high temperatures.

The more successful European copies of Chinese porcelain used a soft paste of clay, sand, and potash or lead.

Because it was not fired at the correct high temperature, it still is not nearly as strong or as light as genuine hard-paste Chinese porcelain. However, the British experiments to improve on these copies did lead to the inclusion of bone ash in both soft- and hard-paste porcelain to create the very collectible bone china.

You really need to study the evolution of European pottery in detail to spot the many reproductions and deliberately deceptive fakes in circulation. Virtually all the work of the main collectible potteries has been plagiarized at some time, and you can sort them out only by studying the materials used, the designs, the style, and the multitude of markings, both true and false.

For example, the flood of mass-produced European copies of Chinese porcelain in the eighteenth and nineteenth centuries adapted the Oriental decoration to European tastes of the period and are very distinctive when put alongside genuine examples. The copies reflect a stylized, often almost-cartoonlike European interpretation of Oriental figures and scenery.

This is readily visible in the many modern copies of the traditional Willow pattern that, nevertheless, continue to do quite well with collectors. In fact, copies of copies of Victorian Willow-pattern dining and tea services are being produced at very low prices in Europe and presented to U.S. buyers as quite old and valuable. Actually, there are no really old Willow-pattern sets—or any other of the enormously popular blue-and-white china—available at bargain prices.

Another trick of the trade is to display and sell modern reproduction Willow pattern and other traditional designs as if they are single examples,

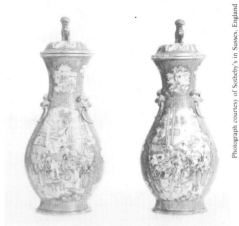

Look at the rims of the lids and the finely executed relief work of these beautiful Mandarin vases, worth around $18,000. By studying such authentic pieces in museums and galleries, you will soon get the appreciation of the genuine, which is crucial to identifying fake copies.

wrapping them tenderly in old newspaper before the buyer takes them away in a different box or in carrier bags. Once the buyer has left, the dealer whips out another boxful of copies from the storeroom, all crisply packed for shipment. With this method, dealers get better prices than they would by simply offering a number of identical, prepacked sets.

The popularity of the Willow pattern illustrates how very salable and frequently faked is chinaware with blue-and-white coloring. The famous Flow Blue is especially easy to fake and sell because it looks naturally old and rather primitive with the blue patterning bleeding into the white areas to give a pleasing effect. Sand may be added to the glaze to increase the primitive, pseudo-old appearance.

In any case, telling original hand-painted work from copies can be difficult, but try following the tips offered for judging the authenticity of paint-

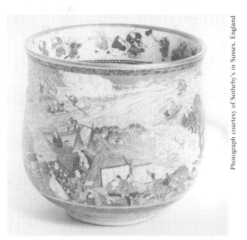

The exceptional quality and artistry of the enamel and gilt work on this Satsuma bowl make it virtually impossible to fake with any cost-effectiveness. The 3½-inch piece sold for around $2,000.

Ceramic replicas of Greek museum pieces displayed for sale in an Athens store, where they are popular mainly with tourists.

ings as you examine suspect ceramics. Here, too, genuine painted designs have the natural fluidity of original artwork, not the stiltedness of the hand of the copier.

Another indicator of a ceramic piece's authenticity is its surface. Old ceramics acquire the equivalent of the patina found on naturally aged furniture. This can be simulated in fakes in a variety of ways, notably by cracking the glaze to reproduce the effects of a genuinely old piece that has expanded and contracted over the years due to changes in temperature and humidity. Look inside a vase or jug to see if the glaze there has cracked also, as would be the case in a genuinely old example. Also ask yourself if the craquelure is too uniform to be genuine.

Experts can identify many fakes because they do not have the characteristic coloring of the glaze used by the different factories at specific periods, while the texture of unglazed areas shows that the correct type of paste has not been used. They also find clues in the methods of molding used. Quite a number of fakes have been made by a technique called *slip casting,* in which clay in a very liquid state is poured into the mold instead of a more solid mixture being pushed in. Marked differences result in both appearance and weight. Of course, slip casting has been the method of manufacture for some genuine originals as well.

Often, the size of ceramic figures faked on a vast scale gives away their falseness—they are slightly smaller than the genuine examples because they have been cast from a mold made

from the original. Also, there is usually a loss of surface details in such copies.

Frequently, ceramic pieces will have been doctored in an effort to disguise repairs. If you determine that this is true of something you're buying, don't pay a high price for it unless the piece is very old and repair work at some point in its life was virtually inevitable. While you may not be able to see where a repair has been made, there may be lingering odors emitted by paint, glue, and lacquer, even if the renovation work was completed a considerable amount of time ago.

Dating ceramics can be difficult, and the only way to do so accurately is by using expensive scientific tests that are only cost-effective on potentially valuable pieces. One such technique is thermoluminescent testing, which operates by measuring the amount of radiation emitted by the piece when it is heated. The clays used to make pottery will have absorbed natural radiation over the centuries, but they release most of that when they are fired. Then, the finished piece begins building up radioactivity again. So by using this kind of test, it is possible to calculate

A modern replica of an ancient Greek urn in one of the many Athens shops selling reproductions.

both the age of original manufacture and whether any repairs or replacements have been made subsequently.

Firing clay also tends to align the particles of iron oxide it contains to create a magnetic field that can be measured with sensitive instruments to provide further evidence of authenticity.

A Quick Test for the Real Value of "Limited Editions"

If you want a quick test of the real value of those frequent contemporary phonies, the "limited edition" collectibles of all kinds, take one to a dealer or an auction house.

In the majority of cases, you will find that attempts to contrive rarity in modern manufactured items is not a route to good invest-

ment and resale value. Leading dealers and auction houses will not even handle many of the chessmen, plates, plaques, figurines, dolls, and so on that are marketed so aggressively as being the collectibles of the future.

The big problem is that limited editions are usually only limited by response to the publicity invested in them. There could be hundreds of thousands of examples sold, and even if the item has an intrinsic interest, it could take decades before

All these items are replicas, handcrafted copies produced in Greece on a vast scale and at low cost.

Some of the most blatant ceramic reproductions being presented for sale in the U.S. don't need such sophisticated and expensive testing. Examine them for labels or marks of their country of origin, which are required by American law for imports. This is not always a sure indicator, however, as many imported reproductions (not just chinaware) have country-of-origin labels made deliberately small and fixed with low-tack glue. These labels can be removed easily, leaving no trace of their existence.

examples are scarce enough to show any tangible appreciation in value.

Also, unless originally the production was strictly controlled, it is far too easy for an edition to be repeated if there is a demand for it. This is happening with reissues and copies of commemorative mugs and plates that, even though they mark past events, you can still buy new today. It is particularly true of items relating to coronations, weddings, and other events in Britain.

For example, not everything relating to Queen Victoria's Jubilee, which was a big occasion for commemoratives of all kinds, actually dates from that period and so has any real value. The fakes are prolific.

Beware particularly of fake Jubilee chamber pots. Queen Victoria, a very conservative lady, was not at all amused about a limited edition linked to the royal bottom. Originals of that issue have two handles and were sold as planters.

CHAPTER

PAINTINGS

8

AND PRINTS

Paintings and Prints

In Search of a Masterpiece

Every time a new art auction record is broken, there's a renewed frenzy over valuable paintings. Collectors and investors become excited, demand for quality work grows further beyond the available supply of valuable originals, and the opportunities for passing off fakes increases again. When millions of dollars are at stake, it pays the faker and the forger to devote great time and expense toward creating convincing reproductions, so many of the phoney works around are very well executed and often get past the experts.

Of course, the opportunists don't always have to invest a great deal of production time preparing for the sale. Frequently, the forgery begins as a skilled artist's legitimate copy of a work of art, with no crime committed until a middleman or dealer forges a signature on it and the copy is peddled as an original.

The work of the faker is also made easier by the fact that buyers sometimes exercise an incredible lack of caution, as indicated in the discovery by South African police of a criminal ring selling copied paintings that were still wet.

Discovering "Lost" Works

One way to get fake art into the market is to forge a missing masterpiece. All major painters are featured in *catalogues raisonées,* which contain full details of all their known works and a comprehensive list of missing pictures. The unscrupulous need only consult such a reference as this in order to determine an apparently safe point of departure for an elaborate fraud.

They might consider, for example, conjuring up a certain Cézanne landscape of Auvers-sur-Oise (similar to one of his works in the Chicago Art Institute), which is among nearly 300 masterpieces that disappeared during the Nazi art lootings of World War II. Others on the missing list include an array of Goyas, more than 60 works by Titian, and about the same number by Velázquez, as well as a number of small oil paintings by Jackson Pollock, that disappeared from the Brooklyn Library in New York.

It also happens frequently that someone buys and displays a copy, fully realizing that it is not an original work. Years go by, the owner of the copy dies, and then a new artistic treasure is "discovered" when the estate is put up for sale. None of the surviving

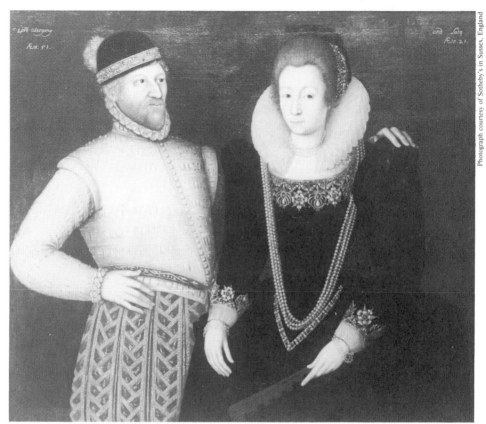

Provenance is vital to the confident authentication of a painting. This late-16th-century English school portrait of Lord and Lady Abergavenny came from the collection of a descendant of the sitter, and is genuine.

relatives really knows the background of the copy, and some may themselves have been fooled by the owner into thinking the work had great value.

Although it is a nice thought, there really are very few valuable paintings just waiting to be discovered in dusty basements. True, the picture that Mrs. Jane Pigg bought for $2 at a Missouri auction proved to be a genuine work by nineteenth-century American artist Martin Johnson Heade, and resold for $154,000. Far more often, though, the findings are simply fakes that have been given a coating of grime and passed through estate sales to get them into circulation.

Stolen Works

What you are more likely to discover is that the original you have bought is one of the many stolen paintings in circulation. This possibility is just as unfortunate as that of buying a fake, and should likewise influence the buyer to proceed with extreme caution. The New York International Federation for Art Research calculated, for example, that only 396 of 2,686 art items reported stolen in 1986 were recovered. Adapt these figures to an international scale, and you get an idea of the actual risk of collectors innocently acquiring stolen works as well as fakes.

Good provenance, including a reproduction in a standard reference work on 1920s artist H.M. Bateman, enabled this cartoon of his to be authenticated, thereafter fetching more than $5,000 at auction.

The situation is confused by the massive thefts of paintings organized by Herman Goering in Occupied Europe during World War II. This, the largest art heist in history, combined with the chaos of the war years to create a gap in records that still helps in the falsifying of the origin of some fakes.

Goering himself acquired many fakes, so proof that something has been recovered from a Nazi treasure hoard is not proof of its authenticity. One of the most famous fakers of all times—Dutchman Han Van Meegeren—was actually unmasked because of Goering. Brought to trial after the war, accused of collaborating with the enemy by selling national treasures to Goering, Van Meegeren had great difficulty convincing the experts that he was not a traitor, but only a faker who had been copying

the works of the Dutch masters on a large scale for years.

The reluctance on the part of the art scholars he had deceived to admit their mistakes—like that of the many collectors who know or suspect that they have bought forgeries, but don't wish to appear gullible—enormously complicates the tracking down of fakes. All buyers would profit if those who have been cheated would follow the example set by multimillionaire Armand Hammer in revealing how he was deceived when he set out to become one of the world's greatest art collectors.

In his autobiography, Hammer describes an apparent bargain in which he paid 50,000 gold rubles for a "lost Rembrandt." Later, as the director of the Berlin Museum was showing off the work to his staff, an assistant rubbed a portion of it with alcohol and the paint dissolved. The painting was discovered to be a forgery by the director, no less, of one of Moscow's state museums, who also copied the work of Frans Hals and Rubens so convincingly that his paintings had been bought by a number of European museums as well as by Hammer.

What to Watch For

Even if the surface of an oil painting appears to be dry, it can take a decade for the underlying areas of paint to dry out properly, especially on works imitating artists such as Van Gogh who laid their paint on very thickly—straight from the tube and often without mixing it.

Art experts frequently use a simple pin test to spot thick paint that has recently been applied. They insert the pin into the paint in an obscure corner where the mark will not be noticed, and if the point of the pin emerges with

wet paint clinging to it, alarm bells sound.

Prospective buyers can also examine the signs of age in apparently old paintings to check for dishonest dealings. The cracking of oil paint as a result of age is very easy to reproduce in a variety of ways. The cracks may simply be painted on in a dark color with a very fine brush, pen, or tip of a feather. Or the surface may be scratched to simulate cracking.

Special "cracking" varnishes give that convincing aged surface within an hour or so. A reproducer of religious icons demonstrated this to me in his studio in Athens.

"How old would you like?" he asked. When I said 150 years would do, he made up a mixture of varnish, dabbed it over a new painting, and very soon the surface was covered with most convincing cracks.

The celebrated British faker, Tom Keating, used a whole battery of different cracking techniques in his copies of the works of such famous old masters as Degas, Constable, Goya, Gauguin, Gainsborough, Hans Holbein the Elder, Edvard Munch, Samuel Palmer, Rembrandt, Rubens, and many others.

Keating was so gifted, he could reproduce an old painting in a mishmash of whatever contemporary materials he had on hand—such as acrylic paint and poster colors—and still get it accepted as an oil by Goya. He used magazine illustrations and postcards of famous works as a guide to style and technique to create works by famous old masters that were subsequently "discovered," fetching enormous prices for the dealers who peddled them, ending up in collections all over the world.

Photograph courtesy of Sotheby's in Sussex, England

Religious icons are being faked extensively in Greece, with special formulations of varnish realistically mimicking the cracking of age and giving paintings such as this a deceptive dark tone.

Like the icon faker I met in Athens, Keating kept a stock of special varnishes from which he could pick a finish that would give the appearance of 50, 100, or 200 years' worth of genuine aging. He put size beneath and on the surface of the paint, and then put his work in front of an electric fire to dry the combination, which would contract and crack convincingly at the same time.

Some fakers have big ovens in which they toast their pictures, some roll the finished painting around a cylinder (a curtain pole is ideal), and others use egg white mixed in with the paint to achieve this cracking.

One of Keating's favored techniques to age drawings on paper was to cover the work with a layer of kitchen gelatine and then warm it in front of a fire to crack the surface. His contempo-

Fakers with a Cause

Most art fakers aren't nearly as colorful as the artists whose work they copy, which is often a giveaway of the hesitant, uncertain, and apprehensive way in which they work. This is reflected in their brush strokes and in the lack of confidence of the lines in faked drawings.

But don't think that all fakers are bland characters who work nervously and surreptitiously for fear of being discovered. German faker Lothar Malskat reveled in the notoriety he enjoyed after his conviction, and he gave numerous interviews boasting of the flamboyant visual tricks he had pulled, including the faces of a German film star and his father in "medieval" frescoes in a Lubeck church.

Britain's most famous faker, Tom Keating, was another larger-than-life character in his heyday. The hundreds of phonies he produced carried his own special touches, such as adding an extra finger onto the hand in a painting of the Huntress Diana, and using his girlfriend as a model for copies of work by old masters long since dead. Even Queen Elizabeth II praised Keating's skills when he was doing a magnificent job restoring some royal pictures, not knowing the skills of an arch faker were being employed in the monarch's service.

Keating expressed what is often the subconscious rationalization of fakers who are also talented artists—they are getting revenge for the way many artists are exploited by dealers, never themselves getting the opportunity to enjoy the fruits of their labors.

"I wanted to avenge my brothers and so took up Sexton Blaking [rhyming slang for faking]," Keating said. He was proud of his achievements and despised the experts who "wriggled like eels" to avoid admitting they had been taken in by one of his many fake pictures.

rary counterparts have found that a hair dryer works even more quickly.

You really need to be an expert to spot the best of the fake cracking, but careful examination under a strong magnifying glass will reveal many of the tricks of the trade I have described.

Be particularly careful of a picture purporting to be more than a hundred years old if it seems too perfect and has no cracking at all. It is almost certainly a recent copy or a grossly over-restored original, in which case much of its investment value has been destroyed.

Don't assume that a painting with murky dark varnish on it is genuinely old. A favorite faking trick is to finish the reproduction with dark varnish, thus creating an impression of age and concealing faults in the brushwork and coloring of the copy.

You can identify new paint and recent changes, such as the addition of a signature, by looking at the surface of the work in the light of an ultraviolet lamp. New paint fluoresces quite clearly. When this technique was demonstrated to me in the back room at

Sotheby's paintings department, it immediately showed up some suspect work that, on the strength of the test, was dismissed from further consideration for an upcoming auction there.

Testing lights are available commercially, or you can make up your own black-light unit from fluorescent bulbs. They are such useful tools that some responsible dealers just will not handle a painting they cannot black-light test (a painting that has been covered with an opaque varnish rather than a clear one, for example, cannot be tested effectively).

Various infrared devices, microscopes, spectroscopes, x-rays, and a battery of chemical tests are also used to verify the authenticity of paintings. These can reveal many faking mistakes such as the use of colors—including ultramarine, chrome yellow, Prussian blue, and cadmium red—that just were not available when a genuine old work of a particular period was created.

Paintings on wood are difficult to assess for age because fakers can easily find old panels on which to make their copies. Examination of the back of this kind of work, however, sometimes reveals that it has been smoothed by a modern plane or cut by a band saw when it should show the irregular marks left by a traditional hand tool. Still, a clever faker will use an old adz to get the right finish, in which case chemical tests are needed to see whether any of the variety of solutions for creating artifical aging have been used to color the wood surface. These include various acids, alkalines, solutions of licorice, tea, or coffee, and contemporary stains (all of which are also used to age faked paintings on canvas or paper).

Experts can determine the different periods in which canvases were

Silhouette pictures—popular among the Victorians—are being faked, although not yet on a substantial scale. Look for indications that the frame and mounting are genuine, and expect some discoloration (the result of age) in the silhouette image itself.

made by evaluating their weave and texture. Machine-made canvases are a distinctive giveaway for fakes purported to originate before the early 1800s, when techniques for machine-made canvases were just being developed. Detection is made more difficult when, as often happens, an old work of little value is stripped so that a genuine canvas from the period concurrent with the work being faked can be used.

Frequently, a valuable old painting with a fragile backing has been re-lined: It has a new canvas stuck on the back to protect and support the old one. It is quite usual to find a genuine old master that has been given a new canvas back and is supported on new wooden stretchers. However, it is also common to find similarly prepared fakes.

All of this tends to interfere with authentication of the painting, but there are some details that can be examined still. If the stretchers are new,

check to see if the painting is actually part of a much larger one that has been cut down. One type of deception I find particularly reprehensible is the practice of cutting up a picture into smaller, more marketable sections when it has been judged too large to sell to private collectors with limited hanging space. In this fashion, the dishonest dealer gets several pictures of a more popular size from the original, thus creating the opportunity for enormous profits.

It seems inevitable that an old picture will have been knocked, bumped, and rubbed against other surfaces during its long life. Fakers simulate such wear marks; rubbing with very fine steel wool is just one trick used to imitate wear on a fake. They are, nevertheless, very careful to create such artifical surface damage in an area that is less conspicuous so as not to destroy the attraction of the piece. They would certainly not rub the nose of a portrait, for example.

Because of the prevalence of faking through the ages, previous owners may have added identifications, seals, crests, and such on the back of works in their collections. These are also duplicated, or genuine examples may be transferred from one work to another in order to create the most valuable combination possible.

Written certificates of authenticity must always be suspect, especially if they are couched in evasive jargon. Some art scholars and dealers issue certificates of authenticity for fat fees without making very scrupulous examinations, or they may have been fooled themselves by a good fake. Consequently, thousands of fakes and suspect works have been credited to artists who never created them.

On the other hand, considering the growing litigation epidemic, responsible experts are wary of commiting themselves because of the fear of being sued if they are proven wrong.

Buying a painting on the strength of the artist's name alone is most unwise. In addition to the dangers of outright faking, consider that many of the old masters had large studios in which they employed both experienced artists and students whose work reflected their style, materials, and techniques. Often the works from these establishments were almost mass-produced, with the master actually only contributing a few brush strokes.

Signatures are deceptive, too. Remember that until about 200 years ago, it was not usual for painters to sign their work. Some forgeries are obvious in light of that fact, while others are physically obvious—actually added on top of the varnish at a much later date. These show up when viewed at an angle under a test light, or sometimes when they are simply inspected under a natural light or a normal artificial light. Tilt the picture or the light so the illumination rakes across the surface to accentuate any shady tricks.

A genuinely old painting may be *in the style of* a well-known artist, perhaps a copy by a student to learn technique. Now that art prices are so high, such copies are often doctored and passed off as originals by the famous artist, with the whole work revarnished so that it appears to be a genuine restoration. These deceptions are often difficult to spot without the help of complicated testing.

Faux Finishes: Painting with a Different Artistic Perspective

When you stand in some of the rooms at the famous Palace of Versailles in France and look up at the fabulous walls and ceilings, you see a beautiful faux *(French for* false*) finish of fake marble. Similar renditions of marble and other stones, ivory, tortoiseshell, and expensive woods are used on items such as furniture, picture frames, and clocks.*

Often genuine materials and less expensive ones treated to look like the real thing are mixed in a piece. This happens especially with walls and fireplace surrounds in areas that are not likely to be touched or examined closely. The French phrase trompe l'oeil—*literally,* fool the eye—*applies both to such work and to a certain style of painting, such as the enlivening of a bare wall by a painted window that appears to look out onto a garden.*

These faux finishes have been commonplace for hundreds of years, providing a perfectly legitimate technique for creating a visual effect at far less cost than would be possible using genuine materials. They are practical for other reasons, as well.

Wood painted to look like marble is so much lighter and easier to work with, it might be preferred to real marble for an area situated high on a wall. When marble clocks were in style, it made sense to use the faux-finish wood so the clock could sit more safely on a shelf, be easier to move around, and be more economically priced. If all the tortoise-shell finishes applied to furniture had actually come from tortoises, the poor creatures would have become extinct very quickly. Similarly, if celluloid and later, more sophisticated plastics had not been invented, the elephant would have been poached out of existence.

Faux marble is easy to spot. It weighs less than the real thing and is not as cold to the touch. Flick it with your fingernail and you will feel the difference between wood and marble.

The painted and stained faux finishes on wood can be more deceptive, but you will soon be able to identify them because there are so many signs that the grain is not genuine. Maybe it is too even and

Prints

Most of us cannot afford original works of art and so must rely on prints. Indeed, for hundreds of years, particularly before the discovery of photography, prints have been a principle method of bringing visual art to the general public.

It is only in recent years that prints have started to become so collectible and expensive, resulting in a plague of fraud and other forms of deliberate deception in the international print mar-

regular, does not continue natu-
rally around edges, or disappears
altogether in places as a result of
wear. When a genuine wood fin-
ish wears or is scratched, only the
surface changes. The grain of a
solid piece (or even that of a thin
veneer) remains visible and, if
moistened, tends to look much
like the still-shiny unworn sur-
rounding area. Also look at hid-
den areas of the wood, which
usually were left natural and were
not finished in the same way.

The creation of faux finishes
was an art in itself, and an old at-
tractive piece incorporating them
should not be dismissed as a fake
unless it is being represented as
genuine marble, tortoise shell,
rosewood, or whatever. Indeed,
much of its value might lie in that
very finish, now an emblem of the
period during which it was
crafted.

Sadly, many faux-finished
pieces have been stripped, leaving
only mediocre items of greatly di-
minished value. Most collectors
wouldn't pay much for a nine-
teenth-century clock in a plain
pine case, but if it had the original
painted marble finish in reason-
ably good condition, it could be
worth thousands.

Hand-colored botanical prints such as this one—for popular decorator items—are widely copied, so proposed examples should be examined by an authority before they are purchased.

ket. The deception often includes promoting completely unrealistic projections of how prints can be expected to appreciate in value. If you spend and select wisely, prints can be a more stable and better investment than original oils and watercolors, but too often this is not the case.

If you're paying a substantial price for a print, you need the same kind of expert guidance, authentication, and written guarantees you would seek before buying an original work of art. With the better-known prints, there are reference books that will give hard facts to help you check authenticity. For example, a listed edition may be, say, 15 inches wide. If your prospective purchase measures only 14 inches across, then it has been trimmed down, produced fraudulently, or produced as part of some other less-valuable authorized printing.

The safest buys, which are also the most expensive, are at the upper end of the market, where prints by Picasso, Chagall, and other celebrated artists, together with such contemporaries as Hockney, are properly cataloged and values well established. A large proportion of other prints sold in the U.S. and

Europe will prove very difficult to sell again for the current asking prices.

Know the Terminology

Dealers may try to enhance the perceived value of prints by using terms which they hope the buyers don't understand. Thus, the first thing you can do to arm yourself against deceptive sales tactics is to be sure you speak the language of this special field of collecting.

The term *serigraph* is another word for silkscreening, basically the same technique used to print T-shirts and much of the labeling on consumer products. It is actually a form of stenciling, the value of which hinges very much on the quality of the work.

Intaglio printing involves getting the image from the crevices that are engraved or etched into the plate. Line engravings and etchings, dry point, mezzotint, stippled engravings and etchings, aquatints, and metal graphics are all examples of intaglio printing.

In contrast, *relief* printing transfers an image from the protruding surfaces of the plate. The work of Rolf Nesch, who builds up printing plates by adding shapes in metal to the surface, is an example of relief printing that can give a very attractive embossed effect.

Surface printing produces the image from the areas and lines on the surface of the plate that have not been cut away. A wood engraving or a linoleum cut are among the types of surface engravings you may encounter.

In addition to these separate categories, you may also find prints that are the result of different techniques combined in one work.

An especially big sales pitch will be made for the *original print*. This is one published in limited editions and

Thousands Paid for Photocopy Forgeries

The steadily increasing sophistication of color photocopiers is a new menace in the field of art and document faking.

Large sums have been paid in the U.S. for photocopies of prints by Salvador Dali, among others. In a nationwide sweep on at least two criminal rings distributing fake prints, the police found that in some instances, more than $4,000 had been paid on fakes worth only a few dollars at most.

The police investigation involved simultaneous raids on art galleries in more than ten American states and was coordinated by the New York City Police art fraud department. The Dali fraud alone is estimated to have involved nearly a billion dollars and tens of thousands of prints, many sold by mail order.

Despite the success of the investigation, like so many involving fakery, it has been hampered by the refusal of some collectors to cooperate, presumably because of a reluctance to admit they might have been cheated.

in close association with the artist. He or she may either do the printing itself, or exercise some tangible supervision of the process. A disputable exception occurs if the artist is dead and his or her heirs or executors authorize a posthumous edition, but this also must be executed according to strict controls.

Prints need to be in pristine condition to fetch top prices. Buyers should also be sure that any hand-coloring is authentically of the same period as the print—as in this case of a Sheldrake medicinal herb subject—and not added later.

Focus on Quality

Prints are being faked on an enormous scale by means of a variety of techniques. Always look for quality—in the paper, the inks used, and the way in which the print has been pulled. Does it reflect careful craftsmanship or mass production by machine?

Even the white space around the print is a clue to value. A quality print will be positioned in paper of size and proportions that enhance it, with enough "breathing space" to set it off to best advantage.

The most expensive prints are reproduced on genuinely old paper that passes the watermark and other tests described in the chapter discussing forged documents. In particular, the best work tends to be done on high-quality handmade rag paper, not on wood-pulp paper, that only came into use early in the 1800s. The fibers of genuine old handmade paper tend to be longer than in modern examples and very distinctive from those found in machine-made wood or fabric pulp paper. (See Chapter 9 for further tips on identifying paper.)

The object when producing handmade rag paper was to do so very carefully and get an excellent, even surface. Contemporary fakers using the old techniques often do not display the same skills obvious in the old prints, or they may deliberately incorporate imperfections to reinforce the fact that the paper is handmade.

Never be fooled into thinking small staining or other defects *don't* substantially affect the value of a print. It is crucial that a print be in good condition if it is to hold its value. The mounting and framing are particularly important; a print should never be stuck directly to the mat or backing board and acid-free materials must be used.

It is a good sign if a print has been properly mounted and framed using special hinges of paper or linen (and the print fastened at the top only) so that it can expand or shrink freely with the effects of temperature and humidity. However, an elaborate forgery would be presented professionally to help pass it off, so the correct mounting and framing methods are not by any means a surefire guide to authenticity.

The Truth About Limited Editions

The loudest, most strident publicity often accompanies the most suspect collectibles in an attempt to give them credibility. Be particularly suspicious of the massive publicity machines try-

ing to inflate the values of contemporary "limited edition" collectibles of all kinds, few of which have any chance of showing significant appreciation in value for a very long time, if at all.

Beware, for instance, of signed limited-edition prints that are actually only limited by market demand. Salvador Dali is reputed to have signed hundreds of sheets of blank paper to be used in running off extra copies of a profitable print. At least those had genuine Dali signatures on them and have greater authenticity than the complete fakes (including forged signatures) of works by Dali and Picasso that have changed hands for millions of dollars in total.

In theory, a limited-edition print is run off under very strict supervision, but controls over limited-edition prints actually vary widely. Unfortunately, many are not as strict as those in New York, for instance, where both artist and printer must make signed declarations of the title and date of the print, the size of the edition, how it has been numbered, and so on.

Generally, a limited edition should carry the artist's signature along with two numbers: 25/100, for example. The second number is the total of prints produced; the first, the number given to that particular print. Following the printing, the plates are supposed to be destroyed or at least defaced to prevent further use. Even if they are, the picture can be reproduced cleverly in many different ways as the demand for it grows. For example, if the original stones or plates are only defaced, the defacement is sometimes insufficient, and the original printing medium can be reused after treatment to restore it.

Some printing processes, such as silkscreening or any of several methods of photo and litho reproduction, are revealed by their texture and the presence of small dots that show up under magnification. Never hesitate to take out a magnifying glass to analyze these factors on any suspect print and compare them to the results you should get for the method used to produce the original limited edition. Polarized light, for example, accentuates such features as the irregular depth of etching on a genuine print from a hand-etched plate.

Close examination of the color boundaries of a print indicates what process has been used to reproduce the colors. In some cases there is distinctive merging of the colors, and in others, they are more clearly defined.

The quality of the colors also gives important clues to a print's value. In particular, examine the depth of black and darkly colored areas. The physical thickness (the actual degree to which it extends above the surface of the paper) of the color indicates whether the print comes from a limited handmade run or a long machine run, which is characterized by a much thinner layer.

Watch out for *counterproofs* of original prints: etchings and engravings that can be taken quite easily by dampening the surface of the original with water or an appropriate chemical solution, putting it in a press with a dampened sheet of copying paper, and getting a reversed second image on the blank sheet. Such prints may require further work to make them realistic, but they can fool the inexperienced buyer, especially when they are on authentic-looking paper (of the period in which the original was made) that has been enhanced by the presence of faked watermarks.

CHAPTER
nine
MANU
SCRIPTS
AND
OTHER
DOCUMENTS

Manuscripts and Other Documents

Forgers have been at work throughout the history of the written word. Like their cousins in other areas of fakery, they resort to some rather bizarre methods in practicing their art. One of their oldest tricks, for example, is to hard-boil an egg, take off both the shell and the inner membrane, and then roll the egg gently over the signature to be copied. Ideally, the egg picks up enough ink to transfer a light image of the signature to another piece of paper, which can then be retraced to create a convincing copy. It is not the easiest or most practical way to reproduce manuscripts, but it does suggest the measure of creativity with which these fakers approach their tasks.

Experts can identify the type of ink used and the probable date of authenticity of a document by analyzing an ink sample using a microscope and various chemicals. The amateur collector, to whom these methods may not be available, has to become familiar with the inks, papers, and pens used for the kinds of manuscripts that most interest him or her, thus getting a feel for the genuine article in order to identify the fakes almost by instinct.

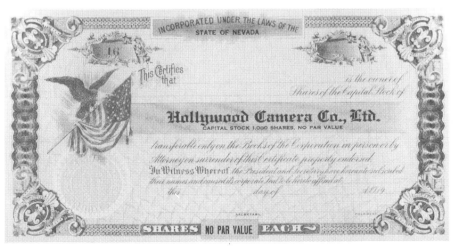

Old stock certificates and bonds are becoming very collectible and are easy to fake.

Just a basic study of their specialty will be of great help to collectors of old railway and confederate bonds who wish to avoid buying phoneys.

Four often-forged signatures: Theodore Roosevelt, Paul Cézanne, French King Louis XVI, and Napoléon Bonaparte.

Pens

With the invention of the pen, writing became a widespread means of communicating, and the use of forgery to alter that communication followed soon after. In fact, some of the metal pens found in the ruins of Pompeii were used for fraudulent purposes.

Knowing the chronology of the development of writing instruments is some help in dating manuscripts and helping to identify forgeries. Autographs of any American President or European statesman written in ballpoint and dated pre–World War II should be obvious fakes, for instance, but some forgers have managed to dump them on very naive buyers.

Material written with a nib pen is much more difficult to forge than that written in ballpoint.

Reed pens were the most common writing instrument until the seventh century, when goose quills replaced them in popularity and reigned supreme until the nineteenth century. Individual writers cut and sharpened their own quills to get the point most suited to their particular writing styles. Consequently, it is difficult to achieve really good forgeries of writings bearing all the individual characteristics that emerge in the strokes of a quill pen.

The quill is much more flexible than the typical metal nib, so the strokes it makes tend to be broader and smoother. While the writer occasionally may have dug the tip of the quill into the paper, such surface marks are very different from the clear indentations of the metal nib—the twin points that engrave a kind of furrow into which the ink flows.

Metal nibs were introduced in Europe in the middle of the eighteenth century, but they were very expensive and too stiff to use comfortably until the start of the nineteenth century when the designs improved and the cost fell with volume production. The first American fountain pen, a Waterman, came onto the market in 1884, by which time forgers were busy all over the world with their dip metal pens and inkwells.

The arrival of the fountain pen was a bit of a problem for them because it again made handwriting more individual. Instead of just reproducing a typical script in ink, they had to copy the distinctive markings that evolved when a fountain pen was used constantly by one individual.

The principle of the ballpoint pen was developed during the latter part of the nineteenth century. Had forgers known how much easier it makes faking handwriting and signatures, they probably would have tried to stimulate its popularity somehow. But the ballpoint just did not catch on until the U.S. Army took it to war in 1944 and popularized it into the universal writing instrument of the twentieth century.

The modern form of the felt—or fiber—tip arrived in the 1950s and has been a further boon to contemporary forgers because it does not give such distinctive characteristics to handwriting as do nib pens.

Inks

Ink came into being 40 centuries ago, developed from the natural dyes with which our early ancestors wrote. (Pencils have also been used for hundreds of years, but because of the impermanence of marks made by lead or graphite, and the ease with which they can be altered, you are unlikely to encounter important collectible manuscripts in pencil.) The host of different types of ink used over the years provides some of the best clues available for dating a document or signature and therefore, for revealing forgeries.

Forgers often make a critical mistake in trying to give that faded, brown look to the writing on old documents. In fact, the earliest inks—made from natural carbonized substances—were very black and did not deteriorate much in coloration. That is not the case with ink made from gall nuts and iron salts, which was invented during

the eleventh century and in popular use until the beginning of this century.

Iron-gall ink fades to a brown color that is difficult to fake, although there are some good imitations—including forgeries of Lincoln's signature—made by mixing ink with iron rust. This was the ingenious approach taken by master forger Joseph Cosey, who flourished during the 1930s. Many of his fakes of the Civil War period have gone undetected because he used a carefully blended mixture of rusty iron filings in over-the-counter Waterman's brown ink to match the iron-gall ink used in those days.

Tobacco and licorice juice are two other substances used to try to reproduce faded writing. In addition, a number of forgeries now in circulation were written in contemporary brown ink, which you can buy in a stationery shop, and they are especially easy to spot once you have acquired some experience in ink identification.

Genuine iron-gall ink is richer and browner, without the reddish tinge and anemic appearance of many forgeries. It attacked the paper on which it was used quite viciously. In many cases, the acid contained in the ink sometimes burned holes right through it. Forgers attempt to recreate the acid-ink burn marks, but it is very difficult to do so realistically.

Aniline inks, which arrived after 1860, are water-soluble and much kinder to paper.

Because of its uniform dense black appearance, which at first glance greatly resembles that of printing ink, India ink is often used by forgers to simulate or change printed matter. Check for this possibility by twisting the paper so that the light strikes it at different angles. This should help you distinguish the shiny surface of India ink from the matte finish of printing inks.

Another very black ink was made from gunpowder, and figures in a number of collectible Civil War documents.

Always look carefully at the consistency of the ink's appearance within a single document. Changes in the color of the ink are obvious clues that writing has been added since the document was originated. In a forgery on old paper—a popular technique—the ink tends to run more than if the writing, ink, and paper had all come together at about the same time. The extra absorption, discernible in the feathery look of the edges of the pen strokes, is seen most clearly where the ink runs into the dust that inevitably attaches itself to the surface of old paper over the years.

A very easy way to figure out whether fresh writing has been added to paper since it was folded is to check the way the ink has absorbed into the area of the fold where the paper fibers have been disturbed. Often the movement of the nib will have been interrupted momentarily as it crossed the fold, causing obvious deviations in the way that the ink is laid down on the paper.

Typewriters

Forgers were not slow to exploit the typewriter once it became a practical proposition. This was in the latter part of the nineteenth century, the first example in volume production being the Remington of 1874. Mark Twain bought one and wrote *The Adventures of Tom Sawyer* on it.

Typewriters have evolved since then in both their efficiency and the style of typefaces used. Anything written on a typewriter has a distinctive identity, like a fingerprint, so the best

A Tale of Forgers and the Story of a Faker

Appropriately, forger Clifford Irving was fascinated enough by the business of fakery to write about it. Fake! The Story of Elmyr de Hory, The Greatest Art Forger of Our Time *enjoyed a modest success with its vivid descriptions of Picassos and Renoirs being produced around the world by a talented Hungarian refugee. But the publishers withdrew it after a libel action was initiated by de Hory's partner, Fernand Legros.*

(A far more entertaining tale of a master art forger is Anne-Marie Stein's Three Picassos Before Breakfast—*published in New York by Hawthorn Books—about the exploits of the author's husband, David Stein. This man, whose phenomenal talent rivaled that of Britain's Tom Keating, took American art collectors for a long and expensive ride before Marc Chagall exposed him. Much of his work in the style of master artists is still undetected.)*

Irving got into much more trouble when examples of Howard Hughes's handwriting in Life *magazine inspired him to try to produce a fake autobiography. He nearly got away with it for a time, but ended up serving 17 months in jail for defrauding publisher McGraw-Hill in a scam that could have grossed millions of dollars. Irving subsequently found his true métier as a novelist, using his obvious talent for writing fiction.*

Although it attracted enormous publicity in the United States, Irving's attempt to fake an autobiography of Howard Hughes was one of several, and does not really rank as the most celebrated forgery of an autobiography during the twentieth century. That dubious distinction would have to go to the fake Hitler Diaries that surfaced in 1983.

When Germany's Stern *magazine and Rupert Murdoch's* News International *paid out $2.4 million between them for a group of documents purportedly written by Hitler, publishers scrambled to throw money at what promised to be the scoop of the century. They should have known better, as Murdoch's* Sunday Times *had already experienced problems in 1967 with fake Mussolini diaries.*

The Hitler diaries were shown to be forged the moment they were subjected to serious scientific examination. The paper, bindings, and glue holding them together clearly dated from after the war, so Hitler could not possibly have produced them.

If that case had not been revealed as an outrageous forgery attempt, the consequences would have been far more serious than just the loss of a great deal of money. The diaries attempted to rewrite history, whitewashing some of the worst aspects of Nazism and making Hitler appear to be a normal human being.

Treasured books are faked in many ways, with many apparently genuine first editions having faked bindings and reproduced title pages and frontispieces. One first-edition forger was found out when he put wormholes on a fake page, but not on those preceding and following it—no worm is thin enough to have eaten his way through just a single page!

way of verifying typewritten documents is to make a comparison of the suspect material to an authenticated document from the same source.

While it may be impossible to fake a document so that it can be claimed convincingly that it was typed on Mark Twain's machine, there have been so many typewriters around for so long, it is comparatively easy to find a well-preserved ancient typewriter, use it to type a phoney text on genuinely old paper, add a fake signature, and pass it off successfully.

Paper

The history of paper and other writing materials also reveals information pertinent to the authentication of certain documents.

The early Greeks and Romans wrote on papyrus, made from a latticework of reeds soaked in water and hammered until the fibers blended together to produce a suitable writing surface. Papyrus can be made today following exactly the same process used by the ancient Egyptians, and their writing reproduced using traditional reed pens and old ink recipes. In turn, such a document can be aged artificially in a number of ways.

However, I have not uncovered much evidence of this being done at present, at least not with the deliberate intention to defraud. A fake papyrus document would have to be put into the market at a very high price and with a detailed history in order for it to be credible, and it would inevitably come under very close scrutiny by experts armed with a battery of sophisticated testing equipment. Basically, then, the challenge of getting away with such a fake would deter even the most enterprising forger today, although several are said to have succeeded before such sophisticated testing equipment became available.

Most fakes are on paper, the universal writing material invented by the Chinese, but unknown to the rest of the world until the eighth century when an Arab army captured a group of Chinese papermakers. The Arabs knew they had found a good thing and, despite the fact that industrial espionage was already a lucrative calling in those days, kept the secret of papermaking from the Europeans until the twelfth century.

There was so much illiteracy in earlier times that, although papermaking rapidly became an important activity in continental Europe, it did not spread to England on any scale until the sixteenth century. In North America, it was 1690 before the first mill opened at Germantown, Pennsylvania.

Since its inception, an enormous variety of vegetable fibers have been used to make paper, the most successful being those from linen rags beaten into a wet pulp. The actual sheets of paper come from thin layers of the pulp, formed atop a wire mesh that allows the water to drain away. Early papermakers designed their own brand mark and incorporated it into the mesh, thus creating the first watermarks.

Laid paper is early handmade paper which shows distinctive longitudinal marks that formed as the pulp lay on top of the wires. Papermakers switched to woven wire late in the eighteenth century, and the grid pattern formed by this wire identifies *wove* paper.

Rag paper was—and still is—very expensive. Anything on watermarked rag paper that is dated before the appearance of machine-made paper (at the start of the nineteenth century) is both collectible and a likely target for fakers. The 1826 invention of the dandy roll, used to emboss watermarks, contributed to the ease with which such copies could be generated, as less expensive, machine-made paper was given the watermarks formerly seen only on fine rag paper.

To spot such deceits, you need to examine the paper under magnification, which should allow you to see whether the watermark has been pressed into one side of the wet paper by the dandy roll. The other side will show just the diamond-shaped marks made by the wire mesh used in the papermaking machine. The mesh was stretched very tightly in the old papermaking machines, distorting the wires into this diamond pattern, whereas handmade papers have a square grid wire pattern which is quite distinctive.

At about the same time that papermaking machinery appeared, less expensive vegetable fibers began to replace rag, with wood coming to dominate once economical ways to convert it to pulp were developed.

As papermaking processes were taking shape, important documents continued to be produced on a traditional and very tough writing surface: animal skins. The two main types—*vellum,* made from calfskin, and *parchment,* from the split skins of goats or, more often, sheep—can be quite difficult to distinguish from each other.

Most modern parchment comes from Australian sheep. Contemporary vellum is very expensive and used only for the most important documents. The surface quality of both is very good, but in olden times, the animals' skins frequently had defects caused by insects or physical damage inflicted while the animal was alive or during careless handling of the hide after

Foiled Again

A dealer called Shapira attempted to perpetrate the sale of one of the most famous forgeries of all time—the fake manuscript of the Book of Deuteronomy—to the British Museum. His sales presentation included elaborate stories about how the document was found in a cave and written on strips of skin supposedly 2000 years old.

The Museum's experts were not fooled. Not only did they discover errors in the text; they also found that the strips of skin were actually cut from the margins of Jewish synagogue rolls.

Shapira subsequently shot himself in a Rotterdam hotel room, leaving authorities with the mystery of whether he was a crook himself, or simply the victim of an elaborate hoax that would have netted the forgers millions if it had succeeded.

slaughter. Scribes who drew up common documents became skilled at writing around holes and other defects.

In contrast, the medium used for important documents would generally be in good condition. So if you come across an example which has holes and dirt marks that the writer was forced to avoid, this is a good clue that the work is a recent forgery on an old or artificially aged vellum.

Paper, parchment, and vellum can be aged artificially quite easily, and all forgers have their own special brews and techniques for doing so. A weak tea solution can render a uniform brown tint. Licorice, tobacco juice, coffee, certain leaves and nut husks, and some kinds of soil have a similar effect.

Common Sense Can Be More Revealing than Science

Some forgeries beat the scientific tests, but still may be unmasked by scholarly analysis—or just plain common sense.

Typical is the controversial Vinland Map, originally dated as early as the ninth century. When this map emerged during the 1960s, it was believed to cast new light on the early Scandinavian voyages of discovery to North America.

It subsequently failed a scientific test for authenticity when the ink with which it was drawn was found to contain a comparatively modern component of ink—titanium oxide. In 1987, however, more advanced techniques of testing showed no evidence of titanium, thus raising new questions about whether the Vinland Map might be genuine.

Still, scholars looking at the map believe the early Scandinavian explorers could never have circumnavigated Greenland and drawn it as an island; neither do they believe the explorers could have known the details of the North American coast that the map depicts.

So it is that forgers are often just too clever for their own good.

Old maps, which look so good on office and home walls, are forgers' favorites.

These substances are applied frequently to old maps, which fakers (and some buyers) seem to associate with browned paper and other damage—such as burns, wine stains, and candle wax—as if they have been pored over during the midnight watch by ancient mariners.

In fact, many of the "antique" maps on sale are modern reproductions given a rapid aging before being placed in a truly old or artificially aged frame. A few fly spots here and there and a bit of rough treatment can soon add a hundred years to the proposed age—and several hundreds (or thousands) of dollars to the price—of a map. Cigarette ash is one popular medium for adding in five minutes the appearance of many years' worth of slowly accumulated grime.

The size of the paper used is another clue to a forgery of a collectible manuscript. Different standards of paper dimensions have been maintained at different times and in different places. Europeans and much of the rest of the world have standardized metric dimensions, while Americans retain imperial measurements. So a letter purporting to emanate from the U.S., yet written on metric standard A4 paper is almost certainly a forgery.

Be particularly suspicious of a document that appears to have been cut down from a standard size—it may have been doctored in a variety of ways.

Text that does not fit properly on the page is another hint of forgery. For example, the signature may be very cramped in at the bottom, suggesting that a valuable autograph has been added as a forgery.

Framing

One of the best ways to frame an old document is between two sheets of glass so that both the front and back sides can be seen. However, as many old maps and other collectible documents are sold with frames for viewing one side only, fakers frequently do not pay enough attention to the hidden, reverse side of the paper. If you're paying a good bit of money for a suspect document in a conventional frame, ask for the frame to be opened so that you can see the reverse side, and insist on a certificate of authenticity.

In fact, the forger may have forgotten the reverse altogether, or may have made an obvious mistake. For example, letters from the earlier part of the nineteenth century were not mailed in envelopes, so they should feature the address on the reverse in one of the panels formed when the letter was folded and sealed to form a self-mailer. But even this is not a sure test, since before envelopes became popular, letters were frequently put inside a sheet of paper folded around to form a separate mailing cover.

Detailed Analyses

Authenticating autographs and handwriting is extremely difficult without the appropriate equipment and a detailed knowledge of the subject. Experts use comparison microscopes in order to examine a genuine signature or sample of writing against a suspected forgery. An alternative is the epidiascope (or opaque projector), which produces an enlarged image on a screen.

A good magnifying glass or loupe such as this makes identifying fake manuscripts much easier.

In addition, special measuring gauges enable comparisons of the size of handwritten characters to be made. We all tend to write consistently, forming our letters to a certain size, irrespective of the size of paper we are using. This tendency has contributed to the discovery of some famous fakes in which the forged writing was the wrong size.

One handwriting expert told me that handwriting is a direct representation of an individual's brain processes, like the mechanical pens which trace brain scan patterns in hospitals. Indeed, a detailed comparison of a genuine example to a forged example shows up the myriad ways in which handwriting is so difficult to duplicate. The ways in which a writer forms the loops of letters are usually consistent and distinctive. Each person also tends to put the pen to the paper (and remove it) in a unique fashion, starting or ending a

stroke positively and abruptly or in a gentler, tapering style. The way letters are joined together varies a great deal from one writer to another, as does the positioning of the dot over an *i* or a *j,* and the manner in which a *t* is crossed. Each writer's capital *E* usually has a singular look, and there is even a definite style in the spacing between words, lines, and paragraphs.

In addition to having trouble capturing all these idiosyncrasies, the forger is concentrating so hard on reproducing somebody else's style that there is generally a loss of the smoothness and informal fluidity of natural writing. In fact, a lack of the spontaneity evident in natural writing even shows up if the forgery has been traced from an original.

Still, while a trained eye can find evidence of tracing in a full letter or other document, it is difficult to detect when it has been used in a signature alone. That is why a clipped signature that is not part of a letter or other document should be regarded with great suspicion. Beware of signatures made by automatic pens. Movie stars and most presidents since Kennedy have used them. They produce absolutely identical signatures every time.

One additional note: Not all document-related fraud actually involves forgery. For example, documents purporting to be signed by George III in his later, disturbed years (after 1789) need to be viewed with suspicion. Much of the paperwork that normally would have been signed by the monarch, actually was signed on his behalf by his son or court officials. In some cases, this may increase their collectibility, but they would not necessarily have the value of an authentic royal autograph.

CHAPTER TEN

ARCHAEOLOGICAL FINDINGS

Archaeological Findings

Fakery is practiced with almost all kinds of museum-worthy archaeological treasures, whether it's bone fragments, or artifacts such as sculpture and pottery. A German doctor even faked an ancient Egyptian mummy, embalming the corpse of a young girl which he then passed off as the mummified remains of Queen Nitokris. He was a rather sloppy faker, caught in the act when his handiwork began to smell very strongly.

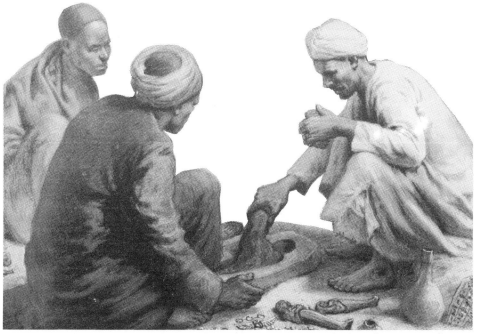

The forging of antiquities was going on long before Norman Hardy drew this picture of Egyptian fakers, published in the Illustrated London News *in 1913. "The chief of the makers of bogus curios was very proud of his work and quite pleased to show me examples of it," reported Mr. Hardy. "He made all sorts of Egyptian antiquities, breaking them so that, when mended, they would look like old things just found. At night he could be seen burning the fires used for the melting, from bits of ancient necklaces, of old blue glaze, which was then put on the forged figures, amulets, scarabs, pectorals and other articles designed to be sold to unsuspecting tourists."*

Ethnic artworks are highly subject to fakery. All over Africa you can find traditional handcarvings being buried for a few weeks to be attacked by acids and alkalines in the soil, which gives them a quick patina of age that is only skin deep. Look for signs of new cracking, which will reveal the shallowness of the discoloration of the wood from artificial aging.

The Fake Castle Was an Emperor's Playhouse

While there is a lot of phoniness about the famous castle built in California by eccentric publishing tycoon William Randolph Hearst, and while Disneyland's castles are undisguised fantasy recreations, they must surrender all claims as the world's largest fake castles to the Franzenburg Castle near Vienna, Austria.

Franzenburg, completed in 1836 for Emperor Franz I, is a completely phoney medieval fortress, torture chamber included. Even the lake and island upon which it sits are artificial. Emperor Franz had two monastries dissolved to yield authentic building materials for Franzenberg, which is a copy of a real castle that existed during the fourteenth century. The lavishly furnished 27-room reproduction is, for all its imitation, nevertheless decorated with many genuine items.

You can still find similar (but smaller) architectural fantasies on the grounds of large British country homes. The eccentric English gentry used to copy all kinds of structures to create "follies" to add interest to their property.

A collection of fake artifacts on sale to tourists at the ancient site of the Greek city of Ephesus, in Turkey. The coins are aged by putting them in buckets and then lowering them into the local sewer for a few weeks.

There is a hidden danger in this kind of archaeological faking that is not readily apparent, but is damaging society's ability to know and understand the ways in which our forebears lived and thought.

By careful study of the artworks of past generations, we acquire an enormous amount of knowledge about both the practical and the subtler intellectual influences existing in bygone times. Historians maintain that it is only by understanding past generations that we effectively develop our own contemporary society.

This ongoing historical detective work is seriously complicated by the large number of fraudulent antiquities appearing on the market. While an authentic piece can provide valuable clues about the society that created and prized it enough to ensure its preservation, a counterfeit provides all kinds of false trails.

For example, a faker working today on an ancient Greek statue may unconsciously include elements that reflect contemporary life, but are completely false to ancient Greek society. Often, because the experts doing appraisals are exposed to those same contemporary influences, they do not spot them. That is why something accepted as genuine two or three decades ago by the experts functioning then will be rejected by those operating today, who have been subjected to different influences in their thinking and evaluations of style.

Serious moral issues are raised when curators and scholars stall and do not readily admit being taken in by fakes. While they are protecting their positions, they are also contributing to a distortion of history. Their secrecy is aggravated by the fact that many antiquities have made their way into collections as a result of illicit excavations

Ethnic carvings often appear at swap meets, but are almost invariably modern works of poor artistic quality and little value.

Faking the Parthenon

Even ancient Greek buildings such as the Parthenon are becoming significantly phoney as they are heavily restored and reconstructed. Parthenon restorers will eventually replace some 2000 pieces of masonry, using new blocks cut from ancient quarries to fill in the gaps.

"We have the information to accurately reconstruct the whole temple, but that would be creating a new Parthenon," said Mr. Manolis Korres, the architect in charge of restoring the Acropolis site, visited by 10,000 tourists every day. "Deciding how much restoration to do raises philosophical and aesthetic problems."

In other words, the world's most famous archaeological site could itself become predominantly "faked."

In this picture, the dark areas of the columns are reconstructions that eventually will blend in with the genuine ancient masonry.

The World's Only Fake Loo

The world's only fake public lavatory is to be found at Ephesus, in Turkey, founded in 1300 B.C. and once at the center of all international trade routes. It is an incredible archaeological site well worth a visit—and near the genuine ruins is an impressive open-air market selling a wide variety of fake artifacts.

There is such a wealth of material being excavated that restoration of the city's buildings can be achieved with remarkably little faking. However, reinforced concrete has been used to rebuild the seat tops over the spring water sewer in this public lavatory dating from the Roman period some 2000 years ago.

Concrete may not be as aesthetically appealing, but it does have certain practical advantages over the original marble, maintained my guide. He kept a perfectly straight face when he described how, in cold weather, Romans who felt a call of nature coming on would send a slave into the lavatory to sit on the marble

Faking in the Lavatory at Ephesus

for a few minutes and warm it up before the master's arrival.

Some of the tourists visiting Ephesus actually believe that story and so flock outside to buy coins, statuettes, and relics that the vendors claim are as ancient as the city itself. In reality, they are newer than the bottled Coke sold next to them. The fakers supplying the Ephesus tourist trade have found a fast and convenient way of adding the corrosion and patina of age to their forgeries by dunking them for a week or two in the local sewers and cesspits.

and export from their countries of origin: If a museum says too much about the provenance of some of its exhibits, it might be forced to give them back.

Piltdown Man: The World's Most Famous Fake

The world's most famous fake demonstrates how easy it is to fool even the experts with an indifferent forgery. The Piltdown Skull, purporting to be that of the earliest known inhabitant of ancient Britain, deceived scientists for more than 60 years—and there are still arguments about it today.

Although now it is clear that Piltdown Man was actually an elaborate pastiche of deception involving an orangutan's jaw deliberately broken and aged, coupled with a similarily faked human skull, hundreds of learned scientists' papers, special debates, and elaborate tests failed to perceive the fraud.

Two reconstructions of the Piltdown Skull fragments showing how two different experts can produce such widely conflicting interpretations from the same physical evidence. Both were made in 1913, when the Piltdown controversy was raging fiercely, and published by the Illustrated London News. *The one on the left, by Smith-Woodward, assumes a brain capacity of 1070 cubic centimeters; the other, by Smith-Woodward's rival, Professor Arthur Keith, uses the same bone fragments to produce a skull reconstruction with a manlike jaw and a brain capacity of 1500 cubic centimeters.*

Even the British Government was taken in, which led to its making the Piltdown site in Sussex a national monument. A memorial was erected there to honor Charles Dawson, one of the leading archaeologists involved in the plot.

It was in 1908 that attorney and archaeologist Charles Dawson claimed he had found a portion of an ancient human skull in a Sussex gravel pit at Piltdown. Over the next few years, other fragments appearing to belong to the same ancient Briton were unearthed, including a jawbone with two teeth, found by anthropologist Sir Arthur Smith-Woodward. Both men claimed the fragments were as much as half-a-million years old.

Work on the theory of human evolution was thrown into confusion by Piltdown Man as reconstructions of the head of this first-known Englishman were made by learned professors and leading museums. All of them used the various bits and supplied their ideas of missing pieces of the skull jigsaw to support their own theories.

Because a workman's pick had conveniently broken off a piece of the skull, there was quite a margin for error and differences of opinion. This break made it impossible to judge accurately whether the skull was big enough to contain the more developed brain of a man, or the much smaller brain of a member of a lower species, such as an ape.

That same pickaxe also broke off crucial portions of the jawbone, making it difficult to identify whether it was actually part of the skull to which it was claimed to belong, and even whether it was human at all.

Two key elements of fraud in the Piltdown case are recurrent in any deceit of this nature. First of all, an important find—a picture by a famous painter, an archaeological rarity, or whatever—creates great excitement. It is only human nature to try to make the known facts support authenticity, and for experts to want a share of the attention. The fact that the scholars and experts involved in this case were especially preoccupied with bitter rivalries and lust for publicity and glory contributed a great deal to the initial acceptance of the Piltdown Man fake and to the fact that it remained masked for so long.

Secondly, some of the fragments of the Piltdown Skull were found a mile or more apart, and that alone should have raised far more doubt about its credibility than it did at the time. Also, the damage done by the pick and the absence of just those pieces that would enable authenticity to be proven illustrates how fakers often exploit the ravages of time to baffle the experts.

Only when the skull was tested for fluorine content nearly half a century after it was discovered by Charles Dawson was it proven beyond doubt that, far from being hundreds of thousands of years old, it was comparatively recent. The drill used to take a sample produced the characteristic smell of comparatively recent bone (described in the section on fake ivory,

Chapter 14). Further, the jawbone was proven to be an artificially aged sample taken from an ape. Just a simple investigation at the time of the Piltdown Man discovery would have shown that the stain used for aging did not penetrate below the surface as it would have done had the find been genuine.

Instead, the debate concerning Piltdown Man raged on and still is not resolved completely. It seems that Dawson was the prime mover, motivated to seek publicity for himself. He collaborated with an Oxford geology professor, William Sollas, who was involved in a long-running personal feud with Sir Arthur Smith-Woodward and wanted to embarrass him.

A spin-off from the hoax perpetuated on Smith-Woodward was his publication of a learned paper about engravings on an ancient bone that had, in fact, been doctored by two schoolboys and intended as part of a prank on their science master. Sollas knew about this, but allowed Woodward Smith to go ahead with his publication and then, later, discredited him.

How Looting and Fakery Intertwine

The looting of archaeological treasures from the Mediterranean region and other areas of historic sites around the world provides an ideal cover for the passing of many fake artifacts.

Under the cover of looting, fakers peddle archaeological phonies as legitimate—to buyers who are restricted by conditions of secrecy. In turn, the buyers dare not refer the fakers or their phonies to responsible experts or use the sophisticated authenticity-testing facilities of the major museums. By telling a buyer that a collectible was

One Reason Why Fakes Prosper

If Piltdown Man had not provided such good press copy, it wouldn't have gotten the media attention over the years that turned it into a public issue and thus resulted in the fraud being exposed. Fortunately, Piltdown Man was not allowed to become a subject for cozy debate within the scientific community.

In more recent times, media investigations have revealed the existence of other fakes and the scale on which such deceit is taking place. Still, the exposed charlatans represent the mere tip of the iceberg of faking because the different trades involved are close-knit, resisting any investigation that will undermine their credibility and profits.

For example, it took a courageous editor, William Rees Mogg of the London Times, to defy threats of lawsuits and publish extensive details about the activities of fakes painter Tom Keating in perhaps the most important exposé of art frauds ever.

Few art correspondents follow the example of Geraldine Norman and the editors at the Times, investigating and exposing the problems that abound within the field. Often they are too close to the commercial side of their beat, in the same way that few wine writers really criticize bad vintages, or restaurant review-

SEEKING REMAINS OF THE OLDEST KNOWN ENGLISHMAN: LOOKING FOR RELICS OF THE SUSSEX MAN

AFTER THE BRINGING TO LIGHT OF THAT REMARKABLE "FIND," THE JAW OF THE SUSSEX MAN: MR. CHARLES DAWSON AND DR. A. SMITH WOODWARD SEARCHING FOR OTHER PARTS OF THE SKELETON ON THE SITE OF THE FIRST DISCOVERY

The Illustrated London News paid tribute in 1913 to the "discovery" of the earliest known Englishman at Piltdown in Sussex.

132

ers, the rotten meals they inevitably encounter (especially if the restaurants advertise in their publications). In general, all who are involved with the art and antiques business, like the archaeologists affected by the Piltdown fraud, are resistant to publicity that challenges their expertise and "trade" practices.

Geraldine Norman wrote of the circumspection, hypersensitivity, and lack of cooperation with which art dealers greeted her questions.

"Considering the substantial area of doubt in the attribution of paintings over 100 years old, it is significant how seldom you come across pictures other than firmly attributed in commercial galleries," Ms. Norman says in the classic story of master faker Tom Keating, The Fake's Progress (coauthored by Geraldine Norman, Frank Norman, and Tom Keating; London: Hutchinson & Co. Ltd., 1977.)

"There is a universal distaste at publicity concerning such matters," she says. "Really knowledgeable dealers or auction experts are still rare birds, though there may be a few more of them around than there were 30 years ago. Moreover, if you scratch the surface of the art trade, you still find the same range of fiddles and questionable practices."

Ms. Norman's criticisms of the defensive attitude of members of the art trade and their unwillingness to pry into each other's affairs applies throughout all areas of collecting.

If you find it difficult to believe that experts and dealers are reluctant to publicize faking, look through any selection of normal books on collecting and see just how little, if any, attention is paid to faking. Often there is no reference at all to fakes in the indices of books claiming to give comprehensive information on particular areas of collecting, antiques, or art.

stolen, looted, or illegally exported, a faker avoids all kinds of potentially embarrassing questions about provenance and reduces the risk of a fake being exposed by expert opinion or scientific testing.

One particular problem claimed by the Greeks is systematic looting by the Turks of medieval treasures from the northern part of the island of Cyprus, an archaelogical paradise (with a history beginning more than 6000 years back) rich in treasures from the Egyptian, Assyrian, Roman, Persian, Venetian, and Ottoman occupations. The Turks occupied Cyprus in 1974 to prevent a plot by Cypriots of Greek origin to unite Cyprus with Greece. Subsequently, the Greek Ministry of Culture has repeatedly claimed—and the Turkish officials repeatedly denied—that hundreds of looted items from Cyprus are now on display in collections all over the world, and many more are traded secretly in the U.S. and Europe.

The original photograph of the earliest specimen of European printing when it was first discovered in Crete at the beginning of the century. This Minoan clay disc has been copied many times since, and attempts made to pass replicas off as the original.

In Ireland, original early-Christian gravestones are being removed from the reach of looters and put into the safety of museums. Irish masons have been sent to Germany to learn faking techniques so they can manufacture almost indistinguishable silicone rubber reproductions to put into the graveyards instead.

American Indian artisans in Utah have proposed to stop the looting of genuine Anasazi pottery by flooding the market with fakes.

A conference on looting at the University of Pennsylvania learned that helicopters, bulldozers, and armed guards are involved in a highly organized looting racket operating around the world. These criminal groups have rapidly reduced the number of genuine antiquities available, and are well-geared to supplement genuine supplies to a greedy market by offering sophisticated fakes.

The looting of archaeological sites has become such a public concern that actor Harrison Ford, who portrayed the fictional archaeologist/adventurer celebrated in the movie *Indiana Jones*, lent his support to a campaign effort to stop this multibillion-dollar illicit trade.

Very Old Fake Religious Relics

The faking of relics is actually an ancient craft stemming from a mass-production operation created during the eighth and ninth centuries to feed an insatiable demand for sacred religious relics. Even then, such fraud involved the clergy, just as some priests of the Greek Orthodox Church today paint icons that are artificially aged and distributed as being genuine.

In Rome, you can still buy pieces of wood that are claimed to be from the original Cross. Of course, so many fragments of the Cross have been sold since Christianity began that, if assembled together, they would probably stack higher than the twin towers of New York's World Trade Center.

Other frequently faked relics include tufts of beard and hair from Christ and various saints, fragments of the Manger, bits of leather purporting to come from Christ's sandals, and even drops of saintly blood in little flasks.

Special placement in the Topkapi Palace Museum in Istanbul is given to bones purporting to be from the hand and skull of John the Baptist. But there has been such an enormous trade in fake religious relics over the centuries that there must be serious doubts about the authenticity of even those in the most celebrated collections. They may be very old, but they could be very old fakes.

Controversy arises regularly over the authenticity of the Shroud of Turin, which many Catholics believe to be the actual burial cloth of Christ. Pathologists say the patterns of blood flow on the linen tie in so closely with what is known about Christ's wounds that they are probably beyond the anatomical knowledge of a medieval forger. Mr. Ian Wilson, who has written two books on the origins of the shroud, is convinced it is genuine.

As this book went to press, there was a new campaign raging to persuade the Pope to allow small fragments of the shroud to be subjected to Carbon-14 dating tests in seven specialist laboratories around the world. This would give a completely independent scientific judgment of the age of the famous relic in Turin Cathedral.

However, such tests could only give a rough estimate of the shroud's age and, should they estimate its age at around 2000 years, would only disprove the long-held belief by some researchers that the shroud was created by a medieval forger.

To prove (or disprove) the shroud's authenticity involves a battery of subjective judgments and objective scientific tests like those used to identify art fakes. Even then, because crucifixion used to be such a common method of executing both criminals and religious and political opponents, the results might not be conclusive.

CHAPTER ELEVEN

TRANSPORTATION RELATED ITEMS

Transport-Related Items

An International Web of Deceit

As I was researching this book, a national magazine commissioned me to do an article on investment cars—the kind that should increase in value after you have bought them, rather than depreciating rapidly whether or not you use them. These rare cars, in good condition, have become such a respectable investment category that Christie's and Sotheby's have leaped into the business, offering Rembrandts this week, Chevys the next.

It was a revelation to unearth the faking and forgery going on internationally in the collectible car business. The temptations are certainly there, with prices of investment cars running into the millions of dollars. For example, a 1981 Bugatti Royale sold in the U. S. in 1986 for $6.5 million, having been valued at less than $1 million six years previously. And the technical and entrepreneurial skills required for success with this kind of fraud is as impressive as the amount of money involved.

With the dollars flowing, the crooks are active in the collectible car business in a big way. Be warned that even if they have done nothing dishonest with the metal, wood, and leather, they could have pulled some really dastardly tricks with the logbook.

The web of deceit in the collectible car business stretches from Europe across the Atlantic, and through Africa to the Far East. Sophisticated organizations take expensive stolen cars from one country, forge documentation for them, and ship them vast distances across the world to unsuspecting foreign buyers.

Many wrecked cars—insurance write-offs left over from accidents—are being rebuilt and moved to new countries with new identities, their pasts reconstructed on paper as skillfully as the panel beater smooths out their dents. Sometimes the wreckage of two or three cars is blended together. There are experts in Europe who can take the rear half of one Porsche involved in a front-end collision and mate it to the front of another one that has been hit from the opposite direction. Bodywork specialists can do wonders with metal and glass fiber, turning even a rusty, dilapidated old car into a restoration so sleek, the inexperienced eye cannot see where the metalwork ends and the resin begins.

The SL sports-car range from Daimler-Benz is very collectible. Foreground: the 300 SL gull-wing door coupe and the roadster version (1954–1963). Background: (left to right) the 190 SL (1955–1963), the 230/250/280 SL (1963–1971), and one of the 107 series in production from 1971.

I have also heard of a few cases of faked modern reconstructions of chassis of valuable veteran and vintage cars being dumped in fields and farmyards in France and Germany so that they could be "discovered" and given a false provenance.

Less-than-careful investors are making bad buys both at auctions and in private deals. They purchase genuinely classic cars that have been "faked" to some extent, usually by restorations that conceal the use of non-standard parts and the ubiquitous fiberglass and resin filler.

Actually, there is a very simple test for distinguishing fiberglass from metal, which should prevent these unlucky purchases. A little pocket magnet can tell you where the metal stops and the resin begins. Some cars originally had body sections made of aluminum, which does not react to the magnet, but

in those cases, a tap with your knuckle can tell you audibly whether there is metal or resin under the gleaming paint.

To spot accident damage and extensive bodywork repairs, look carefully along body panels for signs of imperfections. Get your prospective purchase up on a hoist so that you can examine the underside for welds that should not be there.

The standard rule for spotting fakes and phonies—*beware of bargains*—applies equally to collectible cars. If you're at all suspicious that a prospective purchase is not what it purports to be, get a qualified engineer's evaluation. Beware of self-proclaimed experts whose limited knowledge can prove extremely dangerous.

Actually, the biggest risk of getting stuck with a fake in the car collecting business is not being deceived by

140

Replicas of old vehicles have become popular, but they have no real investment value and are identified easily.

something fraudulent about the vehicle itself, but by tampering with the documentation that goes with it. See Chapter 9, the discussion of manuscript fakes and forgeries, for help in spotting the more obvious deceits. Also, your local police station will give expert advice and assistance in checking the authenticity of a car, even if it cannot help much in other aspects of collecting. The registration department is also a source of free assistance.

Thousands of Faked Cars, from Ferraris to T-Birds

The manufacturers of fake cars call them replicas or look-alikes. When they are built and sold with the intention of deceiving anyone into thinking they are the real thing, however, they are both mechanical and visual frauds that every buyer should try to anticipate.

You are unlikely ever to buy a replica car by mistake (thinking it is an original), but it has happened. In such a case, the title documents would have to be forged, too, in order not to give the game away.

There are more than 200 corporations around the world building these imitators, and many times more backstreet operations that come and go with great rapidity. Their production numbers several thousand a month, making it possible for you to buy a fake Ferrari, Porsche, English or Italian sports car, Ford Thunderbird, or other classic models and marques for a fraction of the cost of the original. Some are great fun, but others, disastrous.

Some replicas broadcast that they are phoney long before you even get behind the wheel. Others, like the best of the Cobra replicas, can be difficult to identify if you are not familiar with the marque. In only a few cases is a replica made in metal with exactly duplicated trim and instrumentation. Most have fiberglass instead of sheet-metal bodywork, and their engines and transmissions are taken from another model. The most popular chassis and powertrain on which to base a replica has for many years been the Volkswagen Beetle, but there is a tendency now to create a special chassis and bolt onto it components from a number of the major manufacturers.

Look-alikes built by amateurs using kits in the home garage usually fall below proper production standards, but ironically can be more reliable (because of their use of standard mass-produced components) than the originals they mimic. They are usually faster as well, having lighter bodies and more powerful modern engines. This, and the fact that they don't offer much protection in accidents, makes replicas very difficult to insure.

Of course, no one would expect to pass off a complete replica car—a fiberglass MG TC sports car on a VW Beetle floor pan, for example—as an original. But there are naive buyers who think such replicas have investment value. They don't. With very few

Fakes with a Special Purpose

This famous boat-tailed Bentley is a complete fake from the wheels up. It was built for the screen version of Ian Fleming's children's story, Chitty-Chitty Bang-Bang, *in which it sprouts wings for the ultimate getaway motoring experience.*

The fake Bentley is based on a European Ford Zephyr. Among other giveaways, the external handbrake is actually the shift for the automatic transmission. But, unlike many fakes made for the movies and TV, it is very realistic, even at close quarters.

"Just after the car was built I was driving it along the Great West Road near London rather quickly when a police patrol pulled me

over," the Ford executive responsible for the project, Harry Calton, told me. "I expected to get a ticket, but the policeman only wanted to admire the car. He looked all round it,

A 1934 painted tin clockwork Aston Martin like this fetched $550 at the Sotheby's sale in New York, a good sign that toy prices are starting to reach the level at which the faking of collectible examples could become viable.

Old die-cast toys such as this Dinky Caravan are also increasing in value, but not yet subject to faking on a significant scale. Don't be put off too much by poor condition (if the price is right). Restoration can be easy and fun.

gave it a pat and said 'Pity they don't make them like this any more, sir!'"

Of course, one expects faking for cars used in show biz, but the practice of making phoney cars specifically for stock-car racing and other forms of motor sport as publicity vehicles comes close to being fraudulent.

When the regulations permit, these are specially built from completely nonstandard components, with the power trains and bodywork bearing no relation (except external appearance) to the production vehicles they mimic. The bodywork, for example, is usually in lightweight fiberglass resin and the engines are rebuilt to make them go faster. Even when the rules do specify original equipment, there is so much chicanery going on that stringent inspections are necessary to try to control cheating.

exceptions, they depreciate even faster than contemporary mass-produced automobiles. They may offer a lot of fun for your money, but do not expect them to bring profit from appreciation.

Model Cars

If you cannot afford collecting classic cars, you can get into the model-car collecting business for just a few dollars. But beware, for there are reproductions circulating in that arena also. With prices for rarities escalating, the temptation to create fakes is very strong, especially considering the resources and technology available.

Most collectible toy cars are made from die-cast metal, so it is the rarer and older examples of tin that are fetching top prices. Sotheby's auctioned a 1930s toy van in England for

$972, and even the mass-produced die-cast models that readers probably remember playing with as children often go now for hundreds of dollars.

You can still pick up restorable model vehicles with investment potential for very small sums in flea markets and garage sales. I paid less than $5 in 1986 for the 1950s British Dinky toy caravan in the picture. It looks a mess, but it is very easy (and great fun) to repaint chipped models like this and make them sparkling new again. Simply scrape off all the paint carefully, smooth the surfaces with fine wet-and-dry sandpaper or glass paper, and wash and dry the model. Then, repaint with the special enamel supplied by model shops, matching the original factory color as closely as possible.

Note that because model-car collecting has become so popular, many manufacturers are reissuing examples of their classic lines. These are identical in almost every respect to the originals, except the responsible manufacturers clearly imprint on the bottom information indicating recent production. The packaging is clearly contemporary, also.

However, it is very easy to distress these models (giving them an appearance of age) and then to sell them without the new packaging. If you are buying a model of a classic Bentley, Ford truck, Cadillac, Hispano-Suiza, or other like automobile, examine it closely for signs of genuine aging.

Art and Artifacts

Artwork and memorabilia associated with motoring and transport have been around almost as long as the car itself. The investment potential in this area is good, with values rising steadily for books, posters, paintings, advertising materials, and brochures, among other items.

A unique advertisement suggesting the diversity of available collectibles related to motoring and transport.

There is very little deliberate faking in this field as yet, but look carefully for reproductions, particularly of posters. At an autojumble auction in Britain in 1986, a brass fireman's helmet went for more than $600—almost as much as the fire engine. I presume it was genuine, but you can never be sure, especially since I also saw realistic copies of British policemen's helmets on a market stall in Hong Kong. I wonder how long it will be before they start turning up in antique shops, masquerading as the real thing.

There is a host of plastic copies around of Mercedes-Benz hubcaps, particularly in parts of Africa where there is a thriving trade in the genuine article. If your Mercedes hubcaps get stolen in Nairobi or Lagos, you can go the next day to specialist market stalls and buy them, or their equivalent, back again (and thus contribute to the cash flow of the local economy). As they will probably be stolen again within a week, Mercedes owners in Africa often keep their hubcaps in the trunk or locked away in the garage.

Cashing in on the Success of the Rolls-Royce

The world's most famous automotive symbols—the Rolls-Royce winged-lady mascot and the angular radiator—have been faked frequently, and the British company battles constantly to protect the design.

In England, kits are available that will dress up the front of a car to look like a Rolls. The kits have been used on Austin-Princess limousines to make them resemble far more valuable Rolls models in the American market. The deception enabled limousine-hire companies to charge premium rates to passengers in what appeared to be the world's most prestigious vehicles, when in fact they were being chauffeured in Austins available second-hand at less than $10,000.

Tires are faked frequently, also. If you are buying a new Rolls-Royce

in the U.S., it should be fitted as standard, with the high-performance Goodyear Eagle radial pictured. Watch out for retreaded and recut tires being passed off as new. They have far more limited lifespans and often reliability and safety problems as well.

Parts Pirates

The most critical faking activity in the area of motoring is the production of pirated spare parts. Factories in the Far East are churning out fake replacement components for all the world's leading cars and trucks in a multibillion-dollar business. Belts, spark plugs, windshield-wiper blades, filters, gaskets—almost every component you can think of is being faked for delivery throughout the world, particularly to developing countries. Often more care goes into reproducing the packaging (so that it cannot be distinguished from the genuine article) than in quality control for the part itself.

The consequences can be disastrous. Fake brake linings can take five or six times the distance that the genuine article would require to bring a vehicle to a halt. In addition, they break up or catch fire in an emergency stop. Cans for well-known brands of oil are being forged on a large scale and then filled with cheap, inferior lubricant that can cause early engine failure.

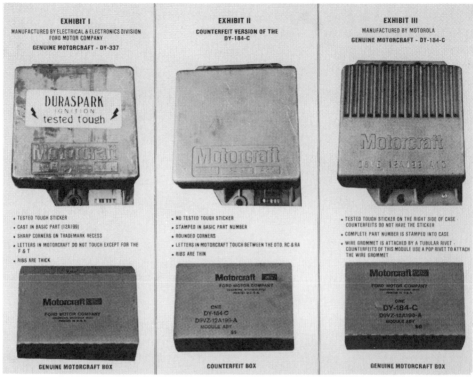

EXHIBIT I	EXHIBIT II	EXHIBIT III
MANUFACTURED BY ELECTRICAL & ELECTRONICS DIVISION FORD MOTOR COMPANY	COUNTERFEIT VERSION OF THE DY-184-C	MANUFACTURED BY MOTOROLA
GENUINE MOTORCRAFT - DY-337		GENUINE MOTORCRAFT - DY-184-C

EXHIBIT I
- TESTED TOUGH STICKER
- CAST IN BASIC PART (12A199)
- SHARP CORNERS ON TRADEMARK RECESS
- LETTERS IN MOTORCRAFT DO NOT TOUCH EXCEPT FOR THE F & T
- RIBS ARE THICK

GENUINE MOTORCRAFT BOX

EXHIBIT II
- NO TESTED TOUGH STICKER
- STAMPED IN BASIC PART NUMBER
- ROUNDED CORNERS
- LETTERS IN MOTORCRAFT TOUCH BETWEEN THE OTO, RC & RA
- RIBS ARE THIN

COUNTERFEIT BOX

EXHIBIT III
- TESTED TOUGH STICKER ON THE RIGHT SIDE OF CASE COUNTERFEITS DO NOT HAVE THE STICKER
- COMPLETE PART NUMBER IS STAMPED INTO CASE
- WIRE GROMMET IS ATTACHED BY A TUBULAR RIVET COUNTERFEITS OF THIS MODULE USE A POP RIVET TO ATTACH THE WIRE GROMMET

GENUINE MOTORCRAFT BOX

Here are exhibits of genuine and fake Ford electronic modules. The counterfeit does not have the full part number stamped into the case. There are subtle differences in the Motorcraft *lettering: Note how the letters* o, t, *and* o, *the letters* r *and* c, *and the letters* r *and* a *touch. The corners of the counterfeit casing are rounded, not square, and the wire grommet on the genuine article is attached by a tubular rivet, while the counterfeit uses only a pop rivet. The lettering on the boxes differs also.*

Hundreds of people around the world are killed every year as a direct result of the use of substandard fake motor parts, usually sold in such convincing packaging that they can find their way onto the shelves of franchised car dealers.

American motor manufacturers alone are estimated to be losing sales worth more than a billion dollars a year to the fake parts suppliers. The leading European and Japanese motor makers are facing similar problems.

In addition, fakers have become increasingly active churning out bogus motorcycle and truck parts, and if you operate a plane or a motorboat, you are vulnerable to the parts pirates in the air and on the water, too. Attempts have even been made to get fake components used in American missiles and the space shuttle. At the other extreme, famous brands of bicycles, including the British Raleigh, have likewise been copied by pirates.

Often the only way to spot these fakes is to compare them and their packaging against the genuine article, noting particularly the quality of materials and workmanship, and defects in the printing of the box.

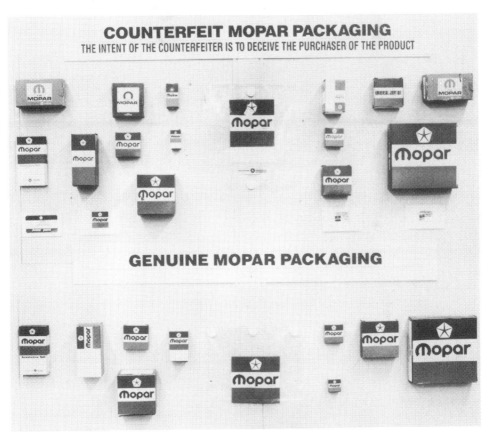

Trying to inform its dealers and customers of the dangers of fake products, Chrysler mounted this display of genuine and counterfeit Mopar packaging. The differences are sometimes very difficult to detect.

Fake Reconditioned Car and Truck Engines

Among the many phonies in the motor business is the fake *remanufactured* or *reconditioned* replacement engine for cars or trucks. The rogues engaged in this game wash down old engines, repaint them, and fit them with new spark plugs and perhaps some other low-cost components, or anything that is really broken. Then they sell these shoddy units, plagiarizing the names or marks of genuine engine remanufacturers at a vastly inflated price.

A properly remanufactured engine or other automotive component will have been stripped down, thoroughly reconditioned to bring it up to stringent specifications, and only then given cosmetic treatment to add buyer appeal.

The problem is worldwide and affects all major motor manufacturers with engine reconditioning schemes, as well as the consumers who buy these fake units.

Again, apparent bargains are the warning sign. It just is not possible to recondition an engine properly and then sell it at a ridiculously low price.

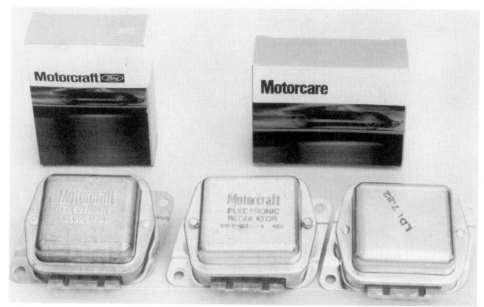

These are counterfeit Ford automotive parts. The genuine electronic voltage regulator is on the left, the fakes and their packaging on the right.

Old collectible bicycles can fetch thousands of dollars and so are being faked. There is a man in England who makes very good reproductions of penny farthing bicycles, those with the big wheel, having pedals in the center and a small rear wheel to help balance the machine.

CHAPTER
TWELVE

PHOTOGRAPHY

COL
LEC
TIB
LES

Photography Collectibles

Photographs

Collecting photographs depicting bygone times is a fascinating and educational hobby, whether the pictures be genuinely old or merely reproductions. I suggest that the beginning collector be guided most in purchasing by the intrinsic quality of the photograph itself. A collector should make artistry, subject matter, and technique the main criteria when seeking value for money. Then, the risk of acquiring a fake reproduction becomes largely immaterial.

Also, skilled photographic reproduction techniques may greatly enhance a recent print from an old negative, making it a more interesting rendering of the photographer's skills.

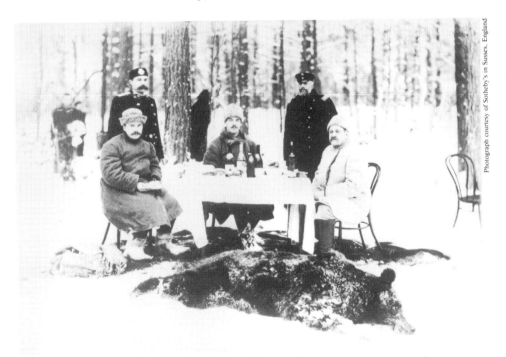

The content of old photographs affects their value—and the consequent temptation to reproduce them and pass them off as being genuinely old. A shot like this of Grand Duke Michael Alexandrovich, heir to the Russian throne, with a bear-hunting party, has tremendous intrinsic historic interest and is so well preserved that it could be copied very realistically using a variety of the techniques described in this chapter.

This is in contrast to reproductions of a painting, in which the true brushwork, colors, and emotions of the artist can never be recaptured.

Vintage Prints and Their Prices

The latest and most ridiculous trend in collecting has been the way prices have soared for so-called *vintage* photographic prints.

The origin of the term *vintage print* has been attributed to Lee D. Witkin, founder of New York's Witkin Gallery. Witkin has been quoted as saying ruefully that it became a "snake around his neck."

"The term was applied to photographs to make a useful distinction, but has been abused to milk more dollars out of unsophisticated buyers," he said, referring to its dreadful commercial exploitation.

One trap that unsophisticated buyers fall into is not realizing that, by its very nature, the photographic print is reproducible not only in quantity, but also in different sizes. Values can vary enormously according to the dimensions of the same picture.

A classic example of this is Ansel Adams' "Moonrise." Christie's auctioned one of these prints in 1980 for the then world-record figure of $16,000, while another print of the same picture was sold privately by a dealer the following year for over $70,000. The difference between them? The "cheaper" print was the less rare one of 16 × 20 inches, while the latter was the larger, and far rarer, 40 × 60–inch version.

While much of Adams' artistry lies in his printing expertise, both prices do seem rather ridiculous when one can so easily enjoy this photographer's genius through excellent book reproductions at a much lower cost. The price differential between the two

Photos like this one of famous big-game photographer A. R. Dugmore on safari have good collectible value if they are genuine.

sizes of prints from the same negatives seems even greater nonsense, although it points up a way of possibly spotting a fake. If your potential purchase is a famous picture, the size of authentic prints should be recorded in reference books. If you are offered a print that is not one of the correct sizes, it must be a fake. (The same check for size will reveal many fake drawings, paintings, and documents.)

As you consider the escalating prices of photographic prints, keep in mind that this collecting market has been turned upside down in recent years by the entry of major interests with seemingly bottomless pockets. For example, because of Internal Revenue Service requirements, the parent trust for the J. Paul Getty Museum in Malibu, California has a buying budget of around $100 million a year. IRS regulations demand that such trusts

spend a certain percentage of the value of their endowments, which in the case of Getty, total well over $2 billion.

Recently, a significant proportion of the Getty's purchasing power has been deployed on photographic prints. This has generated a ripple effect throughout the market, just as the Getty's big spending did previously with international prices for collectible art.

Although the Getty set out discreetly to assemble probably the best photographic collection in the world, it soon sent prices soaring. It is believed that in just its initial photographic spending spree, the Getty splashed $20 million around the world, buying up major collections on both sides of the Atlantic. Although the Getty stimulated the already steadily rising market for genuine irreplaceable antique collectibles (such as the daguerreotypes it bought in Hamburg), it also acquired significant quantities of twentieth-century prints, incidentally helping to underpin a market for work which is comparatively easy to fake.

In addition, other institutions with big budgets began to put together similarly impressive collections of photographs. The waving of so many dollars at a very limited quantity of good original material naturally attracts the interest of forgers and fakers, much the same as bees are prompted to swarm around a honeypot.

Again, Ansel Adams' famous "Moonrise" is the perfect example of the effect these spending sprees have had on market prices. At the beginning of the 1970s, one of the 850 authorized prints made of this classic was available for a mere $150. By 1980 they were fetching $14,000 each, and they had added another $10,000–$24,000

by the mid-1980s, with no end to their continuing appreciation in sight. Thus, the genuine article is now a very attractive investment, presenting an obvious temptation to fakers.

In fact, the demand for collectible photographs and the resulting high prices being generated for them make faking potentially one of the most profitable areas for fraud. Many of the more than 1000 private and corporate buyers who flock to the Association of International Photography Art Dealers' annual fair have enormous discretionary spending power. Twenty-five thousand dollars for a print by *the* Ansel Adams is almost petty cash to some.

And prices continue to escalate. Two thousand dollars each was a good price in 1972 for prints of the portraits of American Indians made by photojournalist Edward S. Curtis. In the late 1980s, they attracted investors at $45,000, $50,000, and up.

Photographic Picture Postcards

One type of image not being faked and traded fraudulently to any significant degree is the photographic picture postcard. Although now a very popular collecting category, these items are still readily available at reasonable prices. As suggested above, your buying decision here should be based on the condition and the attractiveness or intrinsic interest of the picture itself.

While postcard prices have not risen to the extent that would make faking them worthwhile, there are many reproductions of old photographic postcards becoming available, particularly in tourist locations. You should guard against being offered one that has been artificially aged to make it appear to be a genuinely old photograph. Obscuring the small type with

the contemporary printer's and copyright details would be an obvious clue.

Most of these reproductions are lithographic prints that result from ink being laid onto paper, instead of continuous-tone genuine photographs created by a chemical reaction with a light-sensitive coating on the paper. Because of this, they are easy to spot. Examining them under a low-power glass will show the dots of the screen used to break the continuous tone down so that it can be reproduced in ink.

Copying Photographs

There's a genuine scarcity and consequent justification for the high prices being charged for antique negatives, slides, and prints. These items were made by processes which are now obsolete, and existing examples have acquired the aura and equivalent of the patina that distinguishes other aged collectibles. But photographs of all kinds can be reproduced so easily and so closely in appearance to the originals that one might wonder whether the fakers are the only people operating in this volatile collectibles market who are being realistic.

There are many ways to copy old photographs and generate faked antique prints with a warm sepia tone. One of the easist is to underexpose a Polaroid positive/negative film and paper sandwich, salvaging the negative part that is usually thrown away. Then, a sepia-colored contact print is made using a special paper exposed to sunlight.

Conventional negatives can be produced by copying an original photograph, and then faking the paper so

Fraudulent copying of postcards was prevalent early in the century when they were produced mainly as collector items before becoming used widely for postal communications. Look out for originals of limited editions and those of historical interest.

Hand coloring of prints and postcards, as well as old maps, is done frequently to enhance their value. Examine the quality of the work and watch for runs of color on old paper surfaces to spot the fakes.

Photographic images can be made to look old by a variety of techniques described in this section, including sepia toning and artificial cracking. There are still a number of good buys around after the fall in prices from the boom times of the 1970s, but there is only real investment potential in quality prints with interesting subject matter.

Collectible movie stills are being copied extensively. This is W. C. Fields in the classic David Copperfield.

The value of such stills is linked closely to their scarcity and the fame of the stars and the movie involved. This is a fake of an original publicity shot of Gary Cooper and Merle Oberon in The Cowboy and the Lady.

that it looks old. Sepia and brown toners achieve this effect. You can even shoot what look like vintage pictures with your own simple camera: Load up with film designed for photographing under tungsten light and put a warming filter over the lens. This produces colored prints or slides with that vintage sepia look.

Of course, you won't fool the experts. But skilled work in the darkroom can produce copies of venerable prints which are very difficult to distinguish from the original. Indeed, sometimes they are better (in both technical quality and aesthetic appeal) than the original prints.

A thinking collector may, for example, get great satisfaction from such items as the outstanding portfolio produced in contemporary times by the Kodak Museum in Britain. For this collection, modern materials were used to produce very high quality prints from photography pioneer Fox Talbot's original paper negatives.

Indeed, some photography enthusiasts with a genuine desire to explore the skills and techniques of the past are getting remarkable results from their adaptation of the way that photographic prints were made in the late-nineteenth and early-twentieth centuries. So, for less praiseworthy reasons, are the fakers.

They even go to the lengths of recreating the old rag paper and soaking it in solutions of egg white to recreate the albumen prints that have such wonderful warm brown tones. After its egg bath, the paper is coated with sensitizer—a solution of silver nitrate that reacts with the albumen in the egg coating to form silver chloride, which is sensitive to light.

When this paper is used for the daylight printing of slightly overexposed negatives shot on large format cameras, and the resultant prints are then given a rapid artificial aging treatment, it is very difficult to tell one made yesterday from the genuine article of a hundred years ago.

An examination of the back of a print may give clues as to whether it is a modern copy or an original made at about the same time the picture was taken and the negative created. But remember, the experts can slice off a very thin layer just beneath the image and then glue this onto a genuinely old paper. A British bookbinder once showed me a banknote he had sliced in half,

Artificial sepia toning and aging is easy to achieve and will become more prevalent as the attraction of old photographic prints and postcards increases.

perfectly separating the front of the note from the back to produce two thin sheets. If that can be done, imagine how much easier it is to slice much thicker photographic paper. At any rate, the effort is well worthwhile if you are trying to get a fake accepted in the marketplace as a genuine vintage print, at the present inflated prices.

If you are doubtful whether the print you are considering is genuinely old or a modern reproduction, the best protection is to base the purchasing decision on aesthetic qualities. Will the content of the picture and the way in which it is rendered give you sustained pleasure and pride of ownership? If the answer if *yes* and the price is acceptable, it won't really matter if your acquisition is a fake, will it?

Old fashions could make the subject of a fascinating collection.

Special Collectibles
Investors are being persuaded to put their money into tintypes, collodion wet plates, calotypes, and daguerreotypes by dealers who maintain that there is a very limited stock of photographic images produced by these pioneering processes, and that prices must therefore increase.

That is just not true.

In the most undeveloped parts of Africa there are illiterate photographers working under primitive conditions, producing tintypes in the same way that Europeans and Americans created the images that are now becoming so collectible and valuable.

Even the beautiful daguerreotype, with its crispness and tonal range, can be produced with little experience and very simple equipment. (It can still be made by much the same process that Louis Daguerre revealed to members

Damage on a print can be masked in the framing. Always open up a frame to investigate.

of the French Academy in 1839—the reaction of iodine and mercury fumes on copper plates coated with silver.) Already, daguerreotypes are the Rolls-Royces and Cadillacs of collectible photographic images, and as their prices soar, they will become a very profitable area of faking.

The genuinely old glass negatives and daguerreotypes exist only in the media of their times, and so have an age and a rarity that can certainly make them appreciating investments if they're bought wisely. They also have physical substance; in other words, they are not just images on paper.

But how can you identify the genuine examples? One way is to see how the image changes as you vary the angle at which the light strikes the surface. The picture will only be clear if the light is at the correct angle.

Also, watch for calotype photographs of period scenes—say, someone in period dress or a street of restored old houses—that have the look and feel of being genuinely old. They resemble pencil and charcoal drawings in some respects and can be most attractive, with a softness about the outlines that is very distinct from the vividness of daguerreotypes or the images produced by modern films and processing.

Old plate cameras are rising in value because of the quality of their materials and workmanship, their comparative rarity, and the fact that they make attractive display pieces. Beware of modern reproductions made from readily available kits, which are attractive, but do not show much appreciation in value.

The calotype process—named from the Greek words *kalos,* meaning *beautiful,* and *typos* for *print* or *impression*—was revealed in 1840 by William Henry Fox Talbot, one-time member of the British Parliament. This was the first form of photography to use negatives for producing positive prints.

Calotypes are formed from a wet paper negative, and printing paper that can be made in the kitchen, using a shaded torch or a candle as a safelight. The negative is produced from the thinnest possible pure rag tracing paper, which must be washed and dried carefully to remove any size or artificial impurities.

Wet plates, on the other hand, use negatives made from glass. A photographer would take a print from the plate in the same manner described for paper negatives, or would use it to make an *ambrotype.* Ambrotypes are coming into vogue among collectors because they are unique positives. Instead of being produced from a negative used to make any number of prints, an ambrotype is a negative converted to a glass positive, ready to view and display. The negative image (light tones where there should be dark, and vice versa) is reversed simply by adding a black background—by coating the back of the glass with matte black enamel or gluing on a piece of black cloth such as velvet. An antique brown tone can be given by using a brown instead of a black background.

Genuine tintypes are similar to ambrotypes, except the collodion wet-plate negative was made on a previously blackened sheet of metal, rather

158

The disc camera is not a new invention. This one dates from 1910 and is called the Zoetrope. It takes 24 images, which give the illusion of movement when seen through a special viewer.

These discs are very rare and collectible. If prices go up, the temptation to fake them will be great.

than paper or glass. The contemporary African photographers I mentioned earlier, however, produce their versions of tintypes on sensitized black paper or cardboard.

The tintype and the ambrotype were used when only one copy of a photograph was required. They were most popular about the time of the American Civil War (which is why they are becoming so collectible today). But there are many other examples around from county fairs, weddings, and other events, right through to the 1920s and 1930s.

Cameras

You are less likely to encounter fakes when collecting cameras than photographic prints, although there are some phoneys around that might fool you.

The range of collectible cameras runs from rare examples in good condition, dating from the early days of photography (in the second half of the nineteenth century) and costing tens of thousands of dollars, to less than $20 for a mass-produced box camera of the 1930s. This means that watchful collectors can pick up bargains in the most unlikely places. Prices also vary greatly from country to country and are generally lower outside the United States.

Some of the simple cameras of the past consistently fetch very high prices because of their rarity or because they were landmark models that pioneered unusual or new features.

In general, however, the prices of the early classic cameras are rising fast, but not at a rate that would inspire the enormous effort required to create convincing fakes. Still, they are such beautifully impressive objects, with their polished wood, gleaming brass fittings, and black bellows, that reproductions are being made. Kits are available with which you can construct, with a great deal of effort, a working full-plate bel-

The Kodak.

KODAK—Abroad.

KODAK—Caught on the "Fly."

KODAK—On Board Ship.

W ITH this Camera is presented an entirely novel and attractive system of Amateur Photography, by which the finest pictures may be taken by anyone having no previous knowledge of the art, and without the necessity of dark room or chemicals.

The comparative size of the Kodak is shown in the accompanying illustrations.

AS A TOURISTS' CAMERA

it is unrivalled. No cumbersome tripod or plate-holders are needed. It is carried like an ordinary field glass, and with it may be photographed objects moving, or at rest, landscapes, animals, interiors of rooms, or cathedrals.

ONE HUNDRED EXPOSURES

may be made consecutively.

FOR CHRISTMAS

the Kodak offers novelty, beauty, and usefulness.

PRINCE HENRI D'ORLEANS has used the Kodak and writes us saying:

"The results are marvellous. The enlarge-"ments which you sent me are superb."

Full Information and Samples of Work done by the Instrument will be furnished upon application, or a Personal Inspection may be had at the Office of

THE EASTMAN DRY PLATE & FILM CO.,

115T, OXFORD STREET, LONDON, W.

You can enhance the value of a camera collection by linking it to the contemporary publicity material, like this advertisement for the pioneering Kodak Tourist Camera introduced in 1888. Although there is no profit in it, such advertisements can be faked by photocopying originals and then rapidly fading the paper by leaving it in strong sunlight, or using sepia or other tinted paper to make the copies.

Old bellows cameras are very collectible, and there are specialist firms that will restore them. The text also describes a formula to give cloth-based bellows a new lease on life.

Novelty cameras, like this Bicycle Kodak, were popular Victorian novelties that should increase in value.

This Kodak is one of the earliest pocket bellows cameras.

The classic Bull's-Eye Kodak, introduced in 1895 and the first to use roll film.

lows camera that looks very much like the original article.

These are not being passed off as genuinely old collectibles to any significant degree, although if the market continues to flourish, people will undoubtedly be tempted to age them artificially using the different techniques for treating wood and brassware (described elsewhere in this book).

Pirating of the best-known camera brands has long been big business in the Far East and the Communist bloc countries, which have produced their own versions of well-known German cameras, notably the Leicas. Indeed, when Germany was partitioned after World War II, the Communists legitimately acquired production facilities for Leica cameras and the reknowned Leitz lenses. Cameras and lenses produced in the Communist bloc nevertheless have far less resale value than their Western equivalents, even though often the workmanship holds up under comparison.

Leicas are an example of quality cameras that offer good investment value, but be aware of the problems with pirated copies, the East German versions, and the enormous differential between the going market prices for different models. Collecting Leicas is a specialized business, and the prevailing market values are well documented.

Most of the prewar Japanese copies of Western cameras are easy to identify, if you can compare them directly to the genuine article, because the production quality and finish are not as good. Nowadays, of course, the Japanese have gained a world lead in quality camera design and manufacture, so they no longer need to produce fakes.

However, pirated substandard copies of famous Japanese and European cameras and lenses still emanate from elsewhere in the Far East.

Points to Consider

The worth of any camera, even some inexpensive old box that Kodak made by the millions, is considerably enhanced if it is in mint condition and, especially, in its original packaging.

You may pick up an apparent bargain on a bellows camera because the bellows looks tatty and damaged, but the camera could finally prove quite expensive if it has to be sent to the few specialists who do this kind of repair work. If not too far gone, bellows can be rejuvenated with a coating of solution of 16 ounces alcohol, 4 ounces shellac, and about a quarter-ounce of oxalic acid. Mix these constituents thoroughly; then add about 3 ounces of linseed oil. Apply carefully to the bellows and allow to dry.

A good wax polish will do wonders for less than attractive leatherwork on the body of a camera,

This Victorian projector is comparatively easy to copy, but is an example of a specialized area of collecting where prices have not yet risen sufficiently to justify the time and expense involved.

I have heard rumors of plans to fake this 1910 disc camera. See the chapter on instruments for tips on identifying the genuinely old items.

or for its case. Black or brown staining shoe polish can be used sparingly to restore color, but test either on a small section before applying extensively.

Repairing the mechanicals of any camera is best left to specialists and can be very expensive. If you're buying a camera you want to be in working order or which is priced as being in functioning condition, there are several

simple checks you can make to reduce the risk of wasting your money.

First, look at the general condition related to the type of camera. A professional-quality camera (such as a Leica or Hasselblad) may be well worn but still working perfectly, while an amateur model could be in a very sad state after much less use. Beware of any dents or heavy markings that indicate rough handling. These could be a sign of damaged lenses and internal components.

All the moving parts should operate smoothly, without sticking or nasty grinding sounds. There should not be much play between moving sections, and you should make sure the leaves, which vary the aperture, open and close without sticking. Their black coating should not be damaged, or internal reflections could cause problems. The iris diaphragm, which controls the aperture opening, should be symmetrical at all settings; this ensures that none of the leaves are sticking.

The leaves of the shutter also tend to start sticking with age and become really gummed up if someone has tried to oil them to make them work better.

Many of the best cameras—and virtually all modern-quality 35mm ones—have focal plane shutters at the rear, made either of very thin metal or of cloth. You should determine that these are not damaged, as a repair is again very expensive.

You cannot verify the accuracy of shutter speeds without either shooting a test film or using specialist equipment. However, you can get an idea that they are in working order by seeing that the shutter opens and closes smoothly at the slowest speeds.

Another very quick and easy test is to take a magnifying glass and look at the small screws visible on the camera body and lens. If any are burred or otherwise show signs of having been removed, there's a good chance the camera has been tampered with by inexpert hands and should be avoided.

Your Camera As a Powerful Tool to Spot Fakes

Fakes are fascinating; I hope that's the message you are getting from this book.

They may be dishonest, morally reprehensible, and a scurrilous way of parting honest people from their money. But investigating them, tracking them down, and then being able to analyze the techniques used to create them adds a whole new dimension to collecting and can be an absorbing pastime in itself.

In particular, combining photography with your existing collecting hobby or using it to explore the underworld of fakes and phonies can give you hours of pleasure. I really only understood this when I spent an afternoon in a darkroom with an expert in forgery. Signatures are his abiding interest. He had become so knowledgeable that he was frequently called as an expert witness, consulted by banks, lawyers, and corporations to investigate suspect signatures on important documents.

To aid in this work and to extend his expertise, he had taken up macrophotography. By taking magnified photographs of genuine and suspect signatures and samples of both typed and handwritten documents, he is able to compare the details of how individual letters are formed on the page by either the impression from a typewriter key or the movement of a

pen across the paper. For example, two signatures that both appear to be authentic will, when photographed and enlarged, display very obvious differences when the enlargements are placed side by side. Even a traced signature will show subtle differences from an original.

You can use a camera in a similar way to investigate a variety of fakes, using simple techniques of magnification and ultraviolet or infrared light. With little expense or trouble, it can be a powerful tool for revealing details of the brushwork in a painting, the writing on a document, the surface of a coin or medal, and the intricate workings of a piece of jewelry, among many other applications.

Although it is possible to use the cheapest Instamatic, the most practical type of camera is the universally popular 35mm single-lens reflex. It has a single lens that is used both as a viewfinder and to transmit the image to the film. A mirror behind the lens reflects the image you are taking into the eyepiece. When you press the shutter, the mirror flips up out of the way and allows the image to go straight through to the film.

The single-lens reflex enables you to see in the viewfinder exactly what image will go onto the film. It also makes focusing much easier since the depth of field in close-up photography is far more limited than for normal portraits or scenes.

Most of these cameras now have through-the-lens metering, which means the light is measured as it passes through the lens and not by a meter elsewhere on the camera. This makes it much easier to get accurate exposure when you add the lenses necessary for macrophotography.

Magnifying lenses that screw onto the front of the standard lens are cheap and effective, with a supplementary lens of + 2 or + 3 diopters producing remarkable results. You get more flexibility at low cost by adding extension tubes that fit between the camera lens and the body. They physically increase the focal length of the lens for greater magnification. Make sure your extension tube is specifically designed for your camera and that it has the linkage required to enable the automatic exposure control system to continue functioning. A bellows unit performs the same purpose as tubes, but is still more versatile.

You can also buy special reversing rings that enable the lens to fit onto the camera the wrong way round to give an enlarged image, but they prevent the automatic exposure mechanism from working and so require more photographic skills.

Many zoom lenses sold today have a built-in macrophotography facility, a button you press to extend the range of the zoom beyond that used in normal picture-taking. This lets the camera take magnified close-ups.

To achieve really high magnification, you can get adapters for the more sophisticated 35mm cameras to enable them to be fastened to a microscope.

Whatever setup you use, the resulting negatives can be enlarged many times in the darkroom to give still greater magnification. If you are planning to enlarge the negatives considerably, choose a slower, fine-grain film. A tripod and cable shutter release will ensure sharper pictures at slow shutter speeds under difficult lighting conditions.

Besides practicing macrophotography, if you take photographs using

A selection of copies of old movie stills from my collection of fakes.

the raking light technique, where the light is angled sharply to the surface of the object, you'll discover even more information about the subject under scrutiny.

You can also use a camera to exploit the infrared and ultraviolet sections of the light spectrum, which are among the most powerful tools used by museums and major collections to detect fakes. (X-rays are an invaluable antiforgery weapon also, but obviously require very special facilities.)

Infrared is the first color outside the human range of vision at the red end of the spectrum. Infrared light and infrared film have a separating effect that can show up details not visible to the eye. When used to examine paintings, they can have a penetrating effect, revealing previous underpainting or the charcoal or pencil lines the artist may have used when starting the work.

Infrared can also separate colors to detect forgeries or help prove authenticity. While the darkening of leather or paper over the years may make the writing on it impossible to decipher under normal light, the writing may become clear under infrared because of the differences in the ways the surface and ink reflect the infrared beams.

Ultraviolet light (from beyond the human eye's range at the violet end of the spectrum) causes materials of different ages to fluoresce in distinctive ways. You use special filters on the camera lens to photograph this fluorescence, which can reveal a host of faking tricks such as fake patina and artificial aging, repairs and alterations to ceramics, and dishonest work on paintings.

Infrared and ultraviolet techniques can be quite complicated, with special lights, films, and filters being required, and exposures critical. But those techniques can be learned rather quickly, and there are a number of good photographic books explaining them.

Macrophotography, however, is simple and does not demand expensive equipment. Your existing camera and a cheap magnifying lens—or even shooting through an ordinary magnifying glass—will give you an effective weapon to help spot fakes.

CHAPTER

THIRTEEN

FURNITURE

Furniture

Artificial Aging:
Even the Chickens Help

"Even their . . . chickens help the English to fake furniture," a disgruntled American dealer commented to me after a frustrating buying trip during which he had found plenty of phonies, but hardly any genuine antique furniture at sensible prices.

"They make their reproductions and put them in the chicken houses for a few weeks . . . The wood gets a realistic aged look very quickly. I don't know if they give the chickens something special to eat, but it sure works!"

Actually, there are several varieties of farmyard effluent that will help fake antique furniture to look really old, but the skilled faker does not need them any more. He has a whole arsenal of modern chemicals to recreate the colors and textures of genuine *patina*—that surface which radiates age from wear, polishing, waxes, and sunlight to give a venerable appearance far more than just a "skin-deep" shine. However, such aging can sometimes be scraped away to reveal natural wood underneath that is much lighter than really old timber.

No one can quantify the extent of the international trade in fake antique furniture, nor exactly draw the boundary where the legitimate reproduction

Gently scratching the surface of a piece of furniture in an inconspicuous place (and with the seller's permission) can reveal a fake or disguised restoration job. Surprisingly often, fakers give away a piece by not artifically aging (or by using inappropriate materials) in areas not readily visible, such as the back and interior.

of a classic style ends and the intention to deceive starts. Certainly most reproduction furniture starts life honestly as such, but when it gets to the retail buyer it may be doctored deliberately to accentuate the impression of age, and then be blatantly passed off as something really old.

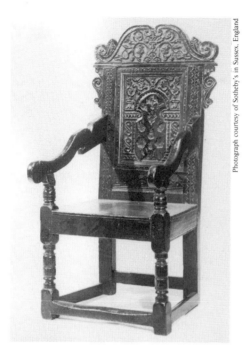

Reproduction furniture of earlier traditional styles is often distressed in various ways to make it appear old. Look at the wear patterns on the front cross-piece at the base of this oak chair and then at the comparatively small amount of wear on the seat or parts of the arms where elbows would rest. If the chair had been used so much that the crosspiece on the bottom was extensively worn away, wouldn't the arms and seat be similarly distressed? Indeed, Sotheby's experts were very careful in their cataloging of this piece of furniture, describing it simply as "a single oak armchair with panel back, carved with acorn and thistle decoration." Note the careful absence of any attempt at dating or provenance, sounding a clear warning to buyers. The chair sold for $1,600, a fair price for an attractive piece reflecting considerable craftsmanship, whatever its age.

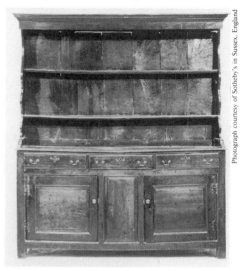

Dressers are very popular items of antique display furniture, but rarely do you find genuine examples of this age (early eighteenth century) and quality in oak with matching tops and bases. You can expect to find extensive restoration work or outright faking.

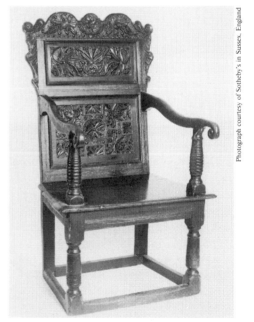

Compare the $1,600 chair to this authenticated Charles I oak chair dating from the 17th century, with its more natural wear and beautiful patination. It sold for more than $7,000.

LADIES' ROCKING-CHAIR, 18s. 9d.
Black and Gold, £1 8s. 6d.
A large variety of Austrian Bent Wood Furniture on view in the Show-Rooms.

Bentwood furniture is now a popular mass-produced reproduction line selling for many times the original small cost of the genuine article. The finish of the reproduction furniture can be aged and distressed quite easily, but note that the presence of new cane work is not in itself suspicious, as one would expect this eventually to be replaced as a result of natural wear.

Measure the width and thickness of the timber used on old furniture. Genuinely old pieces have irregularities that are not apparent on more modern furniture created with timber cut and planed by machine.

Another way of spotting the irregularities in old hand-dressing work is to look along a straight edge with the light of a flashlight or bulb, or even with sunlight shining from behind. The straight edge will be almost flush with the surface of modern machine-cut wood, and you'll see very little light underneath it, while the irregularities will be revealed clearly if the wood has been worked by hand.

There is a big undercover business in deliberately faking (at the manufacturing stage) the more popular and valuable pieces, often with more time and money invested in them than the original craftsmen needed many years ago. However, with demand for good antique furniture far exceeding supply, and prices steadily rising, all that effort and cost are well worthwhile to the counterfeiter.

For instance, a significant monetary milestone was passed in 1986 when a Philadelphia pie-crust tea table fetched more than $1 million. But even further down in the collectible furniture market, the premium prices inspire faking in a big way.

Most of us buy old furniture because we like its style, its quality construction, and its intrinsic qualities of age and exclusivity. And we hope it

171

Screens deteriorate with use over the years. You need to look carefully to spot hidden repairs or possibly even the complete replacement of decorative panels that have been treated in various ways to appear as old as the framework.

If you check components, such as chair legs, with calipers or a vernier gauge, you should be able to get clues to their age and authenticity. Old, low-speed lathes could not make perfectly round wooden turnings or pegs. Hand tools and slow lathes also caused surface blemishes and irregularities that are not so apparent in manufacturing by modern machinery.

will prove a sound investment, steadily continuing to increase in value, while a modern piece bought from a department store depreciates as we take it out the door and perhaps only starts to appreciate again many years hence.

So the first step in buying good old furniture is essentially to be able to determine whether it really is old. Later on we will get into the finer points of the woods, joints, and metalware used in various periods and the great complexities of style.

Sadly, many furniture buyers cannot even distinguish between weeks-old chipboard veneered furniture and genuinely old pieces. I have to encourage 90 percent of the buyers in my antique store to take out drawers to look at the different woods, methods of construction used, and the indications of genuine age and use. Hardly ever do they get down on their hands and knees to inspect the undersides of tables, or ask for sideboards, dressers, desks, closets, or chests of drawers to be turned around so that they can inspect the backs.

I have been offered some excellent ranges of Eastern and European reproduction furniture to sell, and I certainly have a good market for them, but if I put them in among the genuinely old pieces, many of my customers will be further confused.

So let's have a quick, basic crash course in detecting age in furniture to keep the most obvious fakes, reproductions, or reworked pieces from being passed off so frequently as being genuine.

Oak drop-leaf dining tables with gate legs have been faked for hundreds of years, and some Victorian and later examples of little value often get passed off as being older and more expensive. Consider that matching tops and legs, pleasing proportions, and the quality of the wood and its patination from use and polishing over the years all indicate genuine age. Expect wear from the constant raising and lowering of the flaps and the movement of the supporting legs. If the condition is too good, you should suspect that the piece is not old at all.

Removing the handles from a drawer or cupboard will tell a lot about the genuineness of furniture. Here, we see changes in patination and the additional hole, which shows that the drawer pulls are not original. In addition, always look inside drawers if you suspect a reproduction or fake.

Furniture has always been made to be used. It has also (because of the expensive material and labor content) always represented a considerable expenditure for all income groups. So a quality piece of old furniture will reflect both its use and the care that previous owners have lavished on it.

That brings us to the notion of *patina*—the visual and tactile surface appearance. Your first assessment of the patina should not be made close up, with your nose almost touching the surface. Stand right back and get a first overall impression. By examining a good deal of furniture, you will soon sense whether the lines, style, and proportions of a piece reflect quality and period accurately, or whether the piece is a later copy.

Surveying the color from a distance also gives you a lot of information, although there is a current trend to strip old furniture and give it a uniform fresh stain or varnish to make it look new. It breaks my heart to visit establishments where attractive old pieces that radiate venerability are being given this kind of unfeeling face lift. Dealers protest that they are satisfying market demand—particularly in the United States, Germany, and France—and report that most buyers just do not want to take into their homes furniture that reflects the wear of age.

Since the patina is one of the most difficult things for fakers to reproduce realistically, this buying trend makes their counterfeiting job much easier.

On a piece that has not been stripped, your examination at a distance should show changes in color that have happened gently and subtly over the years from the effects of light and the abrasion of wear. Look at surfaces where hands, knees, and elbows

have rubbed. They should have a lighter, but somehow, deeper coloration, and a definite smoothness you can detect by lightly touching them with your fingertips.

If you see differences in patination that are sharper, harsher, and just do not have a natural feel about them, it's a warning to look closely for artificial efforts to age the piece. Another warning is differences in the wear patination of two matching pieces—a pair of chairs, for example. That can be an immediate giveaway of either a fake or of extensive restoration to one of the pieces that has resulted in its being different from the others.

You can expect, however, to find patination on working surfaces different from the rest of the same piece. The top of a table or chest may have had to be treated extensively to remove the unattractive signs of use, such as water and alcohol stains from parked glasses, or marks from burns or scratches.

Look also for color and patination differences that are logical. When opened, drawers and doors that have spent most of their lives closed reveal the natural color differences between exterior and interior sections made of the same wood. The exterior sections will have suffered different degrees of oxidation from exposure to the light, and will have been polished more frequently.

Often, you can open the drawers on a piece of furniture made a hundred years ago and see that the concealed areas look remarkably fresh and new. But, if you turn those same drawers upside down and examine the runner sections that form the drawer supports, there should be clear, distinctive signs of wear from decades of use. Sometimes, the bottom edges of the sides of

Move suspect pieces around to view them with the light shining from different angles. This should reveal blemishes or other clues, such as variations in moldings—whether they match, are of the right period for the rest of the piece, and are hand- or machine-cut.

Some examples of moldings are shown in the bottom illustration. Look closely at moldings like these, which were in use until about the middle of the 19th century. If they are handmade and genuinely older than about 1850, they should show slight irregularities and be held in place by small iron brads. Gluing was not used widely until Victorian times.

a drawer become so worn down that a fresh strip of wood has to be tacked on to enable the drawer to function properly. Rarely do fakers add such strips as a detail touch to aid deception.

However, the fakers routinely add dirt and distress to both solid and veneered wood surfaces to falsify age.

Garden Furnishings:
The Next Growth Area
for Faking

What's going to be the next growth area for faking? My tip is the area of garden statuary and furniture, which has had an unprecedented growth in values during the late 1980s, with fakes of the most desired pieces now starting to appear. Demand for garden items that a couple of years ago had very little perceived value is strong in the U.S., Europe, Australia, and the Far East. Thieves have even hauled away large statues and architectural pieces that required a crane for lifting.

Molds have been made from period Coalbrookdale cast iron benches and seats produced by the famous English Midlands' foundry during the late nineteenth century. With genuine examples fetching more than $6,000, such easily reproduced pieces of garden furniture are an obvious target for fakers.

Important buyers are coming from the inner cities, making large investments in statuary or fountain focal points around which small city gardens can be designed. Repeat buyers usually have larger suburban or country gardens with a great deal of scope for decor pieces.

Even the high shipping costs involved in purchasing such large items as fountains, cast iron furniture, and statues fail to discourage buyers and fakers, as the wealthy, having packed their homes full of collectibles, are now dressing up

their gardens and patios as well. One Texan is virtually designing his house around the garden and architectural bits and pieces he is collecting in Europe. Some Americans are sending over-prized pieces to the main international sales center for garden furnishings, Sotheby's in Sussex, England. There, other Americans are buying the pieces and shipping them home again at vast expense.

The high prices being paid by chinaware collectors for Doulton pieces are mirrored now in prices for the big garden fountains and ornaments that the famous pottery produced until 1910. One person paid $22,000 for a Doulton fountain dating from around 1890, while an imposing Italian bronze wellhead of about the same period fetched more than $62,000.

Urns are very popular (in one instance, an eighteenth-century sandstone pair with lids brought nearly $70,000), so buyers need to be increasingly suspicious of lots that may be faked. The safest bets are pieces of sculpted one-of-a-kind stonework, which are difficult to reproduce convincingly.

A glorified type of concrete mix, composition stone, *can be molded to look like a carved statue, fountain, or bath. Various treatments are then used to artificially age it a hundred years or so. Yogurt or sour milk painted on the surface encourages*

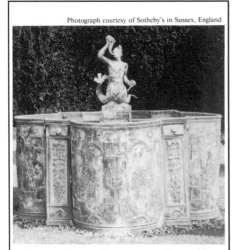

Impressive garden statuary items like this Georgian lead cistern can now fetch well over $30,000. While this is a genuine piece dating from 1720, the merman on top was added later. Watch for such changes and additions, as they could affect value. Some pieces, notably antique garden furniture from the best-known foundries, have already been copied and offered for sale as being genuine.

moss to grow quickly, acid simulates weathering, and a rubbing with soot can soon give the appearance of many years of air pollution.

The bottom of a chair or table leg will tell you much about its age, so the faker distresses this area to simulate natural wear. After looking at a number of genuine examples, you should soon be able to distinguish all but the most skilled attempts to fool you.

dirt in a corner or the niches of a carved area may prove to be hard and brittle when pried with the point of a knife or a pin. This indicates that it was added recently with the help of some glue.

Also, check the wear often simulated on soft wood surfaces like pine, achieved by rubbing with a wire brush in the direction of the grain, or by sandblasting. Fakers frequently slip up by distressing the bottoms of the feet of legs and tables to give the impression of wear that an old piece could have sustained on harsh stone floors (but they often forget other areas where there would have been natural wear in use). Is it natural, regular wear or a quick five-minute job with a rasp? Are the back legs of a chair more worn

They don't beat up furniture with chains or fire shotguns at a piece to simulate wormholes. Modern faking techniques are far more subtle and effective than that. You need to look closely to assess whether such surface marks are logical and natural, or artificial. Frequently, the distressing is done on areas that just would not, in normal use, be likely to get damaged in that way. The inside surfaces of chair legs is a good example. An accumulation of

A genuinely old, handcrafted chair reveals subtle details to help you judge authenticity. For example, measuring the roundness and thickness of wood reveals the inevitable slight differences between matching components, such as chair legs, which stem from handwork. Machine-made furniture is far more regular.

Look carefully at this drawing of a ladderback chair, where two clues of genuine aging have been exaggerated. The backs of the turned tops of the chair are worn where they have rested against a wall over the years, and the feet of the legs also have been worn irregularly from contact with the floor.

Joints are like fingerprints on furniture, giving vital clues about the age, quality of craftsmanship, woods and fastenings used, repairs, and so on. This fake shows up because the artificial staining and patination on the door looked alright when it left the workshop, but within a few weeks, lightened and appeared completely different on the end grain of the cross-pieces.

down than the front, as almost invariably is the case in real use?

Old wood and new wood have such very different physical and visual characteristics that you'll soon be able to spot them with just a little experience. However much stain fakers may have applied, they cannot get that evenness of deep-down tone that is so characteristic of properly seasoned old wood. Compared to the very little depth and the unevenness of coloration in newer kiln-dried timber, the distinctions are apparent.

But do expect different types and colors of timber in areas not normally on show. It was usual for the old-time furniture makers to use cheaper timber for the hidden parts of drawers and the backs of pieces. Remember, though, these parts should be genuinely old also, and often, finished quite roughly. You'll soon learn to see the marked differences between the surfaces of these areas, which in old pieces have been cut and finished with hand tools such as saws and adzes. They are completely different from the distinctive marks left by modern machine tools.

Of course, modern hardboard or plywood used for concealed components such as drawer bottoms are an immediate giveaway of reproduction and inferior-quality work.

Now, start to look at the joints. Machine-made dovetails and other types of joints are very regular, while old, handmade joints have inevitable variations. You'll often see illegible handwritten notes. These are the pencil lines used to help the worker line up the dovetails.

The craftsmanship on some modern fakes is awful. The poor fitting and the filling of gaps with a glue and sawdust mixture would make the experienced furniture makers of the past turn in their graves. However, the old primitives from the homes of farm laborers which have now become so fashionable reflect some pretty crude work. How do you distinguish between the two? The secret is in an apparently strange word to use: *charm*. The rough results of a bygone woodworker using unsophisticated tools has a quaintness and naturalness about it that the modern faker somehow just cannot imitate.

A little knowledge is a dangerous thing. I often see buyers who have a smattering of knowhow become quite obsessed when they try to establish the value and authenticity of a piece by examining hinges, door and drawer knobs, and other fittings. They can be quite put out when there are holes and changes in the patination around these fittings, which indicate they are not original.

This kind of approach should be tempered with a realistic appraisal of the situation. An old chest of drawers or cupboard from a hundred years or more ago has led a charmed life if its knobs and hinges have not broken or

Screws are often a giveaway to age, since a modern machine screw looks completely different from an old one made by hand, as shown in these illustrations. Screw A, produced by the thousand, by machine, is very regular and has sharp edges. Screw B is irregular and far more primitive, revealing both its age and evidence of being handmade.

deteriorated to the point of requiring replacement at least once. If the knobs and hinges are in good shape and there is no evidence of previous ones being fitted, then the chances are good that you are looking at a recent piece.

If you are lucky, and the old fittings have survived, they are often indicated by a darkening of the wood around the screws and a natural corrosion of the metal. These things are difficult to fake realistically.

Don't hesitate to ask for a screwdriver to take out a screw for examination (being careful not to damage the piece when doing so, of course). If the screw is difficult to remove and its thread corroded, with accompanying discoloration of the wood in the screw hole, then it has probably been there for a long time. Fakers often add a touch of acid to the tops of new screws to make them look old on the surface, but few bother to let a pile of screws soak in acid or water to become corroded all along the thread. Even when

Don't hesitate to have a table or other piece of furniture turned upside down so that you can examine the wood underneath for signs of authenticity and take a close look at screws and other fastenings. An old hand-made piece of furniture, for example, has probably had the timber dressed using a plane with a slightly convex blade. Although the finish will have been sanded smooth on exposed services, the back, interior, and underneath of drawers should reveal this old hand-dressing technique.

Compare the diameter of a round table in several places as a check for genuine age. Wood shrinks across the grain and really old round tables become slightly oval, something you may not be able to see, but which becomes apparent when measured. The across-the-grain measurement should be shortest in diameter.

they do, such accelerated corrosion often gets rubbed away when the screw is inserted.

Machine-made screws did not appear until 1850 or so. You can tell them from the older hand-cut threads because they are more uniformly cut.

Expect some slackness from wear in an older hinge or a lock or catch. If everything is too tight, the item is probably new.

A study of carving techniques can also be a great aid to dating and authenticating furniture. Victorian and later machine carving, including faking to upgrade an undecorated piece, is cut into the wood. If a fine piece was built to be carved, usually it was made with sufficient wood to permit the carving to be done in relief, above the surface. The workmanship and artistic qualities may be suspect as well.

The characteristic shrinking of wood across the grain can provide valuable clues to aging. A genuine round antique table should not be circular any more, but should have shrunken to an oval shape. Although the oval may not be discernible to the eye, you can quickly check the measurements with a tape measure.

Succeeding generations of fakers have applied a great deal of creativity to dining tables over the years, often by responding to changes in taste and the size of homes. You need to check that the leaves, base, and legs all belong together, and that the dowels used to hold leaves together are right. Look for telltale signs at the edges and underneath, which show that the dimensions of the table have not been altered to make it more salable.

Note, too, that joints open up as the wood shrinks. You can often spot this in the paneling at the back of a piece. Quite wide gaps can open up between tongued and grooved joints, for example. I have an old refectory table with a massive top made up of three thick pieces of timber. The maker allowed for the shrinkage that would occur over the centuries by providing hidden bolts right across each end of the table and through each of the pieces. The gaps that formed as the timber shrank could be closed periodically by tightening the bolts together.

Other Shifty Maneuvers

The term *pastiche* is used in the trade for a broad category of faking in which a piece of furniture is altered substantially by additions and by the use of various component parts to make other items. The faker may create two or three new pieces from a single old one, each appearing to be authentic. Much furniture has been altered through the years without any intention to deceive, but you need to watch out for it in case the value has been affected. A typical example is a tall piece

The captain's *or* smoker's *chair, along with the similarily shaped high-back classic Windsor chair, is being reproduced on a vast scale and often passed off as being genuinely old. Another common deception is to remanufacture these chairs from bits and pieces of broken ones, adding and artificially aging new wood where necessary.*

There is a shortage of really good genuine antique or near-antique chairs to meet current market demand, so faking is rampant. One deception that is not actually faking (but is certainly misleading for buyers) occurs when light-construction bedroom or salon chairs are presented for use as dining chairs. A solid, substantial chair like this one is needed to stand up to the rigors of heavy use to which a dining chair is subjected.

Not all marriages are made in heaven, as in the antique trade, where the term *marriage* is used to describe the bringing together of two pieces of furniture to create a more salable piece. Low chests of drawers, cupboards, and writing desks often get this treatment with the addition of another unit on top—a chest on top of another chest, or a bookcase on top of a writing bureau, for example.

If passed off as being genuine, original combination pieces, such marriages must be classified as fakes. You can spot many of them quickly because the two elements just do not look right together; the proportions or styles are wrong. You may need to look at the back of more skillful marriages to see if the paneling there matches. The color (especially in the hidden areas inside drawers and cupboards), the workmanship, and the fittings should all match if the piece is genuine. If you are still uncertain, remove the top section and look at where it stands on the base. If the covered surface of the base is veneered or otherwise as well finished as the parts that show, this can indicate a phony. When the combination furniture was originally made, there would have been little point in using expensive veneering on a surface that would never be seen.

Marriages, pastiches, and amputations are all popular tricks used by furniture fakers. A skilled English cabinetmaker showed me just how easy it is to create a highly salable dressing table from a less valuable chest of drawers and, by judicious cutting down and addition of legs, to age and upgrade a rather ordinary Victorian tallboy into a Georgian chest on a stand.

of furniture designed for an upper-income home with spacious rooms and tall ceilings that, sometime in the past, was sold to a lower-income buyer with smaller rooms and lower ceilings. This buyer may have been forced to have a cupboard or tallboy cut down to fit into its new home, or perhaps had one piece turned into two, or a table reduced in size.

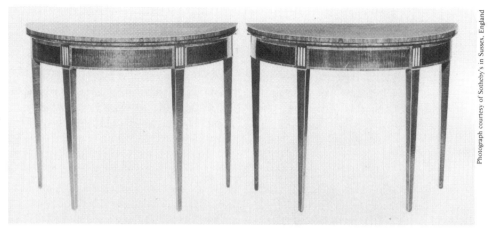

Look carefully at pairs of tables. A genuine pair is worth much more than the combined values of the tables sold separately. Often, one of the pair will be a copy of the other. You may need to turn them upside down to see the difference in the aging of the wood. Remember that too much similarity could be another warning sign: A skilled faker may try to make the undersides, as well as the visible areas, match.

This same craftsman is particularly adept at creating antique chairs. Give him three unsaleable dining chairs that are falling apart and he will produce a highly desirable complete set of six, each with genuine components, but all, in fact, reproductions with little claim to authenticity.

Although supplies of old wood from which to make reproduction furniture are becoming scarce, a lot of fakes produced in this way are in circulation. The extensive rebuilding in Europe after the ravages of World War II produced masses of old wood paneling and floor boards from demolished buildings. These were seized by fakers to manufacture apparently antique furniture. Look particularly for floorboards that have had their nail holes filled in.

As you become more interested in old furniture, you will acquire more information to identify the fakes. You will learn how old veneers are much thicker than the modern ones cut by machine; how different woods were used in different periods, with tell-tale trends such as the natural darkening of the Virginia walnut used in place of mahogany in early reproductions; the subtleties of the practical design of genuine military furniture used in the time of Napoleon and Wellington (now being reproduced in vast quantities); the Victorians' exaggerated style in their many reproductions of earlier pieces; and so on. In fact, the faking of furniture is so varied and complex that it merits a book on its own.

But at least you now have the basic ammunition with which to spot the indifferent and the bad merchandise in the container loads of shipping goods that flood into the U.S. from Europe. You're also closer to being able to spot the similarly large quantities of reproduction furniture coming onto the U.S. market from all parts of the world (including American workshops).

The Perils of Transatlantic Shipping

Many fakes arrive in the U.S. and Australia in loads of shipping gear. Predominantly junk furniture, dating from the 1920s through the 1940s, this merchandise is thrown out of British homes and bought at estate sales, auctions, and elsewhere by itinerant pickers *and* knockers *who scour the countryside for stock. It eventually ends up with specialist export dealers, packers, and shippers who either carry out a minimum of stripping and refinishing or load the furniture in its raw state into shipping containers.*

As shipping rates are calculated mainly on bulk, not weight, gaps between the furniture and spaces inside are filled with a variety of smalls, *including a good deal of reproduction English chinaware that is subsequently passed off as being genuine. Popular examples are large toilet-water jugs and bowls with the style and patterning of the genuine Victorian washstand items: chamber pots, shaving mugs, and Toby-style mugs and jugs that feature traditional figures but are actually fresh out of the Staffordshire pottery kilns. Some have an artificially cracked glaze, which simulates age.*

Reproduction furniture often finds its way into these shipping containers and then gets a bit of knocking about on the transatlantic trip to add to the distressing already imposed by artificial aging and natural wear. Two items currently being reproduced and passed off as genuine are Victorian towel stands, useful for displaying quilts, and elm or pine dough troughs (popular for planters) originating from Holland and other European sources.

It costs about $600 to pack a 40-foot container in England and another $2,600 or so to ship it to the U.S. Add to this about $1,000 for incidental expenses. And, while the actual cost of buying the contents varies enormously, that can be done for about $6,000. This total investment of a little more than $10,000 can finish up with a retail value in the U.S. of more than $40,000. The margins are wide enough for many American dealers to send an order containing only broad categories of the types of furniture and smalls that sell successfully to their clientele. They generally leave it to the British shipping dealer to put the load together—and to take a substantial profit.

Be very careful of dealers who specialize in shipping gear, especially those who do not go across the sea to do their own selection and buying. Too often their retail prices are unrealistic. More importantly, they are a natural avenue for fakes and phonies, which they may have neither the expertise nor the motivation to identify for buyers.

I could take you to many barns, warehouses, and industrial estates where furniture is being doctored in various ways to foist off on unsuspecting American buyers. The

resulting pieces might be attractive, but you wouldn't want to pay the prices of genuine investment antiques for them.

If you are thinking of importing directly, it's well worth the expense to go over and choose your first shipment in person and, just as important, to identify shippers and dealers you can trust. Label and list everything carefully. (As I write this, I am in a legal dispute with two British dealers who substituted some items I bought for others of little value.)

It is impossible, when you're running around buying hundreds of items to fill a container, to remember exactly what you have acquired, how much you paid for it, and where it was bought. Use your own distinctive labels and have your own code indicating the price you paid and where you made the purchase. This label should stay with the piece all the way through to your home or

store, as it is an enormous help when you're checking inventory or negotiating discounts to other dealers or hard-bargaining retail customers.

In many cases, it's worth photographing key items at the time of purchase, using color print film and a simple automatic pocket camera with a built-in flash. This way you have a invaluable visual record in case there's a dispute. You also sound a discreet but clear warning to the vendors that you are thorough and careful, which reduces the temptation for them to try pulling any fast tricks on you.

Photographs also help dealers presell shipments while the merchandise is still on the water. Customers love to get on an inside track to bargains or unusual pieces and may place orders against photographs of inventory on its way to you.

Approach Stripped Furniture with Caution

If you have bought a genuinely old piece of furniture that you feel needs stripping, think very carefully before reaching for the paint or varnish stripper. There is far too much stripping of old wood furniture going on, destroying the patina which adds so much to the attraction of old pieces.

Fashions are also changing. While it used to be all the rage to strip and refinish old furniture, to remove the blemishes of wear and thus, achieve a lighter-toned surface, there is now a tendency, particularly in Europe, to try to restore old finishes and preserve

their natural color. The exception is painted old pine, which looks far better and becomes more valuable when the paint is removed and the natural wood waxed to an attractive glow.

You should consider, however, this word of warning about stripped pine. It is the practice in Europe to dip painted pine furniture in vats of hot caustic solution as a fast and economical way of removing the paint. (It also kills woodworm very effectively!) But unless this dipping is done very carefully, there will be warping of the wood and joints may open up. Also, the caustic may not be properly washed out or the piece not dried thoroughly. This creates all kinds

Library bookcases like this are being reproduced, but are generally inferior to the originals in quality. The distressing is rarely realistic and the screws fastening the upright slats may also indicate a fake. As always with suspect furniture, examine the areas where the wear and variations in surface coloration would naturally occur. In this case, the books would prevent light from getting to the surface of the shelves, and there would be some marking from taking them in and out over the years.

of problems, especially if it's been impossible to dry the pine before it is shipped from England's damp climate. Several weeks locked into a container across the Atlantic, perhaps being cooked in the high ambient temperatures passing through the Panama Canal on the way to West Coast, can have very bad effects. I have seen numerous badly stripped items of pine furniture unpacked in California. These pieces then deteriorate even further when the wood adjusts to the hot, dry West Coast climate. I think selling pine in that condi-

tion without a warning to the customer is a form of faking.

Look particularly for signs of crystal formation on the surface of stripped pine, indicating that the stripping medium was not washed off properly.

If you are tempted to strip and refinish yourself, do stand back from the piece and evaluate its worth if the finish is simply restored as much as practicable to its original state. This is a quicker, cheaper, and simpler option that may enhance the value far more.

Frequently, you can work wonders by washing off any water-soluble dirt and then carefully rubbing the surface with the finest wire wool dipped into turpentine, paint thinner, or mineral spirits. Experiment in an inconspicuous place and be careful not to rub too hard or the friction of the wire wool could cause new damage. An old toothbrush is ideal for getting into awkward corners.

Then, wipe the surface with a rag moistened with clean turpentine. I prefer to use paper towels or toilet tissues, discarding them as they become dirty.

If you are lucky, you may quickly see a clean, even surface that can simply be polished with a good wax of the right color and buffed up to a natural shine. This is far more attractive than revarnishing. I had a booth at an antique fair next to a dealer who was displaying some beautiful (and genuine) old American oak furniture. Everything had been stripped and revarnished to the same uniform shiny finish and color. He did very little business because potential buyers passed him by, assuming from a quick glance that all his furniture was reproduction. In contrast, my sales were good because most of my furniture had simply been rejuvenated and each piece had the different and distinct coloration and patina that had evolved over the years.

Tricks with Paint

There's been a revival of interest in hand-painted furniture. You should beware of the dangers of being deliberately deceived into thinking that a modern reproduction piece dates from the nineteenth century, when the most valuable examples from this category originated.

First of all, the chair, cupboard, clock case, or chest you are evaluating for authenticity should reveal its age from the various clues already described.

Also, the paint used on genuine examples, such as the much-copied Pennsylvania Dutch pieces and Hitchcock work from Connecticut, contained soured milk. Its texture and subtlety of color are quite distinctive when compared alongside modern paint that has been artificially aged and has had the surface distressed to simulate natural wear. On the other hand, the decoration was more often stenciled than painted freehand, and so can be copied easily to make even an inferior piece of reproduction furniture look far more attractive. While a piece with copied Hitchcock stenciling is worth a fraction of the value of one that originated from Connecticut in the last century, such a copy may be really old, as Hitchcock's work has been

Chests of all kinds attract many kinds of suspect trade practices. A plain chest may be altered with the addition of handles and inlaid work or painting, or it may be artificially aged to make it appear genuinely antique.

imitated for more than 150 years.

Dealers find that wooden chests can be made to sell more readily by giving them a simulated old paint finish. The techniques they use include wiping away areas of the fresh paint before it has fully dried, or rubbing vigorously with thinners. A chest or piece of furniture treated in this way to pander to the collecting fad for authentic worn paint is less valuable than one with a genuine old finish.

CHAPTER 14

CARVINGS:

WOOD IVORY

AND

BONE

Carvings: Wood, Ivory, and Bone

The tremendous growth of interest in collecting and the subsequent spectacular increase in prices for genuine items is stimulating substantial faking of a host of collectibles carved from wood, ivory, and bone—ranging from pieces of American folk art, such as whirligigs, to the delightful scrimshaw (or *scrimshandering*) executed by seamen and prisoners on teeth, bone, tortoiseshell, and even the surfaces of eggs.

Because the resultant selling price is usually enough to reward long hours of skilled work, the imitations can be very good. Even cheaper, mass-produced items can be convincing. In London, for example, I paid ten pounds for a fake cast-resin walrus tooth on which a beautiful nautical picture apparently was engraved. Then, as an experiment, I put it in my American shop and priced it at $32.

It attracted a lot of attention and completely fooled most potential buyers who thought they had found a bargain (a genuine piece of scrimshaw like that would be worth ten times the price I was asking for it). Frequently we had to point out that it was a reproduction.

Other potential buyers assumed that it was reproduction simply because of the low price and were not interested, but many of them would have bought it if it had been priced nearer to the true market value of a genuine ex-

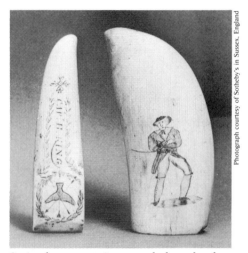

Scrimshaw engravings on whale and walrus teeth are being copied with great realism today by means of resin molding.

ample. This happens all too often, by the way: A high price works psychologically to add value to a good fake.

Hardly any prospective buyer (only a couple of experienced collectors and some dealers) bothered to examine the fake tooth carefully. The artificial patina of staining, cracking, dirt, and wear on the surface made the tooth a quite convincing reproduction. It also appeared to have been very cleverly molded from an original, and even weighed what it should—gone are the days when plastic fakes give themselves away immediately by being too light.

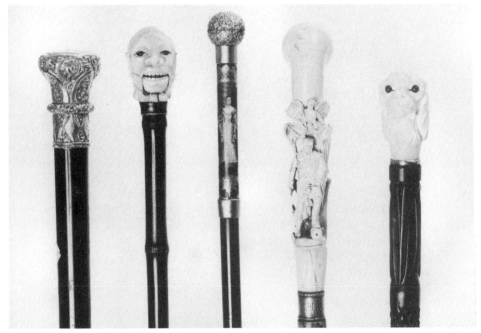

Look carefully at a display of walking sticks to be sure the most attractive and apparently valuable ones are not clever fakes with ornate brass, low-grade silver, or imitation-ivory handles.

Testing Ivory

You can immediately tell by looking at the base of the objects that a very large number of contemporary fakes are not ivory. Real ivory is not solid, but formed from tiny dehydrated tubes. Under magnification, these appear as oval-shaped rings at the point where the tusk was cut at the base. They are similar in some respects to the rings you see in a cross-section of a wooden log.

Faked ivory made from bone is distinctly different from this in structure. It is less dense, and riddled with the little holes and channels used to carry the blood supply which keeps the bone healthy. It often contains brown or black spots that a careful faker may have tried to obscure with dark-toned areas of the design.

When chipped, plastic or resin reveals an underlying surface that is solid and shiny, often a clear white color. Ivory, in contrast, should not be shiny, and the surface revealed by a chip does not present such a sharp contrast in tone to the outer layer. It should be uneven, as one would expect with a natural material.

Often, you can still identify the odor of the resin, especially if you warm the suspected imitation. Also, when you touch the object, remember that plastic feels warmer, and does not conduct the heat away from your hand as readily as ivory or bone would.

A sure test of authenticity involves heating a needle and gently inserting it into a place on the base of the object where the mark will not show. It is difficult to get a hot needle tip into

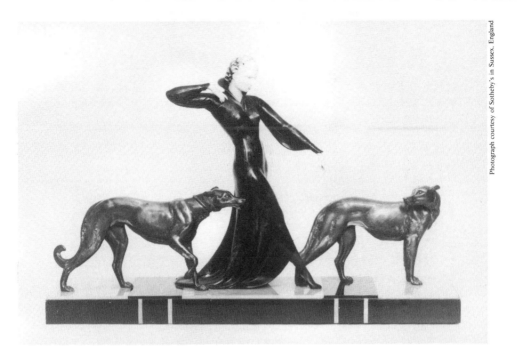

Photograph courtesy of Sotheby's in Sussex, England

Art deco collectibles are all the rage and the 1930s are close enough to our own era to make the faker's tasks easier. But the faker would battle to mimic the ivorine and onyx used in the group pictured here, and probably could not turn a profit even if such a copy fetched the $640 this genuine piece raised at auction.

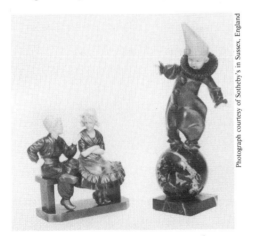

Photograph courtesy of Sotheby's in Sussex, England

Ivory figures were sometimes painted to increase their attraction, which helps the faker. But areas of the precious material, particularly the base and exposed skin on figurines, help in distinguishing real ivory from the many realistic resin substitutes used in copies.

ivory or bone, and you will pick up the same smell that is emitted when a dentist drills your teeth to insert a filling. On the other hand, the hot needle will go into plastic or resin very easily, giving off a noticeably different burning smell. In addition, you will be able to see how the plastic melts around the point of entry.

The style of the work also provides many clues to forgeries, but you need to be quite expert in a particular field to spot the better fakes. The way in which scrimshaw lines are engraved, the form of the lettering, and the general style in use of perspective and proportions, together with the degree of craftsmanship, all provide clues to an experienced eye. Plus, as in other areas of faking, the forger is copying with

191

great care, so the work lacks the confidence and spontaneity of an original.

Particularly difficult to spot, even for the expert, is the case in which a genuinely old (but not very valuable) piece of scrimshaw has had lettering or illustration added to make it worth more. A hundred years ago, for instance, the sailor may have whiled away weeks of enforced idleness at sea by engraving, in a charmingly naive way, the picture of his ship. This work could be enhanced for the contemporary market by the addition of a crest, a flag, or some lettering to make the piece more interesting and valuable. If you suspect such to be the case, look for stylistic differences, something that is out of context with the period, or incorrect proportions. The addition may be reduced, for example, because there was too little space left to incorporate it properly into the original design.

Much original scrimshaw was both undated and unsigned. If a piece is packed with this kind of information, it could be that a forger has been working overtime to try to add value to a phoney collectible.

Note that if a piece appears to be ivory, but is not described as such in an auction catalog, it is because the auctioneer's experts have already decided that it is a reproduction. In addition, a responsible dealer or gallery will give a written description of both the material used and the probable date of origin for a supposed bone or ivory piece. The responsible dealer will also refund your money if the smell of burning plastic results from penetrating the surface of the object with a hot needle, or if you have other good reason to doubt the authenticity of your purchase.

Of course, making a claim can be impossible if you have picked up a bargain in a faraway bazaar, hotel, or airport shop, where many such fakes are offered for sale.

Japanese Collectibles

The faking of Japanese *netsuke* and *okimono* pieces is a particular problem, as these small carvings in ivory and wood have been reproduced in plastic, bone, and wood for many years, ever since Westerners started collecting them. The result is a market in which forging is very attractive.

China is a prolific source of modern reproductions of these collectibles, some of which are made from new, illegally obtained ivory. Look for indications of artificial aging in items you suspect to have originated in this manner.

Wood-Carved Collectibles

Wildfowl Decoys

Now that genuine examples of wildfowl decoys are fetching very high prices—and may pass the $100,000 mark before long—potential buyers should be very cautious about any purchases they might be considering in this area of the collectibles market. Faking of very expensive genuine pieces is still rare, because the dealers and collectors prepared to pay large sums are knowledgeable of the style and authentic methods by which the masters have identified their work. Many of the best examples were not originally marked at all, but have clear *fingerprints* of style and quality the expert can recognize easily.

I found large quantities of decoys being faked in the Far East and then passed through Europe to the U.S. where the main market is located. Some had very convincing artificial faking of the paint and wood, but others indicated the difficulty of reproducing a genuine old working decoy. Such

Chessmen are faked and traditional designs reproduced realistically in various materials. If a set is claimed to be handmade, compare the pieces to see whether they are really carved and so differ slightly in detail, or whether they are simply molded. Look at the bases both for evidence of genuine age and as a place to conduct tests, such as touching with a hot needle to differentiate ivory from plastic. Often you can determine a cast-resin reproduction just by the smell that results from puncturing it with a hot needle.

an original, for example, has been re-painted before each season, and shows the natural wear of use (including immersion in water for long periods), which lacks the smoothness, irregularity, and other effects of accelerated aging.

Collectors also need to be alert for hidden repairs, especially the addition of freshly carved beaks, or even complete heads, for those that have broken off. Some cracking of the wood is to be expected in an old decoy, and may be interpreted as a good indication of age.

Fake Horses from Spain

Carousel horses are likewise fetching enormous prices these days. In response to this trend, some very attractive fakes manufactured in Spain are arriving in the U.S. and various European countries.

These copies are the smaller horses designed for junior rides, beautifully carved in both genuine old wood and wood that has been artificially aged. In London, a major shipping point for the ones bound for the U.S., the horses sell to American dealers and their inventory pickers for around $300 in the bare wood (and later retail readily at twice that figure or more). Some are then painted to increase their attractiveness, often with the paint also artificially aged. Holes may be bored through the top and bottom of the horse to deceive buyers into thinking they had actually been mounted on carousels.

Tap and examine closely any carousel animals to see whether they are of solid or hollow construction. Check to see whether defects have been heavily doctored with wood or plaster filler. Look for joints, as well; if the horse has been assembled from several pieces of wood, it may come apart with changes in temperature and humidity. I bought a carousel horse that began to fall apart when it was exposed to the California sunshine. The four legs dropped off first, revealing that each had simply been connected to the body by straight glued butt joints without any doweling—a mark of very inferior craftsmanship.

Trickery with Ships in Bottles

Models of ships are among the most attractive display collectibles, particularly those in bottles, which have been made by nautical men for centuries. The genuine ones are basically built outside the bottle, then inserted through the narrow neck with the sails and rigging laid flat against the hull. Threads attached to the masts are then used to raise the rigging, after which they are snipped off.

Occasionally I encounter fake ships in bottles that are blatant shortcuts to the real thing. The bottom of the bottle is cut off around its circumference to provide a wide entrance through which a completely assembled model ship is inserted. The base of the bottle is then glued back on and the joint covered by an appropriately nautical band of rope or cord, perhaps plaited or knotted

for decorative effect. This is far quicker and easier than the skilled and time-consuming business of getting everything through the narrow neck.

A genuinely old model ship can often be bought for a good price because the rigging has sagged and looks dilapidated. If you find one of these bargains, you might try to tighten the rigging by wetting it with either water or alcohol so that it shrinks. In extreme cases, you can take up the slack by curling it around a long needle, toothpick, or sharpened match stick, and gluing the resulting ball of thread down against the hull where it will not be too obvious. But be sure to use a quick-drying glue, or you will never hold the thread in place long enough for it to stick.

Finally, look for signs of repeated painting in an example purporting to be old and genuine. It was normal for showmen to repaint regularly without stripping the old paint off, whereas fakers paint only once.

In one shipping dealer's premises in eastern England, I came across scores of carvings of horses and riders. They were mass-produced and imported from India and looked convincingly old. The dealer did not try to pretend they were genuine—he could hardly do so with such an enormous stock—but once these copies have changed hands once or twice, some of them are eventually bound to be used to deceive less-than-careful buyers.

Other Examples of Folk Art

Other forms of wood carving that reflect the traditions of American folk art are now being reproduced in substantial quantities. Predictably, collectors of these items—which include toys, sculptures, smoking pipes, ship models and figureheads, and signs of various kinds—need to specialize in order to be able to identify the old from the new and the good from the inferior.

For example, traditional styles of dollhouses are being reproduced, some of them assembled from very low-cost kits and then artificially aged. The fastenings, paints, use of plywood, and other details usually enable the collector who is familiar with the genuine article to establish the age and authenticity of a dollhouse without much trouble.

CHAPTER FIFTEEN

INSTRUMENTS

Instruments

In Europe, the U.S., and the East (particularly Japan), professionals ranging from doctors to engineers are fueling a boom in the collecting of scientific instruments of various kinds. This is great news for fakers, since the scarcity of good antique scientific, astronomical, and measuring instruments (outside of those already housed in museums and private collections) means that quite a few buyers will be susceptible to the appeal of convincing phonies of one sort or another.

If They Don't Work, They're Probably Phoney—and Other Simple Tests

Fortunately, there is a very simple test that rapidly eliminates many of the fakes. If the instrument doesn't work honestly, it is probably a recent copy. However, that is not an infallible general rule, as for hundreds of years, display copies were made of attractive instruments, such as the astrolabes used as portable sundials and star charts. Many of these reflect woeful ignorance of astronomy and simply do not function.

However, the vast numbers of replica microscopes around do work reasonably well, some with better optics than the genuine antiques they mimic. Particularly collectible are the replicas that American pharmaceutical companies used to give away to doctors to promote their products.

Responsible replica manufacturers over the years have incorporated marks or other devices to prevent their products from being passed off as originals. For example, magnets were incorporated in very high quality replicas of the classic John Cuff microscopes. The originals were made entirely of brass, so a simple test with a compass reveals these replicas. (A pocket compass and a magnet are always useful aids to collectors as they evaluate objects with differing magnetic properties.)

Of course, many existing replicas do not include such devices or protective disclaimers. These can be aged easily by the application of nitric acid or sulfur to generate an artifical patina, after which they might be shaken up in a box filled with nuts and bolts to distress the surface in a very realistic way.

Frequently, a copy bears the name of some original maker, but the name has been misspelled by the copyists in an effort to escape the legal consequences of their piracy. Also, its workmanship may be inferior, although in

the field of old instruments, this is not an infallible check. Remember that the genuine instruments were essentially functional and not styled or fabricated at the time with much regard to attractiveness. Thus, many fakes give themselves away by having engraved embellishments added strictly for eye appeal.

When contemporary fakers attempt to enhance old pieces by adding decorative engraving or by forging a signature, the new work generally has sharp, clearly defined edges quite distinctive from the smoother feel of old engraving that has been subjected to natural wear. A later forged signature or stamp on an old piece will have been put on top of the already aged surface, so watch for unnatural breaks in the patination as another sign of such activity. For example, if a scratch starts and finishes on either side of a signature, but does not run through that area, it is because the signature has been added to the surface at a later point.

Although some collectors think they look a lot nicer, highly polished brass instruments without a natural patina must always be suspect because cleaning can disguise a great deal of faking, such as the replacement of missing or damaged sections with new components to inflate value.

Museums can test the age of brass by a complex spectrographic analysis of molecular structure, but you can buy from better hardware stores and engineers' suppliers a simpler device that spots many fakes, even if it seems that any genuine patination has been destroyed by vigorous polishing or the removal of paint. The device is the readily available and inexpensive micrometer, with adjustable jaws and a scale that enable the thickness of a piece of metal to be measured very accurately. If the thickness of the metal used to make the piece you are examining varies and does not match the standard metric and Imperial gauges which were adopted this century, you have a good indication that the piece is really old. Of course, it could still be a modern replica made from old material, but that is unlikely.

Comparing details of the style of hand-engraved and -stamped letters and numbers of the different periods can be a valuable aid in assessing the authenticity of instruments bearing such identifying marks. For example, Scotland Yard's detectives have investigated a number of incidents of the faking of scientific instruments by an English forger whose work sold well to French dealers for a time. He made the twin mistakes of using modern brass sheeting—revealed by the micrometer test described earlier—and of letting certain idiosyncrasies slip into the style of lettering he used on all his fakes.

Popular Subjects for Instrument Fakery

The recent surge of market demand for outdoor display pieces is stimulating the faking of sundials and is boosting the prices of the replicas of earlier pieces produced on a large scale in England during the 1920s and 1930s. Pocket sundials, telescopes, and other attractive instruments were all copied in Europe during the eighteenth and nineteenth centuries and, although they are now collectible antiques in their own right, you should not pay anywhere near as much for them as you would for the originals.

Early medical instruments are much in demand to decorate the offices and reception areas of medical

Despite the sophisticated weather forecasting services now available, many people still like to have barometers to use and display in their homes. This demand results in barometers being reproduced extensively and passed off as old. Usually, the mechanism on such a reproduction—and the glass of the thermometer, if one is also fitted to the case—is distinctly new.

practices, so they too are being faked, although not yet on a large scale.

Barometers, which look good in almost any office or home, have been reproduced in traditional styles for many years. Look very carefully at the wood and metal components and the quality of construction before buying what you are told is an antique example of one of these.

That ancient counting device, the abacus, is still being made today in traditional styles and is particularly popular among managers of small shops in Japan, despite the advent of the electronic calculator. So not all abacuses are necessarily old, and new ones made in traditional materials can be aged easily.

Globes, of which few genuinely old examples survive in good condition, are especially popular display pieces. In this category, extensive renovation or modern reproductions are disguised by dark varnish, which gives the appearance of age. Another way to check for authenticity is to spin the globe and put your fingers on it and the scales that surround it so you can identify where natural wear and soiling would occur. If the appropriate surface marks are not present, you almost certainly have a modern reproduction. (See also the furniture chapter for a number of tips to help in judging the authenticity of the stands that hold the globes.)

Scales of different types have become very collectible and so are attracting the faker's interest. While the instrument itself may not be a reproduction, there are plenty of fake sets of weights around. Check that the weights are of compatible metal and workmanship with both the instrument they accompany and the period

Fake violins have plagued both musicians and collectors for many years. A sure way of authenticating one is to get an expert to play a tune and analyze both the tonal quality and his or her reaction to the "feel" of the instrument.

Because old horn gramophones fetch enormously high prices these days, an otherwise valueless turntable and base may get its value boosted by the addition of a reproduction horn in various materials. In particular, check that the horn's weight is a good match for the arm so that the unit is properly balanced to work.

A new mass-produced reproduction that shouldn't fool anyone is the old valve radio containing modern transistorized electronics. This is an attractive display piece, but it does not have the potential to increase in value the way the genuine article has done, in spite of advertising claims to the contrary.

from which it is claimed to date. Some are so poorly made that they are not of the correct weight and do not nest properly on top of each other when stacked.

Particularly interesting collectibles are the various instruments and devices made up from books and drawings. These have more value if made in the period appropriate to the publication of the instructions and not reproduced recently to be passed off as genuine old examples. Detailed plans and assembly instructions were widely published in mass circulation periodicals during the nineteenth and the

Bracket clocks are well worth faking; this one, for instance, carried a price tag of $6,000. Look out for substitution of movements and fake dials with forged signatures or maker's marks.

early twentieth centuries, when making all kinds of gadgets that now have more display than functional attraction was popular. The contemporary faker can find originals or copies of these periodicals and reproduce the designs easily because they were intended for amateurs with limited workshop facilities.

Some fake instruments made from published information actually never existed. Among the collection of fakes collected by London's Scotland Yard Antiques and Fraud Squad is a nautical hemisphere that was illustrated in a seventeenth-century book, but never actually produced.

Clocks

Clocks, the most popular measuring instruments of all, are being reproduced on a vast scale and passed off as genuine examples of old designs. A close examination of the casing and of the internal mechanism yields numerous clues to the actual age of outright reproductions that have been artificially aged, but be particularly careful about old fakes—clocks that may be genuine antiques, but were copies of earlier designs.

The tips on identifying age in metals (Chapter 3) provide some clues to authenticity. The gilding on the case, for example, could be an immediate giveaway. It should be high quality and show signs of natural wear and aging.

Another obvious sign of tampering could be that the marks on the case made by the pendulum and weights do not match up with the positioning of wear marks made by the currently installed pendulum and weights.

Look especially for natural wear on pulleys and on the bearings on which the pulleys turn. Because of pressure exerted by the weights, this wear should be considerable in an old clock.

One of the most frequent deceptions practiced with clocks is to *marry* different elements of dial, case, and movement in the same way that pieces of furniture are married together. This can change their perceived date of origin or some other aspect of collectibility that affects value.

For instance, since the prices of long case clocks have multiplied many times in recent years, fakers find it very worthwhile to reproduce the cases and put in movements and dials from other, less valuable clocks. The whole combination is then passed off as original.

You can check the age of a wooden case in the same way that you verify that of furniture. Compare quality, in particular; a good clock will have a quality case. If there is obvious disparity between the craftsmanship and quality of materials used in the different components of a long case clock, suspect a marriage immediately.

In addition, see that the dial and movement fit properly within the case. Any clock case that obscures parts of the dial, or does not properly frame it, should be taken as a warning sign of a marriage.

Types of dials include painted wood or metal and engraved or enameled metal, all of which are being faked. Check for the natural effects of aging, such as grazing of paint or cracking of wood, and look at the back of the dial to see whether it is compatible with the style and apparent age of the front. Also, do the fixing holes or clips holding the dial in place match up? Are there any holes that should not be there? These would indicate that the dial does not belong in this case. If the face has been reworked, the holes may only be visible from the back, where you would see indications of filling with a plug of a slightly different color. Use the silver faking test and breathe on suspect areas to highlight joints and soldering.

When marrying a dial and movement together, the faker is very lucky if the holes for the winding key match up exactly, and as a result, usually has to fill in the old hole and make a new one. It may be that the existing hole in the dial has been enlarged and an attempt made to conceal this by putting a ring around it. However, some wear around winding holes is inevitable, and in these cases, the holes may have been innocently ringed at some time to tidy up the appearance of the clock.

Blocked holes in the casing of the movement may indicate repairs that will influence its value. Still, you expect an old clock to have been repaired and worn out parts replaced during its life, so the important thing to assess when such repairs are discovered is which ones are genuine maintenance and which ones recent alterations.

Another test for authenticity is to check that the board on which the clock sits inside the case is a natural fit, and be sure that there are not extra screw holes there to indicate that changes have been made. Sometimes this seat board will have been put onto blocks to raise it, an action that would be unnecessary if the case contained the original movement for which it was designed.

Many quality clocks are signed, and consequently, forged signatures can be an added complication for collectors. Bear in mind that the test for forgery of a painting—the signature should be underneath the varnish—does not always apply to clocks. Many have had the name of the retailing jeweler painted or transferred on top of the glaze and were never claimed to be the work of that shop at all, but were instead merely sold there.

If it appears that the actual maker has signed the clock or added some form of identification to it, look for indications that this was done at the time of manufacture and not later. Compare the style and general quality of workmanship with those of actual authenticated examples or examples found in reference books.

Skeleton clocks, the type sitting in a glass case or under a glass dome with all the works exposed, have been cop-

The amateur collector or investor must tread warily among the proliferation of fake clocks in the marketplace. Buying through an established, reliable dealer, or auctioneer who offers a worthwhile refund warranty is the safest route.

ied extensively. In evaluating one of these, try to verify that all the components belong together, are in the right proportions, and are of the same period. Consider, too, that various clockmakers across the years have taken a spare movement, dressed it up, and put it under glass as a window display. Such pieces must be judged and valued on their individual merits.

Reproductions of such traditional designs as the nineteenth-century carriage clocks, usually box-shaped with a carrying handle at the top, have been produced in large quantities in Europe and the Far East in recent years. These can be attractive and reliable timepieces in their own right, but become fakes when aged artificially and passed off as old.

Watches

Watches—most commonly the contemporary prestigious premium-priced brands such as Rolex—are likewise popular candidates for fakery. Look for quality and authenticity in the packaging and accompanying documentation for these, and be sure that you get a genuine international guarantee when buying new.

Old Rolexes are also fetching good prices these days, as are old fakes. Beware of bargains, particularly in the Far East, and buy only from established specialist retailers who will give written guarantees of authenticity.

There are two main types of fake watches: the reproductions, which could be genuine antiques but are copies of earlier pieces, and the pastiches made up of a hodgepodge of components.

Since most watches are made to be used, collectors should not be surprised to find that the dials and cases on many of them have become so worn that previous owners have been forced to replace them, doing so without any intention to deceive. These are not fakes unless sold as complete originals. If you suspect that such an example is being presented fraudulently, check carefully to see whether the watch case, the dial, and the movement all belong together.

Because there has been extensive forgery of watchmakers' signatures and other marks over the years, as well as numerous instances of the sharing of many different components from a single supplier, you may find the same cases or movements bearing different marks.

Some phoney watches do not even have proper working parts and can never keep the time. Some of these were made in Holland during the late nineteenth and the early twentieth century. Fakes of contemporary famous-name watches without working parts are still produced in the Far East, along with other examples that use cheap quartz electronic movements instead of the expensive high-quality mechanical movements of the originals.

CONTEMPORARY

CHAPTER SIXTEEN

FAKES

Contemporary Fakes

There is an international epidemic of faking and forging contemporary products, both consumer goods and, as described in the chapter dealing with transport, the replacement parts and other equipment that industry needs to survive. And there is no indication that the problem can be eliminated, although efforts are being made to reduce its scope.

The Range of Possibilities

The General Agreement of Tariff and Trade (GATT, the major international trade-regulating organization) says that counterfeit products are a worldwide problem affecting many key sectors of society in developed and developing countries: manufacturers and producers, consumers, governments, and employees.

"The trade runs into some billions of dollars per annum, is growing, and is becoming increasingly diversified," says GATT. While organizations such as GATT are concerned particularly about the health and safety risks of inferior pirated products such as chemicals, drugs, and automotive and aircraft parts, it's worth noting that a report prepared by the European Communities of nations in conjunction with the European Association of Branded Product Industries says that "no industrial or agricultural sector of trade is immune." Thus, any number of present and future collectibles could be affected by this disturbing trend. For instance, when a trade fair in Tokyo was raided, police seized 20,000 items of fake merchandise including Gucci leather goods, Dunhill lighters, and Rolex watches.

Indeed, instances of contemporary fakery run the gamut from the whimsical to the highly consequential. Among the weightier cases are incidents of honest scientific researchers innocently accepting fraudulent data and using it as a basis for their own investigations. At the very least, this false data leads them up blind alleys and causes a criminal waste of resources needed desperately to tackle medical and technological problems.

Scientific faking creates the false *provenance* that is so important in peddling collectible forgeries, but its implications are far more serious. Scientists rely heavily on sharing the results of their research to ensure progress and to avoid duplicating lengthy and expensive work. Fake results originating at respected institutions such as Yale or Harvard acquire the same kind of credibility attributed to a work of art authenticated and cataloged by Sotheby's or Christie's.

Get the Jump on Golf and Angling Memorabilia

A new area of collecting that can be a lot of fun and is not yet bedeviled by fakes is golfing memorabilia. Golf has been known since the fifteenth century, but most of the current collectible material dates from Victorian times. The field is vast. In addition to focusing on clubs and bags, collectors can search for old golf balls, scorecards, trophies, clothing, medals, programs, tees, postcards, cigarette cards, stamps, and a number of other items linked to the game. All are likely to become prized as the popularity of this field gets a boost.

Replicas of antique golf clubs do exist, especially for the more desirable ones made prior to the turn of the century, of which some beautiful examples are being handcrafted in Britain. The good news is that they are currently sold openly as reproductions. But the prices of golf memorabilia are rising so fast that fakers might soon attempt to pass the replicas off in quantity as originals. With Sotheby's selling a single eighteenth-century wooden club for more than $20,000, the temptation is certainly there, so look carefully for signs of genuine wear on the handles and heads of prospective purchases.

A golfing painting by Charles Edmund Brook sold in London for more than $35,000, but most memorabilia of the sport is far more realistically priced. You can still pick up genuine bargains at swap meets, garage sales, and antique shops.

A good source for genuine collectible printed material about golf is old magazines. Such publications are especially valuable if they can be framed for display. In addition, a number of good collectible golfing books can be found in library shops and secondhand bookstores, with the sellers not yet fully appreciative of the prices these can realize among collectors.

Prints of golfing scenes are being reproduced in sizable numbers (see the chapter on documents for clues to detecting reproductions). Often an old monochrome print has been recently hand-colored, which can make it more attractive, but reduces its authenticity and potential resale value.

Collecting angling pieces is a growing sphere as well, and one in which I have found little evidence of faking. However, it is easy to artificially age mounted stuffed fish, which are fetching steadily increasing prices because of their applications for interior decorating. Vintage reels are fetching high prices also— more than $1,000 for good collectible examples—so they are a temptation to the faker and comparatively easy to reproduce at prices that will show a good profit. As a precaution, look for signs of genuine wear and examine the maker's marks closely.

This genuine shoal of dace dating from 1921 was sold by Sotheby's in Sussex for around $1,700, illustrating the rising prices for stuffed and mounted fish for interior display.

So I have no hesitation in paying tribute to those working to unmask scientific fraud for the public service they are rendering. In particular, June Price Tangney, of Bryn Mawr College in Pennsylvania, has conducted a unique study as part of this effort. Ms. Tangney distributed 1100 copies of a questionnaire on scientific fraud. Of the 245 scientists who bothered to respond, a staggering 32 percent reported that they had a colleague whom they suspected of falsifying data, and most had taken no action to reveal it.

Other types of contemporary fakery might be intended to deceive a particular group of people, but without any kind of repercussions for society. Signs and bars, for example, are a popular area for reproductions throughout the world. There are more copies of bar mirrors carrying advertising messages coming into the U.S. than would fit into all the English pubs ever built, and complete pub bars are now fetching high prices. Some of these have been constructed from fragments of demolished pubs, and are easily identified because they are usually made compact to fit into contemporary homes— never large enough to have been used commercially. You can also watch for those featuring new woodwork and phoney stained glass and brass fittings.

Definitely at the opposite extreme from scientific fraud are many of the fakes of royal memorabilia. The 150th anniversary in 1987 of Queen Victoria's ascension to the throne has stimulated demand for both genuine and fake Victorian memorabilia of all kinds—the Queen's knickers, for example. Queen Victoria would use her underwear only a few times before giving it away to her maids. These *Victorias*, as they are known in the antique trade, are now coming onto the market and fetching around $150 (with prices likely to rise substantially in the future). Genuine examples are very well made (linen with fine embroidery of the royal cypher), and usually are numbered.

Depictions of Prince Charles's ears typify the interest in more strictly contemporary royal memorabilia. Prince Charles's big-ears mugs were first issued at the time of his wedding in 1981 and have increased by more than 1000 percent in value, causing reissues and copies to be made.

Entertainment celebrities such as the Beatles and Elvis Presley are constantly inspiring a tremendous number of collectibles and imitations. With Beatlemania sweeping the world again, prices are skyrocketing for any memorabilia relating to the group. Beatles' concert programs, games, sweatshirts, toys, and other linked products are fetching $100 or more, so expect a wave of fakes and reproductions coming onto the world market. Some of the Beatles' records in their sleeves can fetch $200, and letters, drawings, and other "one-off" relics of the group can go for thousands at auction.

The first wave of Beatlemania generated more than 2000 items of merchandise linked to the group. This merchandise has not been worth faking until recently. Many of the old molds and printing plates are still around, or can be copied easily, and their endproduct is very difficult to distinguish from originals, which have not had the opportunity to develop telltale signs of age.

Fighting Back

Although it may seem from such examples that fakery is running out of control, invading every aspect of contemporary life, help is on the way. Several international organizations have been formed to try to police the faking business. In addition to the special anticounterfeiting bureau established by the International Chamber of Commerce in Paris, there are related groups in Britain, Italy, and the United States. The U.S. International Anti-Counterfeiting Coalition represents 250 corporations, and is trying to make counterfeiting of manufactured goods a criminal act worldwide, resulting in mandatory jail sentences.

A major problem for this effort is that international law is very weak in protecting trademarks and manufactured goods. In the first place, there is not an internationally accepted definition of *trademark*. Many countries are not part of the Paris Convention, the principal international instrument for protection of industrial property, or other important agreements. National laws often do not harmonize with the international agreements or are not enforced properly. Counterfeiters even budget for their payoffs to police and other officials in many countries.

But more responsible companies are starting to act to prevent counterfeiting. This has created a boom in demand for the services of private investigation agencies, which can be far more effective than any of the international organizations or national police forces. The acknowledged leader of these specialist pirate-hunting consultancies is Carratu International in England, founded by former Scotland Yard fraud squad detective Vincent N. Carratu.

The findings of such agencies are intriguing and sometimes dangerous. An investigator working to combat the multibillion-dollar movie- and video-piracy business, for instance, told me he had been threatened with violence frequently as he worked to uncover a video- and film-piracy ring that depended on new-release movies shown during international flights. The movies were being taken off the planes during overnight stops, copied, and the

Photocopiers and Recorders Aid the Faker and the Pirate

Photocopiers have become so sophisticated, that they are used in various ways to help forgers and fakers in their work, especially as they copy documents and packaging.

The biggest fraudulent use of photocopiers is for piracy: the illegal copying, for gain, of expensive newsletters, market research reports, books, and other like items.

Some people have used red colored paper to defeat the pirates. Information on red paper is difficult to copy because the copier confuses the paper with the black ink of text. Unfortunately, red paper also makes the original difficult to read, and thus has not proved very popular. But a pirate-proof paper is being developed that carries an invisible warning, such as unauthorized copy, *which is revealed only when the paper is photocopied.*

Copyright owners also benefit from electronic devices designed to protect original video and audio programs from being taped, but these have been the subject of long legal battles and are not popular with consumers.

At any rate, it seems that as fast as protective systems are developed, pirates develop devices to outwit them.

originals returned before the flight left for its next destination the following day. The film print copies were being processed through a legitimate laboratory without the owners being aware that they were part of the piracy business.

Of course, chasing and catching fakers can be dull, routine work extending over months (and sometimes years) of painstaking investigation. But some agents go to extreme lengths to serve their clients. A private detective working for New York's United Intelligence Inc. on assignment for Chanel went parasailing to get a bird's-eye view of an illicit perfume-manufacturing operation on the eleventh floor of a beachfront building in Acapulco, Mexico. He was towed by a speedboat past the building until he soared high enough to look in through the window with binoculars and catch the fakers at work.

Despite this kind of effort, much work remains to be done in the fight to eliminate the wealth of fakes that currently exist. The counterfeiting of perfumes, for instance, is now such a vast operation that U.S. Customs agents in Florida needed a bulldozer to destroy just one shipment of 10,000 bottles of fake Giorgio perfume valued at $500,000.

I have been inside video pirates' copying rooms that were stacked floor to ceiling with tape machines. The tape machines ran day and night, turning out illicit copies, some of them third or fourth generation. Consequently, these copies were of very inferior sound and picture quality, but they found a market just the same.

South Africa was one of the worst places for movie piracy until international pressure prompted authorities to clamp down on the trade. However, local interests in South Africa are now eagerly awaiting the extension of sanctions against apartheid to more intellectual properties. These extensions

would open the door to enormous profits by internally legitimizing the acquirement and duplication of movie prints or videotapes overseas—thus removing the need to sign expensive licensing agreements with the original copyright owners.

The piracy of records and tapes is another major international faking business with annual turnover running into billions of dollars; nobody can guess intelligently just how far. In Taipei I found music stores selling nothing else but pirated recordings, some with the original labeling copied meticulously in a tribute to the printer's craft. In New Orleans I was openly offered pirated copies of famous traditional jazz performances.

As this book went to press, there occurred an apparent breakthrough in methods of detecting pirated copies of contemporary products. Authorities have devised a method of coding that contains 50 times more information than the conventional bar codes now so familiar on product packaging. This new code, which is very difficult to copy, enables Customs offices and investigators to read the equivalent of a fingerprint on a product and assess quickly and accurately whether it is genuine.

APPENDICES

Appendix A

Museums and Auction Houses

The Auctioneers' Battle with the Fakers

One of the world's best-known auctioneers, Leslie Weller, who runs Sotheby's in Sussex, England, has a collection of intercepted fakes in his office. He enjoys the daily challenge that he and his staff face in outwitting fakers and forgers, but warns collectors that the volume of phonies of all kinds out in the marketplace is growing steadily.

"Of course, there is nothing new about fakes," he told me over lunch in the magnificent Sotheby's mansion. "Nearly every Chinaman in the nineteenth century used to have a reproduction Tang horse or a Ming vase under his bed to sell to some unsuspecting European. In that time, the Victorian era particularly, almost everything collectible was copied, usually without the intention to deceive. Now those copies have become antiques in

Leslie Weller of Sotheby's conducts an auction. He and his staff of experts have prevented many fakes from going under the hammer, and he keeps his own personal collection of the best examples.

their own right, but I am disturbed how often attempts are made to pass them off as originals from an earlier period.

"As another example, there is a certain amount of House of Fabergé work which appeared after the Second World War and now, having acquired the patina of 40 years, can be passed off more easily as genuine.

"It is impossible to quantify the extent of faking going on in the antique and collectibles field, but it is a very significant international business. The manufacture of reproduction furniture is now an important industry and some of the work is very good and sold perfectly legitimately. The problems arise when this quality reproduction work is passed off as original, often when it has changed hands once or twice. Inevitably, we see a lot of blatant fakes that do not take us in because we are experts, but they will fool those without experience or specialist knowledge."

Weller further points out that fakers often use auctions as a way to slip their work into the marketplace. It is a coup for a faker to get work passed through one of the major auction houses, giving it a provenance or history that can add immensely to the value in the eye of a typical buyer. But responsible leading auctioneers guard against this to protect their customers and their own reputations. They have some of the top experts and appraisers in the field working for them to identify any lots that are suspect, and some guarantee a prompt refund against any fake that slips through their inspection procedures and is cataloged incorrectly. Of course, collectors should be prepared to pay a premium for the expertise these auction houses employ in

Reproductions being peddled as fakes often are slipped into a small auction to help them acquire a provenance, *or documented history.*

sorting out the genuine from the phoney, and then standing behind their decision if they are subsequently proved to be wrong.

The better, more responsible, experts keep records so that they can identify works by the same fakers as readily as they do those by collectible artists. But this also poses dangers, because as soon as one or two fakes are accepted as being genuine, they become comparisons against which further fakes from the same source are judged, and so stand a better chance of passing scrutiny.

Too frequently, because it is extremely difficult to be certain whether a particular work is faked or not, even the best auctioneers have little choice but to accept it for sale. But they reflect

It is essential to go to an auction on viewing days, when time and the absence of crowds enable you to inspect the lots that interest you.

their concerns by cataloging the work only under the artist's surname. If the catalog listing simply says *Rubens,* for example, it is a statement that the auctioneers do not believe it to be by the master himself, but a product of his school or studio, or something in his style that may have been created later.

The artist's initials are added to the surname in the catalog if experts are more confident that the work stems from the right period and that the master may have at least contributed to it. And when a painting is cataloged by the artist's full name, the auctioneers are saying that they are confident it is by the master's own hand.

Watch out, then, for this sort of code, as unscrupulous dealers exploit it ruthlessly. Remember that if you are shown a catalog entry of the work as it passed through a reputable auction house, a listing with just the artist's surname is a warning, not an authentication.

Some dealers regularly channel dubious paintings through an auction, where they are traded straightforwardly as suspect works. Thus, a catalog entry such as *Sale by a gentleman* may in reality mean *This work was dumped into the auction by a dealer who dared not be associated with it directly!*

When such a picture comes back on the market again, perhaps in a different country, it may well be fraudulently traded as genuine. You may find great difficulty in probing its origins because the dishonest sellers can always stall questions by refusing, on the grounds of confidentiality, to reveal the name of a client for whom they are selling.

Museums

Oddly enough, museums contribute to the faking problem in a number of ways, usually by accident. The consequence for individual collectors is that the dishonest are encouraged rather than deterred, as illustrated especially well by the tax problem explained later in this chapter.

The Getty and Other Leading Museums

Here's how the world's wealthiest museum is undoubtedly, even if unintentionally, stimulating the international faking business.

The J. Paul Getty Museum in Malibu, California has a nearly $3-billion endowment and must spend more than $156 million a year—double all of Canada's expenditure on its national museums. That is quite a difficult task, given the limited supply of good authentic art on the market.

As a result, not only has the Getty contributed substantially to driving up prices, but it also makes highly controversial acquisitions that are being questioned by experts in different fields both in the U.S. and overseas.

Like the late J. Paul Getty himself, the museum has bought a number of fakes. (The world's richest man had a "Raphael" that hung in his museum for a long time before it was discovered to be a reproduction.) In fact, many experts believe that two of the Getty's proudest antiquarian pieces—its Head of Achilles and a carved marble tomb relief, both from ancient Greece—are fakes. The only way to prove conclusively whether the pieces are authentic is to drill out core samples of the marble and subject them to a battery of tests, a very controversial procedure for valuable works reputed to have cost

The crowds and activity of an actual sale day make it impossible to examine the lots properly. This is the scene at a classic car auction in Phoenix, Arizona; even among the bidders close to the auctioneer, many can only see a video-screen image of the old Rolls-Royce being sold.

the Getty around a million dollars each.

Already, the Getty has needed to use this technique to authenticate its *kouros,* a $6-million Greek figure of a youth that was challenged by outside experts. The case illustrates the high cost and complexity of distinguishing the genuine from the phoney. Using x-rays, analyses of core samples, and various other complicated tests, University of California geology professor Stanley Margolis and other experts spent more than a year in order to prove that the marble came from the right region and had been aged naturally, so that at least its geographical origins and period were authentic.

Not so happy were investigations carried out by the Metropolitan Museum of Art in New York, revealing that its famous Egyptian bronze cat is actually a fake. The St. Louis and Dallas museums of art also found recently that they were among a number of museums that had bought pre-Columbian sculptures from Mexico that are now known to have been faked.

Rodin and Remington Rip-Offs

On both sides of the Atlantic, reproductions of the work of American sculptor Frederick Remington and of France's Auguste Rodin are being peddled as genuine on a large scale. A particular problem is that their works were so popular and widely available, it is comparatively easy to create a false provenance for these copies by pretending they have just been discovered in some attic or basement.

The situation with Rodin works is especially complicated. A recent exhibition of more than 100 Rodin marbles in France, some on view for the first time in 50 years, included ten fakes by an obscure French sculptor. Indeed, Rodin's work was so prized even in his lifetime that, like some of the old masters in the painting sphere, he worked with squads of assistants hired to do the more tedious work on his sculptures. Consequently, these assistants could have been expert at making fakes as well. And of course, even if a Rodin marble or bronze is determined to be genuine, it is very difficult to tell just how much of the final sculpture actually stems from the famous artist's own hand.

All over the world, leading museums have fakes on display. Most have acquired so many, they have a section of them that they keep carefully out of sight in the vaults so as not to be publicly embarrassed by their mistakes.

Copying Their Own Genuine Originals

Collectors should also be aware that a large proportion of the world's most famous museums make a good deal of money by selling replicas. Stone, marble, or metallic powders are added to the casting resin used to reproduce sculpture, for example, and there may be extensive handwork to give the replica the color and surface of the original; the molding process even reproduces original damage very accurately. Museums also make replicas of jewelry, officially hallmarking those in precious metals. If items like these are not clearly and unalterably marked as replicas, dishonest owners may try to pass them off as genuine.

Some of the finest of such reproductions include sculptures, perfume bottles, and textiles from the famed British Museum in London. The best-known copies originating there are of the largest collection of early chessmen found in Europe, molded in resin and hand-finished to look and feel genuine.

In Greece, museums and hundreds of stores and workshops offer all kinds of reproductions of ancient Greek art, many produced in the traditional way. Their exportation is a major industry and they can be very cheap. I was offered pictures, statues, parts of vases, and other copies from ancient Greek originals, all handmade, some of them priced as low as two dollars. These are attractive souvenirs and display pieces—innocent enough until somewhere along the line, someone tries to pass them off as originals, at which point they become fakes.

Unique Exhibition of Fakes in Baltimore

The former director of the Metropolitan Museum of Art, Thomas Hoving, estimates that as much as 60 percent of the art he has seen for sale during his many years of experience could have been faked. While few other museum directors put the proportion that high, the increase in forgeries is acknowledged by many to be quite serious. The Walters Art Gallery in Baltimore, for example, staged an exhibition of fake art (running through into 1988) including a dozen works thought to be genuine that were purchased for big prices.

Walters Art Gallery Director Robert Bergman said that fakers are "taking worthless reproductions of prints and paintings by Dali, Picasso, Miro, and other modern masters, forging signatures and edition numbers, and then selling them as original prints for thousands of dollars. In fact, they are worth the price of the frame."

At the opening of the fakes show, Bergman cited the case of nineteenth-century forger Reinhold Vasters, who was unmasked when a stack of his sketches for fakes was found at London's Victoria and Albert Museum. If those clues had not been discovered, the significant proportion of the Metropolitan Museum of Art's Renaissance decorative arts collection faked by Vasters might still be thought genuine.

The Temptations Created by Tax Laws

Finally, tax laws in the U.S. and several other countries are contributing to the proliferation of fakes. Donors of art and collectibles to trusts and charitable institutions can get substantial tax deductions based on the appraised value of their gifts, and this creates temptations for the taxpayer and the staff involved in accepting the donations. A fake or inferior piece may be offered to a museum, and the curator or a member of the curator's staff appraises it and issues the donor a receipt for tax purposes. Either by accepting the fake or giving an inflated value to an item, museums defraud the Internal Revenue Service of thousands—or maybe even millions—of dollars.

One such instance currently under investigation involves $750,000 in items donated by a single collector. The leading museum involved conducted its own internal inquiry without notifying the authorities, which partly explains why these deceptions are very difficult or impossible to uncover. Museums tend to be secretive about their affairs, and often, misbehavior by staff never becomes public knowledge. Occasional occasional media revelations of tax scandals at museums are but the tip of the iceberg as so much of this criminal activity goes undetected.

The problem is complicated by the fact that if the donation tax deduction is challenged successfully by investigators, the museum can avoid prosecution simply by admitting an error of judgment.

Appendix B

The Secrets of Bargaining

How to Pay Less and Get More

Identifying fakes is not the only way to avoid having someone take advantage of you.

The other way is to have a basic rule never to pay the asking price, and to break the rule only in the case of very low cost purchases or exceptional circumstances.

Marking up prices to show 100-percent profit is commonplace in retail outlets dealing in collectibles. Retail markets must mark up because their business (in many cases, *most* of their business) is with members of the trade, other dealers, or interior decorators.

Decorators generally buy at a discount from dealers who specialize in supplying them, and then sell at a mark-up. That's one of the reasons label prices in many antique and Oriental rug dealers' premises and in galleries are so high. Decorators often bring their clients to these premises and would be hugely embarrassed if the clients could see how much more cheaply the outlet is prepared to sell its furniture, rugs, and pictures. You should automatically bargain in such places and expect to get about 30 percent off the marked prices.

Negotiating a lower buying price is perfectly respectable, makes good common sense, is not a social *faux pas,* and does not indicate that you are poor. In fact, as most dealers know very well, some of the toughest deals are struck by their wealthiest clients.

Yet American and British buyers particularly seem to get easily embarrassed about trying to reduce marked prices, whereas in the East, Asia, and much of Europe, haggling is a natural way of life. You can see this firsthand at the up-market dealerships around Knightsbridge in London, in the fashionable avenues of upper Manhattan, and in the smart shopping areas of other American cities. Both fakes and genuine collectibles are sold in imposing establishments at inflated prices by often arrogant sales staff. And to whom do they sell? Generally, their clients are people who otherwise drive hard bargains, but who pay out with hardly a murmur when brought into the unfamiliar territory of antiques or art.

Of course, you must expect such establishments to ask comparatively high prices in order to cover their impressive decor, rents, and salaries. But their prices should not be so far above the norm that your purchase risks becoming a bad investment.

Consider apparently free services such as elegantly served refreshments, packing and delivery, and interest-free credit. They all cost money, the only

source of which is an extra margin added to the prices paid by the customers.

Don't be intimidated by the sales staff in such up-market retail outlets. Those elegantly dressed men and women often know much less about the goods they sell than appears to be the case. A keen collector who specializes will soon be able to match wits with them successfully.

If you think something is not what it is made out to be or is overpriced, don't hesitate to say so. There is no need to be rude; just express your concerns as to why you do not wish to complete a purchase. (You may succeed in getting the price reduced.) In this way, you'll gain more respect than if you naively strike a bad deal because you lack confidence to pursue the universal right of both rich and poor collectors: value for money.

At the other end of the spectrum (the wholesale warehouses and so-called trade-only dealers) the business of discounting and negotiation is completely different. In most such places, margins are low and profitability hinges on a fast, hassle-free turnover. Here, the salesperson has neither time nor motivation to engage you in idle conversation. Even though you try to maneuver your way into a substantial price reduction, you may get only a 10-percent discount for cash.

Patronize such outlets as if you are a member of the trade and, when you spot one of the bargains often to be found there, pay up and consider yourself lucky.

Beware, however, of the wholesalers who actively woo members of the public while purporting to sell at trade prices. Often their bargains are not good value for money; they handle a

Don't be pressured into giving up your opportunity to examine a prospective purchase thoroughly. Compare suspect pieces to proven, genuine examples if you can. For instance, placing these two silver figure salt cellars, dating from 1859, alongside a modern fake shows up the differences immediately.

lot of the fake stock moving through the trade.

Another warning: Beware if a dealer reduces the price significantly after very little effort on your part. I have yet to hear big discounts volunteered by an art or antiques dealer who should not be regarded with great suspicion. The discount is probably offered so that you will be tempted to buy without making very careful checks of authenticity.

Be especially cautious if the seller is imposing a time limit or playing on your apprehensions that the next person to come along will snap up such a bargain. In combination, the apparently attractive price and the pressure to complete a deal before it's too late make very powerful selling aids in the final phase of producing and marketing fakes.

On the other hand, if you find a dealer who is knowledgeable about the stock, prices it fairly, and describes it honestly, treasure him or her as a po-

tentially invaluable ally in building up your collection and making sound investments. Just the same, don't always pay the asking price!

Bargaining Tips

In order to bargain most effectively, you need to know a few tricks of the trade—the tricks dealers themselves use to buy the items that you are, in turn, interested in getting from them.

• **If you go into a bargaining situation with even the subconscious feeling that you are prepared to pay the asking price, but will just have a try at getting a reduction, you are almost certain to lose.** Your body language, your general attitude, and what you say send out signals the dealer will pick up. Then, the best you can hope to do is get the nominal 5 percent that is knocked off almost automatically, especially if you pay cash instead of using a credit card or check.

• **Remember that every quoted price is the maximum price the dealer hopes to realize.** Pricing antiques and collectibles is much more complex than pricing contemporary manufactured goods, such as cameras or watches. Dealers in antiques and used collectibles must price up to what they think the market will bear, using as a guide the levels at which similar items have changed hands. They cannot adopt the normal retail trade practices for contemporary goods of having a fixed margin over their wholesale prices or following a manufacturer's recommended retail price list.

As few buyers are naive enough to respond to a *What will you offer?* question about unpriced stock, dealers always have to reveal their maximum price expectations. But the asking price could be a long way above the figure that the dealer would regard as acceptable.

That is why you have every right to bargain. Often the price the dealer has put on an item is pure guesswork. If the item hangs around in stock for weeks, the dealer will probably realize it is overpriced and so will accept a substantially lower offer.

The dealer would certainly be very pleased to get the asking price, but is usually perfectly happy to sell for less. That basic principle holds true for nearly all kinds of sales, and special offers as well. If, for example, a dealer pays $5 for a piece of collectible china as part of a job lot and originally offers it for $20, he or she is not exactly bleeding to run a 50-percent discount sale and reduce the ticket price to $10.

• **You must never reveal the maximum you are prepared to pay.** Why should you, even if you're asked? After all, would you expect the dealer to say how much was paid for the item you are about to bargain over?

In fact, when you're learning how to bargain successfully, it pays not to say very much at all unless you have sound reasons for showing that the item is overpriced. It may be damaged or otherwise demonstrate good grounds for your doubting its authenticity, or it may be priced higher than similar items in other nearby shops. You can point such facts out to the dealer and, if what you say is accepted, get the asking price adjusted downward accordingly.

Expect a shrewd dealer to probe to find out the most you are prepared to pay. You should have an acceptable top price in your mind before bargaining, but always keep it to yourself and concentrate on trying to find out what is the lowest price acceptable to the seller.

Circumstances vary enormously, but a reasonable rule of thumb when buying most antiques is to offer about a third less than the asking price. Say the item is marked at $1,000, and the maximum you are prepared to pay is $850. Offer $650, with the reasonable expectation of settling at around $800.

Often you can go for a bigger discount, depending on the circumstances. I watched my daughter, with the confidence of youth, in her first bargaining experience in the Grand Bazaar in Istanbul. The shopkeeper asked $15 for an attractive ceramic. She offered $3, at which he expressed great indignation, eventually settling for a whopping $4.

Dealing in the West is somewhat different. For a start, it is not really acceptable to bargain hard for low-cost items. And, if a dealer in Europe or the U.S. is prepared to drop prices by a large proportion, there is probably something seriously wrong. One reason could be that the item is a fake—which you have failed to identify—and you and the dealer are talking two different pricing languages. You are negotiating on the basis of its being genuine, while the dealer starts at a maximum price to give the fake credibility, knowing that the purchase price can come down substantially while still bringing a profit.

When negotiating, only increase your offers by small jumps, and be prepared at all times to walk away from the deal. Never be rude or aggressive, and apply some psychology, always giving the seller opportunities to reduce the price without losing his or her credibility. Suggest dealer concessions, for example, that do not have an obvious price factor. These could include restoration and repair work, free delivery, or other such services.

An arrogant, highly opinionated person makes a very bad bargainer. You should be prepared to say that your maximum price is all that you can afford or that the item being discussed is only worth that much to you. I have seen shrewd collectors do this with no embarrassment, even though they arrived at the shop in a chauffeured limousine and absolutely oozed wealth.

After all, bargaining is a game of tactics and bluff, much like poker, and you should accept it as such. Don't be afraid to say you cannot pay more than, for example, $100 for a pair of candlesticks. Neither the dealer nor your friends and neighbors will conclude that you are financially distressed.

Do not put yourself under pressure to accept a deal that is above your maximum price. Only rarely should you be more motivated to buy than the dealer is to sell. Don't underestimate the tremendously strong psychological advantage you have in controlling the money that the dealer wants. Don't lose this advantage by communicating a desperate need for the item he or she is trying to sell. Again, be prepared to walk away if negotiations seem to be deadlocked. Anyone who works in retail sales knows that a customer who leaves saying, "I'll think about it," almost certainly won't be back. That could well be the point at which the dealer capitulates, or at least improves the offer to you.

If you really want the item but don't feel you can offer any more, leave your name and address. That way, the seller who really wants to complete the deal can come back to you.

If you sense that the seller is close to accepting your price, pull out your checkbook, or better still, your wallet—at the moment when it is likely to be a clincher. Don't reach for your cash

or checkbook too soon in the bargaining process. It gives the seller confidence to hold out for a better price than the one that would otherwise be acceptable.

Remember, you can usually strike better deals at times when business is slack or when the dealer has bills to pay (for example, at the end of the month). You can often get bigger discounts when there are few shoppers about and the dealer is motivated to generate turnover.

• **If you pay cash—crisp folding notes—you should get at least 10 percent off a dealer's marked prices.**

• **Always get a proper receipt describing the item so that you can use this receipt for a refund if the item subsequently turns out to be a fake.** Making an undocumented antique purchase is as dicey as buying a Nikon camera or a Rolex watch in Hong Kong or Times Square without getting the manufacturer's international warranty. However tight a bargain you have struck, the dealer should always document the purchase; otherwise the dealer has something to hide.

You learn by your mistakes. I bought an apparently gold-plated Seiko watch in Hong Kong once and in the rush for my plane to Tokyo failed to get supporting documentation. In less than a year the case of the watch had corroded through. It was a clever fake and I had no recourse. The purchase price seemed a bargain compared to Seiko's recommended retail prices, but it was a bad buy I should have spotted. If nothing else, the retailer's attitude about giving me a guarantee and detailed receipt should have tipped me off.

All of the above comments apply to normal bargaining in reputable establishments. Some outlets (especially those dealing in Oriental rugs and/or located in tourist areas or big cities) make the bargaining process an integral part of their scam. As already suggested, they let you negotiate big discounts with very little effort because either their prices are way over the top or they are selling fakes or poor-quality merchandise. It is not even worth trying to negotiate a bargain in such establishments.

Bargain Prices: Often the Obvious Giveaway of Fakes Sold at Auction

So-called bargains at auctions combine the elements of attractive pricing and pressure to purchase in a very effective way. It is a sure warning sign that something is suspect if the bidding stops early at a well-attended sale where most lots are fetching realistic prices. Particularly when dealers or keen collectors drop out of the bidding early, you may consider yourself warned that the item is suspect. Probably the dealers and experts have examined the lot in detail during the viewing times and decided either that it is not authentic or that there may be hidden damage that would reduce value.

Although the leading auction houses offer refunds if an item proves not to be as cataloged or described, many smaller auctions (at which the bargains are most likely to be found) have very restrictive refund policies. So study the conditions of sale thoroughly, always carefully examine (at your leisure) an item that interests you, and fix beforehand the maximum price to which you are prepared to bid. Don't get carried beyond it under the pressures of the actual sale.

I once arrived late at a country auction and, from the back of the room, without having had an opportunity to examine it, bid on a book by famed children's writer Enid Blyton.

Advice that bears repeating: Always go to an auction on the preview day to examine the lots. You cannot spot the fakes readily when the sale is actually in progress.

The auctioneer said it was signed by the author. I got it for an apparent bargain price of $17 (still bidding no more than I could afford to lose if it was not a collectible piece). In examining the book afterward, I found that it was part of a promotional edition, reproduced in the thousands, that contained a facsimile signature on the flyleaf. It was of no special value at all—worth around a dollar at most. The conditions of sale gave me no recourse whatsoever, although the auctioneer's verbal description was deliberately misleading to the point of being fraudulent.

I did subsequently pick up good buys at the same sale, but only after I had been able to get around the room and see close-up the items that interested me. And it took only a few minutes to realize that the auctioneer was far from honest in his descriptions. I had to buy on my own judgment, not on his extravagant claims.

Index

medals 76
model cars
 motoring memorabilia 144
 photography 152–53, 157
 prints 105
 rugs 52
investment grade coins 74
ivory 190
 See also carvings

J

Japanese collectibles 192
jewelry 15–22
 artificial aging 16–17
 carats 19
 color 18–20
 costume 16
 diamonds 17–19, 21
 doublets 17
 dyes 18
 gemstones 18–20
 grading 19
 investment 22
 pastiches 15
 pearls 22
 zircons 17

L

lace 58–59
limited editions
 ceramics 92
 medals/commemoratives 76
 prints 107–8
looting 131, 135

M

manuscripts 111–21
 ink 111, 113–14
 paper 116–17
 pens 112–13
 typewriters 114–16
 vellum 117–18
maps 119
medals 73–77
 authentication 76
 commemorative 76
 documentation 75
 grading 74

limited editions 76
mail order 76
medal rolls 75
metals and metalware 25–43
 base metals 39
 brass 34, 200
 Britannia metal 33–34
 bronzes 39–43
 casting techniques 39–43
 copper 34
 iron 28, 32
 japanning 32–33
 lead 25
 pewter 33–34
 Sheffield plate 34–35, 38
 silver 34–36, 38, 39
 tinware 32–33
militaria 29–31
 armor 30–31
 guns 30
movie stills 155, 165
museums 220–21
 museum copies 12, 221

N

numismatics 73–77
 American Numismatic Association
 74

O

Oriental rugs and carpets. *See* rugs

P

paintings 97–103
 aging 102–3
 canvas 102
 catalogues raisonees 97
 certificates 102
 Cezanne 97
 Chagall 105
 Constable 100
 Degas 100
 de Hory, Elmyr 115
 Gainsborough 100
 Gaugin 100
 Goering, Herman 99
 Goya 97, 100